FOR HER OWN GOOD

A SERIES OF CONDUCT BOOKS

THOEMMES

ACKNOWLEDGEMENTS

I want to thank David Fairer for his invaluable help in following up various references, John Whale for his continuing intellectual support, and Marie Mulvey Roberts and Kate Docker for their patience. This introduction was completed during study leave funded by the Humanities Research Board of the British Academy, and I am grateful for research time both to them, and to the School of English, University of Leeds.

THE YOUNG LADY'S POCKET LIBRARY, OR PARENTAL MONITOR

With a new Introduction by
Vivien Jones

THOEMMES PRESS

© Thoemmes Press 1995

Published in 1995 by
Thoemmes Press
11 Great George Street
Bristol BS1 5RR
England

ISBN 1 85506 382 4

This is a reprint of the 1790 Edition
© Introduction by Vivien Jones 1995

Publisher's Note

These reprints are taken from original copies of each book. In many cases the condition of those originals is not perfect, the paper, often handmade, having suffered over time and the copy from such things as inconsistent printing pressures resulting in faint text, show-through from one side of a leaf to the other, the filling in of some characters, and the break up of type. The publisher has gone to great lengths to ensure the quality of these reprints but points out that certain characteristics of the original copies will, of necessity, be apparent in reprints thereof.

INTRODUCTION

Conduct literature, particularly for young women, was a growth industry during the eighteenth century.[1] 'Industry' is not just an empty metaphor here. This was the period which discovered the book as a consumer item, and which saw a massive expansion in the number and variety of printed texts available to a growing reading public. Within this explosion of print culture, women were quickly identified as an important target group: increasingly, booksellers marketed periodicals, miscellanies, conduct books, and of course novels, for an explicitly female audience. If the sheer numbers of titles published are any indication, conduct books were highly saleable commodities and, unlike novels, they claimed to provide impeccably respectable reading for 'the fair sex'.

The Young Lady's Pocket Library, or Parental Monitor is a clear case of a bookseller cashing in on this market for female advice literature. It offers its readers the bargain of four of the most popular and influential of eighteenth-century conduct books under one cover. The earliest text in the collection is the Marchioness de Lambert's *Advice of a Mother to her Daughter* which was first published in English in 1727, but probably

[1] On the growth in conduct books in the late seventeenth and early eighteenth centuries, see Nancy Armstrong and Leonard Tennenhouse (editors), *The Ideology of Conduct: Essays in Literature and the History of Sexuality* (New York and London: Methuen, 1987), p.10.

written thirty or so years earlier than that; the latest is John Gregory's *A Father's Legacy to His Daughters* of 1774; and *The Young Lady's Parental Monitor* itself, first published in Dublin in 1790, was still available until at least 1808, when a third edition was published by respectable booksellers in Edinburgh and London.[2] Spanning a century, *The Parental Monitor* is thus an important text for modern historians of advice literature and, more generally, of femininity itself.

The feminine ideal which conduct literature endorses is very specific in its social identity and relevance. As I have suggested, the popularity of the form points to women as a significant sub-group within a growing reading public. This growth in literacy (still, of course, very limited in terms of the population as a whole) was both symptom and cause of increased social mobility, as economic expansion extended, blurred and redefined social boundaries. Conduct literature addresses an audience of, almost exclusively young marriageable, women who are either already members of, or who aspire to join, the leisured classes. For a woman, social status and mobility depended almost exclusively on an advantageous marriage. Conduct books are guides to success – and survival. They regulate social and sexual behaviour, teaching women to discipline themselves into acceptable forms of femininity in order to achieve and maintain respectability.

Throughout the eighteenth and into the nineteenth century, the most successful conduct texts were in constant circulation: usually as legitimate reprints; quite frequently in pirated editions; sometimes as plagiarized

[2] The Brotherton Library, Leeds, has a copy of a third edition, printed by George Ramsay for J. Thomson Jun., Edinburgh, and John Murray, London, 1808.

extracts embedded in 'new' texts.[3] At one level, then, *The Parental Monitor* provides useful evidence of the enduring popularity of those individual conduct books which it chooses to include. But this perennial popularity raises more interesting questions about the continuities and the changes within ideals of femininity in the period. *The Parental Monitor* suggests not only that these four texts, written over a period of fifty years, are of continuing relevance to young women at the very end of the century, but also that they are unproblematically compatible with each other. It contributes, in other words, to the assumption that femininity is an unchanging, 'natural' condition which successive generations of conduct writers simply describe.

It is certainly true that these four texts have many premises and preoccupations in common. They collectively produce an image of 'proper' womanhood as chaste, modest, dutiful, and self-effacing. But the image is itself internally contradictory: women are presented as both naturally virtuous, and in particular need of instruction; feminine virtue is celebrated both for its own sake, and because it makes a woman desirable; it is uniquely powerful, yet women are constantly vulnerable. And within this shared conception of acceptable femininity, these texts manifest significant differences of approach and vocabulary. Such differences offer access to the subtle shifts of emphasis

[3] Among the most popular and frequently reprinted conduct books were: Richard Allestree, *The Ladies Calling* (first published 1673; latest edition recorded in the ESTC 1787); and George Savile, Marquis of Halifax, *The Lady's New-Year's Gift: or, Advice to a Daughter* (first published 1688; latest edition recorded in the ESTC 1784). Examples of texts which more or less extensively plagiarize other conduct books are: anonymous, *The Whole Duty of a Woman: Or, an infallible Guide to the Fair Sex* (1737); Wetenhall Wilkes, *A Letter of Genteel and Moral Advice to a Young Lady* (1740), which itself went through at least eight editions.

through which cultural change takes place; they also provide points of contradiction and resistance which give the lie to that implicit and influential claim that femininity is natural, inescapable, and transhistorical.

The four texts in *The Parental Monitor* were certainly written out of very various social and cultural circumstances. Their authors, two women and two men, represent differences not just of gender, but of national identity, rank, education, and religion, as well as of literary and social respectability.

Like many other conduct books, the three prose texts address their authors' own daughters. In doing so, they claim the authority of parenthood, and play – again, in a variety of ways – across the divide between the private sphere of the family and the wider audience invited by publication. John Gregory (1724–1773), professor of medicine at the Universities of Aberdeen and then Edinburgh, came from a highly respected family of Scottish physicians and scientists, and was a prominent figure within the Scottish and English medical and literary establishments. His *A Father's Legacy to his Daughters* (1774) began as a private communication and was made public only posthumously, reinforcing its author's reputation as a man of authority and feeling. For Sarah Pennington (?–1783), the estranged wife of a member of the minor English gentry, writing was a means of surviving financially and of regaining social status after the breakdown of her marriage: *An Unfortunate Mother's Advice to her Absent Daughters* (1761) demands public sympathy for a woman forced into print in order to make contact with her children. In contrast, Anne-Thérèse de Marguenat de Courcelles, Marchioness de Lambert (1647–1733), shunned publicity. She wrote only for the privileged members of

the prestigious literary salon which she hosted in early eighteenth-century Paris, circulating her works in manuscript form. When, late in her life, some were published without her consent, *Advice of a Mother to her Daughter* (1727) was immediately translated and assimilated into the English conduct-book tradition.

Fables for the Female Sex (1744), by Edward Moore (1712–1757), is something of a generic oddity within the collection since it is not, strictly, a conduct book at all, but verse satire. It claims authority from poetic tradition, rather than from the prose conventions of instructional literature and moralized personal history. Unlike the authors of the other three texts, Moore depended exclusively on his writing for his livelihood, and the *Fables*' repackaging of a popular verse form for a female audience is shrewdly and unashamedly calculated to appeal to a wide readership. And with considerable success: Moore's *Fables* was reprinted at least once every decade throughout the century – though he himself died in poverty.

Within the common project of offering moral instruction, then, the four texts in *The Parental Monitor* appeal to their readers from a variety of different standpoints. They represent subtle, but significant, distinctions in terms of social rank and respectability, and take up different positions on the question of the respectability of publication itself. I want now to explore these, and other, differences in more detail by discussing each text, and its immediate context, individually. In order to get a sense of historical change, I shall consider the three prose texts in the order of their original publication, rather than following the order in which they appear in *The Parental Monitor*. But because of its generic difference, it will be most useful to

follow *The Parental Monitor* in the case of Moore (which was the second of the texts to be published), and to look at the *Fables* at the end.

Anne-Thérèse, Marchioness de Lambert: *Advice of a Mother to her Daughter* (1727)

The *Advice of a Mother to her Daughter* is more concerned to promote female education than to offer instruction in conventional femininity. Indeed, in its stress on intellectual and moral autonomy, and its rejection of the decorous passivity which is generally assumed to please men, it is potentially a very radical text. The *Advice* begins with the challenging assertion that 'the world has in all ages been very negligent in the education of daughters... as if the women were a distinct species' (p. 134). Thus from the start it questions the common assumption that reason was primarily a male characteristic, and claims equality for women as 'rational creatures' – as Mary Wollstonecraft would later put it.[4] For Sarah Pennington, in her *Advice to her Daughters*, those of 'docile tempers' are 'thrice happy' (p. 64). De Lambert, characteristically, does not completely reject 'docility' but argues that, 'By carrying docility too far, you do an injury to your reason' (p. 158). Throughout the text she urges her daughter to 'entertain yourself with your own reason', to 'reverence and stand in awe of yourself', to use 'your own judgment and understanding' (pp. 148, 152, 158), and she regrets the fact that 'we depend too much upon

[4] Mary Wollstonecraft, *A Vindication of the Rights of Woman* (1792), edited by Barbara Taylor (London: Everyman's Library, 1992), p. 3: 'My own sex, I hope, will excuse me, if I treat them like rational creatures, instead of flattering their *fascinating* graces, and viewing them as if they were in a state of perpetual childhood, unable to stand alone.'

the men' (p. 173). Absolutely central to the *Advice*, then, is the belief that, for women as much as for men, 'the greatest science is to know how to be independent' (p. 161).

'Independent' here describes a state of mind. It suggests intellectual and spiritual freedom, rather than the financial security so often referred to when the term was used of a woman in this period. Indeed, mental and worldly wealth are set up as explicit alternatives:

> You must provide yourself some resources against the inquietudes of life, and some equivalent for the goods you had depended on. (p. 161)

Personal history and the wider histories of class and gender lie behind this familiar moral opposition. Part of that history concerns married women's uncertain rights to ownership and inheritance. When the Marquis de Lambert died in 1686, the Marchioness was granted a pension by the king, but she herself had to conduct a long, complex, but in the end successful, lawsuit against her husband's family and on behalf of her children, in order to secure some return for her fortune.[5] In spite of her aristocratic status, then, de Lambert was no stranger to financial dependency. The *Advice* was not published until 1727, but it seems likely that it was written much earlier – possibly during or soon after the lawsuit. Education and the cultivation of

[5] *Nouvelle Biographie Générale* (Paris, 1859). See also her own account in her *Advice of a Mother to her Son* (1727; 2nd edition, 1736), pp. 10–11: 'I might, my Son, in the Order of your Duties, insist on what you owe to me, but I would derive it entirely from your Heart. Consider the Condition in which your Father left me: I had sacrificed all that belonged to me, to raise his Fortune, and I lost my all at his Death. I saw myself alone, destitute of any Support. ...I met with Enemies in my own Family: I had a Law-Suit upon my Hands against potent Adversaries, and my whole Fortune depended on the Event.'

an independent rational self are recommended to her daughter as a vital resource in the face of, even aristocratic, women's uncertain material fortunes.

Rational independence is also offered as an alternative to love, and here, de Lambert can sound frighteningly repressive to the modern reader. In the *Advice*, love is described as 'the most cruel situation a rational person can be in' (p. 168); reason and judgement, the qualities required for 'independence', are opposed to imagination, the mental faculty assumed to fuel irrational passions (pp. 159–60). But it is important to understand the context which produced such apparent denials of female pleasure. The *Advice* is the only text in *The Parental Monitor* written from an aristocratic, rather than a bourgeois, position, and its representation of love and marriage reflects that class base. When John Gregory, writing almost a century later in *A Father's Legacy to his Daughters*, discusses his daughters' independence, it is as a poor alternative to marriage which,

> if entered into from proper motives of esteem and affection, will be the happiest for yourselves, make you most respectable in the eyes of the world, and the most useful members of society. ...But Heaven forbid you should ever relinquish the ease and independence of a single life, to become the slaves of a fool or a tyrant. (p. 44)

For Gregory, marriage is a personal choice, a relationship based on 'esteem and affection', every young woman's ideal of happiness. De Lambert, unlike most conduct writers, is strikingly silent about marriage itself. She refers to it only once, in the context of warnings against the pleasures of the heart:

> When one sees a young person happy enough not to have had her heart touched...she easily complies, and gives herself naturally to the person designed for her. (p. 147)

Here, the young woman has no choice. She is an object of exchange within the aristocratic kinship system of family alliances and financial transactions, and must submit to the husband 'designed for her', even if he is 'a fool or a tyrant'.

This is very different from Gregory's idealization of marriage as a happy continuum between private affection and public respectability. In a situation where marriage is a dynastic rather than a personal emotional contract, love is a dangerously disruptive force – and particularly so for women, whose reputation depends on modesty and honour. It is perhaps understandable, then, that the *Advice* seems to endorse the subordination of private desires to the social order, and that it concentrates on the dangers of indulging 'the passions' rather than on marriage itself:

> Possess your heart as much as is possible with sentiments for the conduct that you ought to observe; fortify this prejudice of Honour in your mind. (p.139)

In such passages, which rewrite female virtue as intellectual choice, rational 'independence' seems simply to promote an internalized acceptance of the status quo, a willing submission to the dual sexual standard which imprisons women in arranged marriages.

But, as I have already suggested, to reduce the *Advice* simply to this orthodox position would be a mistake. The coexistence of radical and conformist discourses in de Lambert's text can usefully be illustrated by comparing the *Advice* with two contemporary English

texts: George Savile, Marquis of Halifax's *The Lady's New-Year's Gift: or, Advice to a Daughter*, first published in 1688; and Mary Astell's proto-feminist tract *A Serious Proposal to the Ladies*, first published in 1694.

One of Halifax's main concerns is to reconcile his daughter to the fact that 'young Women are seldom permitted to make their own *Choice*', by persuading her:

> That the *Institution of Marriage* is too sacred to admit a *Liberty* of *objecting* to it; That the supposition of yours being the weaker *Sex*, having without doubt a good Foundation, maketh it reasonable to subject it to the *Masculine Dominion*....[6]

For Halifax reason supports, rather than challenges, gender inequality and one of the most chilling passages in his *Advice* is that in which he effectively endorses the sexual double standard by suggesting that a woman's role is to ignore her husband's infidelity: 'next to the danger of *committing* the Fault your self, the greatest is that of *seeing* it in your *Husband*'; '*Discretion* and *Silence* will be the most *prevailing Reproof*.'[7]

Like de Lambert, Halifax is an aristocrat, but in de Lambert's text, gender cuts across class. Halifax's advocation of pragmatic passivity is very different from her stress on active independent judgement. Although, like Halifax, de Lambert is concerned with strategies for survival within society, her position is in many ways

[6] Halifax, *The Lady's New-Year's Gift* (6th edition, 1699), pp. 25, 31. Extracts reprinted in Vivien Jones (editor), *Women in the Eighteenth Century: Constructions of Femininity* (London and New York: Routledge, 1990), pp. 18–19.

[7] Halifax, pp. 35, 37 (Jones, p. 20).

much more comparable with that of Mary Astell, who argued in *A Serious Proposal* for the establishment of a female religious community, 'a Retreat from the World for those who desire that advantage'.[8] Astell justifies the plan not just in terms of religious commitment, but on educational grounds: 'one great end of this Institution shall be, to expel that cloud of Ignorance which Custom has involv'd us in.' She also offers it as a refuge where 'Heiresses and Persons of Fortune may be kept secure from the rude attempts of designing Men'.[9] Like de Lambert, Astell starts from the argument that, 'since GOD has given Women as well as Men intelligent Souls, why should they be forbidden to improve them?'[10] Her rationalist retreat has much in common with de Lambert's more secular and internalized vision of independence:

> Secure yourself a retreat and place of refuge in your own breast; you can always return thither, and be sure to find yourself again. When the world is less necessary to you, it will have less power over you. (p. 162)

Astell and de Lambert have a shared philosophical inheritance in the work of late seventeenth-century French theorists, such as Poulain de la Barre and Jacques du Bosc (both of whose work was translated into English), who used Cartesian rationalism, the principle that humanness consists in the capacity for self-conscious thought, to argue for women's intel-

[8] Mary Astell, *A Serious Proposal to the Ladies, For the Advancement of their True and Greatest Interest* (1694; 3rd edition, 1696), p. 40. Also in Jones, p. 202. Reprinted in *Sources of British Feminism*, Routledge/Thoemmes Press, 1993.

[9] Astell, pp. 50, 99 (Jones, pp. 204, 205).

[10] Astell, pp. 52–3.

lectual equality.[11] But, unlike Astell, de Lambert is also clearly steeped in the classical tradition and the work of contemporary French moral philosophers such as La Rochefoucauld and La Bruyère. What is less obvious from the evidence of the *Advice* itself is her allegiance, too, to the conventions of French heroic romance, in which women controlled a sophisticated and aestheticized game of ideal love.[12] In spite of its promotion of rational independence, then, de Lambert's *Advice to a Daughter* offers an account of gender difference which can be more easily assimilated into the English advice tradition than Astell's uncompromising separatism ever could.

The discussion of modesty (pp. 140–43) illustrates my point. De Lambert identifies the 'great virtues' as 'extraordinary valour in the men, and extreme modesty in the women', and emphasizes modesty as the quality which must be 'inseparable' from all the other 'passions' (pp. 140, 143). Her definitions are echoed in Addison and Steele's *Spectator*, the English periodical which was instrumental in shaping an emergent bourgeois identity at the beginning of the eighteenth

[11] [François Poulain de la Barre], *The Woman as Good as the Man* (1677); Jacques du Bosc, *The Excellent Woman* (1692). See Ruth Perry, *The Celebrated Mary Astell: An Early English Feminist* (Chicago and London: University of Chicago Press, 1986), especially pp. 70–73; Hilda Smith, *Reason's Disciples: Seventeenth-Century English Feminists* (Urbana, Chicago, London: University of Illinois Press, 1982), pp. 115–39.

[12] In her *New Reflexions on the Fair Sex* (translated into English by J. Lockman, 1729), de Lambert works much more explicitly within the French heroic romance tradition, celebrating women's special capacity for love and sensibility, and making direct references to the work of, for example, the romance writer Madeleine de Scudéry. For a helpful summary of French heroic romance in the context of early eighteenth-century English narratives by women, see Ros Ballaster, *Seductive Forms: Women's Amatory Fiction from 1684 to 1740* (Oxford: Clarendon Press, 1992), pp. 42–9.

century.[13] In turn, the definition of gendered virtues in both de Lambert and *The Spectator* echoes La Rochefoucauld's *Moral Maxims* (1694), while the discussion of modesty recalls both Seneca and La Bruyère's *Characters* (1702).[14] What we glimpse here, then, is shared influences which link the French aristocratic text with the English moral tradition.

De Lambert's language retains vestiges of heroic romance. In *The Spectator*, the vocabulary is more unequivocally moralistic: 'valour' becomes 'courage'; 'modesty' is narrowed to 'chastity'; the 'passions' ('Truth' and 'Love') in the *Advice* are the 'virtues' in *The Spectator*. In *The Spectator*, heroic ideals and gender identities are rewritten: they are self-consciously domesticated into the bourgeois ideal of marriage which Gregory still endorses sixty years later. Writing pragmatically for her daughter, de Lambert follows a comparable trajectory. As do so many conduct writers, she warns against romance reading (p. 156), and rejects the extra-marital 'passions' which heroic romance might idealize and celebrate. In spite of significant differences of nuance and context, then, de Lambert's *Advice to her Daughter* was read as fitting safely into the conduct literature tradition within which *The Spectator* plays such a significant role.

[13] See Michael G. Ketcham, *Transparent Designs: Reading, Performance and Form in the* Spectator *Papers* (Athens, Georgia: University of Georgia Press, 1985), especially Chapter 4; Kathryn Shevelow, *Women and Print Culture: The Construction of Femininity in the Early Periodical* (London and New York: Routledge, 1989), pp. 93–145.

[14] Cf. *Spectator* 99: 'The great Point of Honour in Men is Courage, and in Women Chastity'; *Spectator* 231: 'Modesty...sets off every great Talent which a Man can be possessed of. It heightens all the Vertues which it accompanies...'. For references to La Rochefoucauld, etc., see *The Spectator*, editor Donald F. Bond (Oxford: Clarendon Press, 1965), Volume I, p. 416; Volume II, pp. 399–400.

Sarah Pennington, *An Unfortunate Mother's Advice to her Absent Daughters, in a Letter to Miss Pennington* (1761)

Sarah Pennington's *Unfortunate Mother's Advice* is framed by the story of her own marital difficulties, and of her fight to recover her good name after her estrangement from her husband. Indeed, the text itself is a part of that narrative, an act of self-justification which exposes private principles to public scrutiny. The opening of *An Unfortunate Mother's Advice* is thus very different from de Lambert's confident challenge on behalf of women's education. Pennington appeals not to reason, but to sentiment and sympathy, representing herself as tragically caught between the risk of impropriety and her duty as a mother: 'my circumstances are such as lay me under the necessity of either communicating my sentiments to the world, or of concealing them from you' (p. 57). Where de Lambert's conduct book can be identified generically with tracts on women's education and proto-feminist texts, then, Pennington's is closer to that other generic grouping with which conduct literature has close affinities: the periodical and epistolary tradition of moralized narratives.[15]

The Unfortunate Mother's Advice begins and ends with a few sparse autobiographical details (pp. 58–63; 127–9). At the start of the text, Pennington describes herself as a foolish but, she claims, morally blameless, young woman whose 'very high flow of spirits' meant

[15] See, for example: Elizabeth Singer Rowe, *Letters Moral and Entertaining in Prose and Verse*, 3 volumes (1728–32); Samuel Richardson, *Letters written to and for Particular Friends, On the Most Important Occasions* (1741). On women's relationship with the epistolary tradition, see Ruth Perry, *Women, Letters and the Novel* (New York: AMS Press, 1980).

that she 'never broke...into the formal rules of decorum' (pp. 59–60); at the end, she has matured through experience into a living example of the pleasures of retirement, which gives 'more real satisfaction...than the gayest scenes of festive mirth ever afforded me' (p. 127). And without giving any details, she hints that her husband's desire to gain control of her independent fortune lies behind 'many of those appearances which have been urged against me' (p. 61). Both in *An Unfortunate Mother's Advice*, and in her other major publication, *Letters on Different Subjects* (1767), Pennington tantalizes the reader (and her husband) with her power 'to give the world a history of the whole truth'.[16] Indeed, in the preface to the third volume of the *Letters*, she has to justify herself to subscribers who had expected an unexpurgated account of her life. But she chooses the moral high ground, describing how, in spite of extreme and continuing provocation, she has been unable to bring herself to publish memoirs which contain 'so many incidents of a kind which a benevolent heart must shrink with reluctance from the thought of exposing to public view'.[17] Pennington thus implicitly defines her writings against those of the 'scandalous memoirists' – women such as Teresia Constantia Phillips, Laetitia Pilkington and Frances Anne, Viscountess Vane – who became notorious in the period for publishing frank accounts of their transgressive sexual histories.[18] Pennington, in contrast,

[16] *Letters on Different Subjects, in four volumes; Amongst which are interspers'd the Adventures of Alphonso, After the Destruction of Lisbon.* (2nd edition, 1767), volume III, sig. a3v.

[17] *Letters*, vol. III., sig.a4v.

[18] For accounts of these writers, see Janet Todd, *The Sign of Angellica: Women, Writing and Fiction, 1660-1800* (London: Virago, 1989), pp. 128–31; Felicity Nussbaum, 'Heteroclites: The Gender of Character in

presents herself as heroinically maintaining a much more conformist femininity in the face of personal abuse and financial difficulty.

In Pennington's text, then, the power of experience lends authority – and necessity – to a very orthodox account of feminine identity, the main characteristics of which are piety, domesticity, and self-effacement. Where de Lambert's *Advice* recommends independence and scepticism towards received opinions, Pennington uses herself as an example against the mistaken faith that 'the self-approbation arising from conscious virtue' is a sufficient defence for women against 'the public voice' (p. 58). Instead, she urges 'prudence', a term which plays constantly through her text, as necessary for self-preservation in 'a world full of deceit and falsehood' (p. 64). Pennington's daughters are reminded that the 'management of all domestic affairs is certainly the proper business of woman'; and although they should neglect 'no branch of knowledge that your capacity is equal to', self-improvement must be subordinated always to domestic duties, and subject to the humbling recognition that 'all the learning her utmost application can make her mistress of, will be...inferior to that of a school boy' (pp. 76–7).

This 'prudence' involves a strong sense of social hierarchy. On the one hand, for example, Pennington recommends 'decency and cleanliness' of dress such as is 'suitable to your rank and fortune', rather than the 'ill-placed finery' associated with the ostentatious display of the aristocracy (p. 82). On the other, she

the Scandalous Memoirs', in *The New Eighteenth Century: Theory Politics Literature*, edited by Felicity Nussbaum and Laura Brown (New York and London: Methuen, 1987), pp. 144–68; Clare Brant, 'Speaking of Women: Scandal and Law in the Mid-Eighteenth Century', in *Women, Texts and Histories 1575–1760*, edited by Clare Brant and Diane Purkis (London & New York: Routledge, 1992), pp. 242–70.

warns against too great an intimacy with servants 'whose birth, education and early views in life were not superior to a state of servitude' (p. 81). Pennington's ideal woman is thus recognizably a member of the 'middle rank': she fits – much more neatly than de Lambert – into the mould of the bourgeois 'proper lady', the 'new domestic woman' identified by recent feminist commentators on the conduct literature of the period.[19] Nancy Armstrong argues that the ideal bourgeois wife was defined 'in opposition to certain practices attributed to women at both extremes of the social scale', and that the rejection of aristocratic display meant 'the invention of depths in the self', the measurement of femininity in terms of private, internal virtues.[20] Pennington herself emerges from her text as a frustrated example of that ideal figure: she has to fulfil her duty as a mother through the substitute of writing; and her retirement is a solitary version of proper domesticity.

But Pennington's strategic manipulation of the power of print also manifests a less self-effacing version of 'prudence', and a motivation much closer to the 'scandalous memoirists'. In her decorous mixture of conduct literature and autobiography, she uses the identity of the 'proper lady' to secure financial survival as well as social respectability. Sarah Pennington saved her reputation by creating it – albeit within the

[19] On the 'proper lady', see Mary Poovey, *The Proper Lady and the Woman Writer: Ideology as Style in the Works of Mary Wollstonecraft, Mary Shelley, and Jane Austen* (Chicago and London: University of Chicago Press, 1984), especially pp. 3–47. The 'new domestic woman' is discussed in Nancy Armstrong, *Desire and Domestic Fiction: A Political History of the Novel* (New York and Oxford: Oxford University Press, 1987). See particularly 'The Rise of the Domestic Woman', pp. 59–95, also reprinted in Armstrong and Tennenhouse, *The Ideology of Conduct*, pp. 96–141.

[20] Armstrong, *Desire*, pp. 75–6.

powerful constraints of the mid-century's orthodox femininity. The list of subscribers to her *Letters* includes the Queen and numerous members of the aristocracy, and when she died, her obituary in *The Gentleman's Magazine* reproduced the self-image created in her books:

> This lady, whose extraordinary abilities, long since displayed to the world, in her excellent and much-admired writings, which could only be equalled by her piety, charity, and benevolence, united to that patient and unreserved resignation, with which she sustained (through the course of many years) a series of very severe and uncommon afflictions. [*sic*][21]

As in novels, the particularity of Pennington's personal history problematizes the conduct-book paradigm which her text promotes.[22] In *An Unfortunate Mother's Advice*, she acknowledges that her potential as ideal wife was denied in part by her own early failure to match public with private behaviour:

> my private conduct was what the severest prude could not condemn; my public, such as the most finished coquet alone would have ventured upon. (p. 60)

But the real blame lies with her husband. 'Perfectly acquainted with my principles and with my natural disposition' (p. 61), he nevertheless failed to fulfil his side of the new marital contract, preferring material to moral wealth. In her narrative, it is unreformed masculinity which threatens the new feminine ideal.

[21] *Gentleman's Magazine* 53 (1783), p. 978.

[22] On fiction's problematization of conduct-book material, see Carol Houlihan Flynn, 'Defoe's Idea of Conduct: Ideological fictions and fictional reality', in Armstrong and Tennenhouse, *The Ideology of Conduct*, pp. 73-95.

Men, again as in novels, are difficult to read: it can be all too easy to mistake the mere 'Good-Humour' which disguises the domestic tyrant, for 'a truly benevolent disposition' (pp. 98–9); and some of the most painful – but also potentially subversive – passages in *An Unfortunate Mother's Advice* are those in which Pennington offers strategies for coping with a bad husband. They are painful because of their Halifax-like counsel to remain passive in the face of abuse and infidelity (pp. 107, 113), but also because they communicate a level of anxiety which suggests that such abuse is all too possible. Marriage, it would seem, is very likely to be a damage-limitation exercise, staving off 'absolute misery' rather than embodying 'true happiness' (p. 115). The implicit narrative of Pennington's own experience gives such passages a power which threatens to undermine the official moral of her text. Marriage, she asserts, can be 'the highest satisfaction of human life' (p. 116). But:

> so great is the hazard, so disproportioned the chances, that I could almost wish the dangerous die was never to be thrown for any of you. (p. 96)

In spite of her advocacy of 'prudence', then, there are brief moments when Pennington, too, recalls the radical separatism of a Mary Astell.

John Gregory, *A Father's Legacy to his Daughters* (1774)

John Gregory's *A Father's Legacy to his Daughters* has the dubious distinction of having been attacked during the post-revolutionary 1790s both by the radical Mary Wollstonecraft in her *Vindication of the Rights of Woman* (1792), and by Thomas Gisborne, an influ-

ential Evangelical conduct writer, in his *Enquiry into the Duties of the Female Sex* (1797). This critical attention at a moment of ideological crisis is a measure of the text's popularity and influence (Wollstonecraft refers to the 'celebrated' *Legacy to his Daughters*).[23] It is also indicative of the *Legacy*'s peculiarly contradictory quality, its tension between the father as 'friend' (p. 45), as the man of feeling, and as the voice of repressive, even predatory, masculinity.

Wollstonecraft, with her usual sharp insight, notes a symptomatic stylistic inconsistency: between an 'easy familiar style' which is 'particularly suited to the tenor of his advice', and 'a degree of concise elegance in many passages that disturbs this sympathy...we pop on the author, when we only expected to meet the – father'. She goes on:

> Besides, having two objects in view, he seldom adhered steadily to either; for wishing to make his daughters amiable, and fearing lest unhappiness should be the only consequence, of instilling sentiments that might draw them out of the track of common life without enabling them to act with consonant independence and dignity, he checks the natural flow of his thoughts, and neither advises one thing nor the other.[24]

Her reading radically disagrees with the less politically astute 'Preface', in which Gregory's editor presents the text as a spontaneous, 'domestic' communication, entirely private and therefore, supposedly, forced to

[23] Wollstonecraft, p. 30. The other text Wollstonecraft uses to epitomize conduct-book discourse is James Fordyce's *Sermons to Young Women* (1766), which Mr Collins tries unsuccessfully to read to the Bennet sisters in Chapter 14 (Book 1) of Jane Austen's *Pride and Prejudice*.

[24] Wollstonecraft, p. 104.

make no 'sacrifices' to the public world, to 'prejudices, to customs, to fashionable opinions' (p. iii). Wollstonecraft is concerned to deconstruct precisely this assumption that private, family relationships are free from political 'prejudices' and 'customs'. Of Gregory, she declares: 'I respect his heart, but entirely disapprove' of his *Legacy*, which she uses to 'show how absurd and tyrannic it is thus to lay down a system of slavery'.[25] Writing in the 1790s, in the immediate aftermath of the French Revolution, Wollstonecraft adopts the terms of revolutionary political analysis – 'tyrannic'; 'slavery' – to expose the injustices in sexual politics.

Like Wollstonecraft, Gisborne objects to Gregory's over-protective suggestions that women should conceal their learning from men (p. 13) and their love from their husbands (p. 35). For Wollstonecraft, such dissimulation precludes the rational friendship – 'the most holy band of society'[26] – which should be the basis of marriage. Gisborne's view of women and of marriage, in contrast, rests on the Pauline doctrine of inequality: a woman's role is to 'learn to place delight in the performance of duty', and, in the words of St Paul, to 'see that she reverence her husband'. To conceal her affection is thus a failure in her duty to 'render herself pleasing to him'. He therefore also deeply disapproves of Gregory's potentially radical view that young women might develop non-sexual friendships with men (p. 30): 'no advice could easily be more repugnant to discretion and common sense'.[27] Gisborne's concern is that Gregory's

[25] Wollstonecraft, pp. 30, 35.

[26] Wollstonecraft, p. 32.

[27] Thomas Gisborne, *An Enquiry into the Duties of the Female Sex* (6th edition, London, 1805), pp. 139, 152, 171, 173n.

ideal of easy social relationships between the sexes might give women too much autonomy rather than too little. His conduct book, published right at the end of the century, points forward to the Victorian 'angel in the house'.

Gregory's persona in the *Legacy* is as important as that of Sarah Pennington in the *Unfortunate Mother's Advice*. He is the mid-eighteenth-century man of sensibility, the domesticated hero who can be traced back to *The Spectator*, and to Richardson's last novel *Sir Charles Grandison*.[28] Compared with Gisborne's stern Evangelicalism, then, Gregory seems to represent a liberal and enlightened version of masculinity. At the beginning of the *Legacy*, he carefully displays his 'honourable' view of women: 'not as domestic drudges, or the slaves of our pleasures, but as our companions and equals'. The terms seem almost Wollstonecraftian – until assumptions about sexual difference begin to undermine the egalitarian implications of 'companions and equals'. Women, it seems, are in fact 'designed to soften our hearts and polish our manners', and their place in society demands 'a certain propriety of conduct' (p. 3). And slightly later in the text, femininity and companionship have become explicitly antithetical: frankness of behaviour, we are told, 'might render you more agreeable as companions, but it would make you less amiable as women' (p. 15).

Wollstonecraft's response to this passage is to expose Gregory's collusion with women's 'degradation': 'this desire of being always women, is the very consciousness

[28] On sensibility generally, and the man of sensibility in particular, see John Mullan, *Sentiment and Sociability: The Language of Feeling in the Eighteenth Century* (Oxford: Clarendon Press, 1988); Janet Todd, *Sensibility: An Introduction* (London and New York: Methuen, 1986).

that degrades the sex'.[29] In spite of his gestures towards equality, Gregory endorses precisely that infantilizing identification of femininity with 'delicacy', with 'softness and sensibility' (pp. 4–5), which Wollstonecraft so devastatingly deconstructs in the *Vindication*: 'to their senses, are women made slaves, because it is by their sensibility that they obtain present power'.[30] 'Delicacy' is the term which constantly recurs in the *Legacy*. The motivation throughout the text is to shelter the fragile bloom of femininity: from the 'chaos' of religious controversy which 'has no good effect on the heart' (p. 6); from reading anything which could stimulate 'sentiments that might perplex you' (p. 22); from 'the first impressions of love' (p. 41). And from itself: Gregory reproduces the classic double bind of sensibility, through which women's highly-tuned sensitivity can flip over at any moment into sensual excess.[31] Women, we are told, are 'peculiarly susceptible of the feelings of [religious] devotion', but they are just as apt to be led into 'a dissipated state of life' (p. 5); and a girl dancing 'with spirit' can too easily be 'thought to discover a spirit she little dreams of' (pp. 23–4). Gregory's tactic here is typical: throughout the *Legacy*, he justifies his protectiveness by offering privileged access to a male gaze which is assumed to have the power of definition.

Again Wollstonecraft comments: 'why, to damp innocent vivacity, is she darkly to be told that men will draw conclusions which she little thinks of? Let the libertine draw what inference he pleases.'[32] Her

[29] Wollstonecraft, p. 107.
[30] Wollstonecraft, p. 66.
[31] See Mullan, pp. 217–24.
[32] Wollstonecraft, p. 31.

'spirited' refusal even to entertain the libertine interpretation exposes Gregory's own anxious collusion with predatory and lascivious masculinity. There is a continuity, rather than the difference Gregory claims, between the man of sensibility and the rake; in Wollstonecraft's rationalist analysis, they have the same effect on women:

> [Women] have, to maintain their power, resigned the natural rights which the exercise of reason might have procured them.... Exalted by their inferiority...they constantly demand homage as women, though experience should teach them that the men who pride themselves upon paying this arbitrary insolent respect to the sex, with the most scrupulous exactness, are most inclined to tyrannize over, and despise the very weakness they cherish.[33]

As a man of sensibility, Gregory ostensibly rejects the double standard in sexual behaviour which the Marquis of Halifax, for example, took for granted in his conduct book of 1688, when he advised his daughter on how to cope with an unfaithful husband. A double standard certainly operates in other areas: in matters of religion (p. 9), learning (p. 13), and conversation (pp. 14–15), for example, Gregory takes it for granted that gender imposes different rules of behaviour. But male sexuality is rewritten in sentimental terms: for Gregory, men, as well as women, are ideally creatures of 'spirit and delicacy' (pp. 28, 37). Indeed, in a reversal of the usual assumption, it is men rather than women who are most susceptible to the individual attachments and emotional extremes of romantic love (pp. 33, 35). Women, we are told, do not have 'much of that sensibility which

[33] Wollstonecraft, p. 59.

disposes to such attachments'; having less choice, they have been 'assigned...a greater flexibility of taste on this subject': they experience 'gratitude' rather than love (pp. 32–3). Perhaps, then, in Gregory, the sexual double standard has not so much disappeared as mutated.

The terms of that mutation are important in plotting the history of sexuality and subjectivity. Dominant definitions of gender identity and of sexual relations have shifted considerably in the period represented by the three prose texts in *The Parental Monitor*. Marriage in Gregory, as I pointed out earlier, is a site of personal happiness rather than mere social and financial convenience; and the influence of Sarah Pennington's 'prudent' feminine ideal (represented in Gregory's case by the deceased wife who haunts his text) has 'improved' and feminized masculinity into a new 'delicacy' of sensibility. The shift can be characterized in class terms as signalling the transition from a traditional aristocratic to a dominantly bourgeois culture; from a culture of public alliances to one of private 'relationships'; from, in Michel Foucault's terms, 'the deployment of alliance' to the 'deployment of sexuality' as the dominant principle in the social organization of sexual relations.[34] In terms of literary genres, it is central to the difference between heroic romance or Restoration comedy and the Richardsonian novel. What is much less clear is what women gained from this 'feminizing' process. It is very difficult to decide

[34] Michel Foucault, *The History of Sexuality. Volume I: An Introduction*, translated by Robert Hurley (Harmondsworth: Penguin, 1981), pp. 106–7. On the shift to a culture of affectivity during the eighteenth century, see also Jean Hagstrum, *Sex and Sensibility: Ideal and Erotic Love from Milton to Mozart* (Chicago and London: University of Chicago Press, 1980); Lawrence Stone, *The Family, Sex and Marriage in England 1500–1800* (Harmondsworth: Penguin, 1979).

whether women experienced greater 'independence' in de Lambert's aristocratic setting of arranged marriages, or as the civilizing influence within Gregory's bourgeois ideal of domestic complementarity.

John Moore, Fables for the Female Sex (1744)

The first edition of Moore's *Fables for the Female Sex* made its literary allegiance immediately clear: the title page, typeface and woodcut illustrations exactly replicate the style of John Gay's second volume of *Fables*, published posthumously in 1738. Thus Moore's text claims a place within the literary establishment, and within the tradition of moral satire. Gay was a member of the Scriblerus Club, a friend of Pope and Swift, and his *Fables* were for a long time his most popular work, running eventually to over 350 editions.[35] In producing a version for a female audience, Moore, and his collaborator Henry Brooke, strategically combine two popular forms. One is the beast fable itself, long-established in both classical and vernacular literatures, used by Chaucer and Spenser, and most famously represented by the fables of la Fontaine and 'Aesop'; the other is anti-female satire, again with immediate French and classical precedents in Boileau and Juvenal.[36]

[35] See *John Gay: Poetry and Prose*, edited by Vinton A. Dearing, 2 volumes (Oxford: Clarendon Press, 1974), volume II, p. 619. The first volume of Gay's *Fables* was published in 1727. A facsimile edition of both volumes was published as an Augustan Reprint Society special edition in 1967.

[36] The first thirteen Fables are by Moore; the last three, as their very different style suggests, are by Brooke (1703?–1783), a prolific professional writer, who was also connected to the Pope/Swift/Gay circle. On the beast fable, see *John Gay: Poetry and Prose*, volume II, pp. 620–21; on traditions of anti-female satire, see Felicity Nussbaum, *The Brink of all we Hate: English Satires on Women 1660–1750* (Lexington: University of Kentucky Press, 1984).

Interestingly, from the point of view of advice literature, the connection between the two forms had already been made in *The Spectator*. In *Spectator* 209, Addison playfully translated characterizations of female types, by the classical Greek poet Simonides, which compared them with particular animals. Versions of several of these characterizations recur in Moore.[37] Simonides includes a positive example: the Bee is the type of the 'best Wife that Jupiter can bestow on Man'; 'Her family flourishes and improves by her good management'. Addison uses this representation of an ideal to make an important theoretical point, rejecting the purely negative anti-female satires of Juvenal and Boileau: 'where they have endeavoured to expose the Sex in general, without doing Justice to the valuable Part of it. Such levelling Satyrs are of no use to the world.'[38] In keeping with Addison's reformist position, Moore's *Fables* do not reproduce the kind of damning generalizations about women which, for example, Pope perpetuated in his 'Epistle to a Lady' (1735): 'Most Women have no Characters at all'; 'Ev'ry Woman is at heart a Rake'.[39] Nor, however, do they offer the complex individual portraits which problematize those generalizations in Pope's poem. Instead, they deal in general terms with satiric commonplaces, predictable situations and feminine types, and they promote an ideal femininity very close to that celebrated by Pennington and Gregory. Like *The Spectator* itself, then, but in poetic form, they occupy a position which

[37] Fable XIII, for example, recalls Simonides' account of the swine-like woman: 'A Woman of this Make is a Slutt in her House, and a Glutton at her Table' (*Spectator* 209; Volume II, p. 319).

[38] *The Spectator* 209, p. 320.

[39] Alexander Pope, *Moral Essays*, 'Epistle II: To a Lady', ll. 2, 216.

xxxii *Introduction*

connects classic moral satire with the more narrowly-directed preoccupations of female advice literature.

Like Pennington and Gregory, the *Fables* work with the affective bourgeois marriage as their ideal: Fable XIV, for example, sets the faithful dove's hymn to the comforts of marriage and the family against the sparrow's empty libertine pleasures: 'Thee, wretch! no lisping babe shall name' (p. 262). And elsewhere, the *Fables* expose the deathly consequences of marriages based on lust or mercenary motives (Fables IV, VI). The grotesque portrait of the wife who neglects her family for learning (Fable XIII) recalls Pennington's more sober advice to put family before self-education (p. 76), and in Fable XV, prudence is personified, lamenting that she is now 'held as one whose form intruded' (p. 308). Several of the *Fables* attack female vanity and display (Fables II, III, X, XV), and the prurient fascination with modesty of dress in Fable X is only a more explicit version of Gregory's warning that men are not necessarily attracted 'by the fullest display of...personal charms' (p. 17): 'The maid, who modestly conceals/Her beauties, while she hides, reveals' (p. 231). Conduct literature is haunted by predatory male sexuality in the form of the rake. Pennington, for example, points to the 'unhappy victims to the ridiculous opinion, "A reformed libertine makes the best husband"' (p. 97). In the *Fables*, those 'unhappy victims' are graphically realized in the Gothic melodrama of Fable VI, where the wolf/rake feeds off his wife's sister-lambs at her own table: 'The crashing bones he grinds for food,/And slakes his thirst with streaming blood' (p. 211).

The *Fables*' satiric techniques position the reader very differently from the implied reader of the other three

Introduction xxxiii

texts in *The Parental Monitor*. From an individualized authority based on personal experience and parental status, which produces the reader as the innocent in need of instruction, we move to the generalized, but much more precarious, moral authority of the satiric observer. The fable form itself, with its beast parallels and allegorical landscapes, puts contemporary manners and forms of femininity in a timeless context. But the *Fables* have to prove their moral case in aesthetic terms, through the wit and skill with which the connections and parallels are made. They ideally assume a quite sophisticated reader who can pick up on classical allusions, and who can also appreciate the satirical connections being made between sexual politics and, for example, legal abuses or Grub Street (Fables VIII, XIII). The reader is invited to share – but is also given a critical space in which to judge – the poet's analysis of human, or feminine, 'nature'.

References to Grub Street would, of course, be of less immediacy and relevance to readers of *The Parental Monitor* in the 1790s – as would the Cartesian debates of the late-seventeenth century which de Lambert evokes in her text. But that does not mean that the conduct books reprinted in *The Parental Monitor* are therefore safely outside or beyond debate and controversy. *The Parental Monitor* was published in 1790, at a moment when the French Revolution had generated revolutionary activity and fierce political confrontation in Britain. As is so often the case at times of political crisis, definitions of gender and the family came under radical scrutiny in this period, and *The Parental Monitor* could well be read as an intervention on behalf of traditional values. Like every other text, conduct

xxxiv *Introduction*

books are written, reprinted – and received – in particular, changing, circumstances. Though the intention might have been conservative, de Lambert's engagement with Cartesian rationalism, for example, could well have taken on newly radical meanings in the revolutionary 90s.

Conduct literature is sometimes presented as a thoroughly efficient disciplinary apparatus, an unambiguous guide to the history of gender identity. Conduct books certainly clearly articulate a dominant and repressive ideology of femininity – a 'system of slavery' in Wollstonecraft's words – and their popularity suggests a wide readership and a pervasive influence. But while we can learn a lot from conduct literature about the cultural production of gender, we need to guard against producing our own, critical, mirror-image of a transhistorical 'proper lady'. In individual examples of the genre, as I have tried to suggest, contingent circumstances alter that ideology in subtle but significant ways. And, again as with any text, conduct literature is subject to the unpredictability of interpretation: how, and alongside what other kinds of writing, it will be read. The implied reader of conduct books is clear enough, but it is very difficult to assess precisely how, and by whom, conduct literature was used, how the 'proper lady' was mediated in lived experience. It is certainly dangerous to assume that its readers were simply passive consumers.

In Jane Austen's *Pride and Prejudice*, the odious Mr Collins tries to read James Fordyce's influential conduct book, *Sermons to Young Women*, to the Bennet sisters.[40] He doesn't get very far: 'Lydia gaped as he opened the volume, and before he had, with very

[40] Jane Austen, *Pride and Prejudice* (1813), Chapter 14 of Book 1.

monotonous solemnity, read three pages, she interrupted him.' Mr Collins is 'much offended', and shocked at his cousins' indifference to instruction. We laugh at his pompous judgement, but we might hope that, for once, his observations at least are accurate: 'I have often observed how little young ladies are interested by books of a serious stamp, though written solely for their benefit.'

Vivien Jones
University of Leeds, 1995

EXPLANATORY NOTES

p. 3. *a little Treatise of mine.* John Gregory, *A Comparative View of the Faculties of Man with those of the Animal World* (1765). The passage referred to reads: 'If we impress their minds with a belief that they were made only to be domestic drudges, and the slaves of our pleasures, we debase their minds, and destroy all generous emulation to excel; whereas, if we use them in a more liberal and generous manner; a decent pride, a conscious dignity, and a sense of their own worth, will naturally induce them to exert themselves to be what they would wish to be thought, and are entitled to be, our companions and friends' (7th edition, 1777, pp. 116–17).

p. 3. *To raise the virtues...human life.* James Thomson, *The Seasons* (1730), 'Autumn', ll. 606–9: 'To raise the virtues, animate the bliss,/Even charm the pains to something more than joy,/And sweeten all the toils of human life:/This be the female dignity and praise.'

p. 19. *Grace was in...and love.* John Milton, *Paradise Lost*, VIII, ll. 488–9.

p. 22. *'But when I reflect...vanity or convenience'.* Untraced, but the comment is a contemporary commonplace which could have come from any number of conduct books or novels.

p. 35. *Thomson's Spring*. In *The Seasons*, 'Spring', ll. 983–1075, Thomson describes the 'charming agonies of love,/Whose misery delights' (ll.1074–5).

p. 67. *Doctor Hoadly's*. Benjamin Hoadly (1676–1761): became Bishop of Winchester in 1734; his prayers were published as part of his complete works. (See also next note.)

pp.70–1. *Bishop Hoadly's...Nelson's Christian Sacrifice*. Hoadly's *Plain Account*...(1735) caused great theological excitement when it was published, since it argues that the sacrament of the Lord's Supper is simply a commemorative rite. Robert Nelson (1656–1715): religious writer and Jacobite sympathizer. His *Great Duty*...was published in 1707.

p. 74ff. *necessary and polite acquisitions*. Pennington recommends the standard female curriculum of the period, as offered at respectable boarding schools for girls.

pp. 86–7. The recommended reading was expanded by Pennington herself in the fifth edition of *An Unfortunate Mother's Advice*, published in 1770, and again by the editor of *The Parental Monitor*. Pennington's revision simply expanded existing categories: sermons; classical moralists (which would be read in translation); periodicals; histories; poetry; and narrative conduct books by Rowe and Moore. It is interesting that, in spite of Pennington's warnings against fiction, the editor of *The Parental Monitor* added several novels to the list, including Charlotte Smith's *Emmeline* (1788), a novel which excited controversy when it was published because of its sympathy for a woman who has an illegitimate child. The surprising

omission from the list is Samuel Richardson, whose last novel, *Sir Charles Grandison* (1753–4), particularly, was generally considered a masterpiece of moral fiction. His novels were approved, for example, by James Fordyce in his *Sermons to Young Women* (1766).

p. 88. *The Vicar of Wakefield*. (1766), a comic novel by Oliver Goldsmith, the essayist, playwright, and poet, which follows the fortunes of its innocent and moral hero, Parson Oliver Primrose. The novel deals, among other things, with Primrose's search for his lost daughter and his imprisonment for debt – situations which might have appealed particularly to Sarah Pennington.

p. 90. *Mr Garrick*. David Garrick (1717–79): the most famous of eighteenth-century actors. When Pennington wrote, he was manager of the Drury Lane theatre, and at the height of his fame.

p. 116. *Oeconomy*. The term 'economy' shifted during the eighteenth century from a primarily domestic application to its modern specialist definition. The first definition in Samuel Johnson's *Dictionary of the English Language* (1755) is: 'The management of a family; the government of a household.'

p. 134. *entails*. An entail is any settlement which restricts the terms by which an estate can be bequeathed in subsequent generations. A frequent common law arrangement was the entail 'in fee tail male' (the situation of Mr Bennet's estate in Jane Austen's *Pride and Prejudice*), which ensured that only males could inherit.

p. 140. *Agrippina...says Tacitus*. Agrippina: granddaughter of Augustus and wife of the Emperor

Introduction xxxix

Germanicus who died in AD 19. Publius Cornelius Tacitus (c. AD 55–117): historian of the Roman Empire.

p. 140. *nice.* In the now almost obsolete sense of 'particular, precise, strict, careful, in regard to some special thing' (*OED*, definition 7b). It was during the eighteenth century, that 'nice' began to take on its modern usage, loosely referring to something pleasing. In Jane Austen's *Northanger Abbey*, for example, Henry Tilney criticizes Catherine Morland for using 'nice' as an imprecise term of approbation (Chapter 14).

p. 145. *the Graces.* In Greek mythology, minor goddesses, usually three in number, who personify loveliness or grace.

p. 147. *the spleen.* 'Excessive dejection or depression of spirits; gloominess and irritability; moroseness; melancholia' (*OED*, definition 8c). One of Anne Finch, Countess of Winchilsea's, most famous poems was 'The Spleen. A Pindaric Poem' (1701). Cf. also the Cave of Spleen in Canto IV of Pope's *The Rape of the Lock* (1714).

p. 151. *Montagne.* Michel Eyquem de Montaigne (1533–92): French essayist. His *Essays* (1588) are sceptical meditations on a vast range of subjects.

p. 152. *Seneca.* Lucius Annaeus Seneca (c. 4 BC – AD 65): Roman writer and Stoic philosopher, best known for his *Dialogues*, moral treatises and letters, and tragedies. His *Letters to Lucilius* offer guidance in Stoicism.

p. 154. *Curiosity.* De Lambert here challenges the common view, that curiosity was a dangerous tendency in women. Cf. the contemporary French writer on education François de Salignac de la Mothe-Fénélon in his *Treatise on the Education of Daughters* (1687): 'In regard to Girls, some exclaim, "why make them learned? curiosity renders them vain and conceited: it is sufficient if they be one day able to govern their families, and implicitly obey their husbands!"' (1805 translation, in Jones, p. 102).

p. 155. *Cicero, Pliny.* Marcus Tullius Cicero (106–43 BC): Roman orator, statesman and deist philosopher, whose writings were taken as a model of prose style during the Renaissance and the eighteenth century. Pliny 'the Younger' (c. 61–c. 113): Roman writer, best known for his ten books of letters on a wide range of subjects.

p. 156. *Corneille.* Pierre Corneille (1606–84), French poetic dramatist, best known for his tragedies, some of which explore the classic heroic conflict between duty, honour and passion.

p. 159. *Seneca and Epictetus.* Seneca: see above, note to p. 152. Epictetus (c. AD 60–140): Greek Stoic philosopher. The two are linked here as representatives of Stoicism, which stressed detachment from and independence of the material world.

p. 162. *Pliny.* See above, note to p. 155.

p. 164. *Horace.* Quintus Horatius Flaccus (65–8 BC): Roman poet, author of the *Satires* and *Epistles*, who had a pervasive influence on later poets in the classical tradition.

p. 165. *M. de la Rochefoucault.* François, Duc de la Rochefoucauld (1613–80): French moralist, best known for his *Refléxions ou sentences et maximes morales* (1665), an analysis of human motivation.

p. 169. *St. Augustine.* St. Augustine of Hippo (345–430): the reference here is to the *Confessions*, the account of his conversion to Christianity.

p. 178. *Caesar...an example of it.* Gaius Julius Caesar (c. 102–44 BC). This incident, from the Civil War against Pompey in 49 BC, exactly parallels Antony's treatment of Enobarbus in Shakespeare's *Antony and Cleopatra* (Act IV, Scene 5).

p. 202. *Silenus...Plutus.* Figures from Greek mythology. Silenus, a satyr, here represents lust; Plutus was a personification of wealth.

p. 205. *Appollo...Phoebus.* Phoebus Apollo: in Roman mythology, the god of music and prophecy.

p. 215. *Appelles.* Apelles: known as the greatest painter of the ancient world. He worked for Alexander the Great in the fourth century BC.

p. 223. *Romish.* Roman law.

p. 224. *Hardwick.* Philip Yorke, first Earl of Hardwicke (1690–1764): as attorney-general, he prosecuted Curll for libel in 1727 (see next note); he became Lord Chancellor in 1737, and was associated with reform of the legal system.

p. 246. *Blackmore...Curl.* Sir Richard Blackmore (d. 1729): physician to Queen Anne and author of some very long heroic poems. Edmund Curll (1675–1747): bookseller and pamphleteer. Both figures were attacked

by Pope in *The Dunciad* (1728; 1742). (See also next note.)

p. 247. *Cibber...Henley*. Colly Cibber (1671–1757), playwright and hero of the 1742 edition of *The Dunciad*; John Henley (1692–1756), known as 'Orator Henley', also features in the poem.

p. 248. *thy talents scan...meant for man*. Cf. Pope, *An Essay on Man* (1733), ii. 1–2: 'Know then thyself, presume not God to scan/The proper study of mankind is man.'

p. 268. *Sabaea*. Ancient name for the Yemen.

p. 271. *Hesperia*. A (mythical) western land.

p. 281. *Sirens...Ulysses on the main*. In ancient myth, the sirens were female figures who lured sailors to their death on the rocks by their singing. Ulysses, in Homer's *Odyssey*, escaped them by filling his sailors' ears with wax and lashing himself to the ship's mast. Ausonia is a poetic name for Italy.

p. 281. *Hermes*. In Greek mythology, the messenger of the Gods, represented with wings on his sandals.

p. 282. *Medusa*. In Greek mythology, one of the snake-headed gorgons who turned to stone anything that met their gaze. Frequently used as a type of destructive femininity.

p. 283. *Barca*. The desert coast of North Africa.

p. 285. *Midas*. Semi-legendary king who was granted the power to turn all he touched to gold.

p. 285. *Niobe*. In Greek mythology, mother of seven sons and seven daughters who were killed by Apollo and Artemis when she boasted of her childbearing.

Niobe wept for them until she was turned into a column of stone, from which her tears continued to flow.

p. 297. *a new Promethean plan.* In Greek mythology, Prometheus made mankind out of clay.

p. 298. *Ducalion.* Deucalion: in Greek mythology, son of Prometheus. When Zeus destroyed mankind in a flood, Deucalion escaped and created a new race by throwing stones over his shoulder.

p. 301. *curl'd in tresses kiss the gale.* This passage clearly echoes Pope's portrait of Belinda at her dressing-table, attended by her sylphs, in Canto II of *The Rape of the Lock.*

p. 303. *Sampson's pillars.* In the Old Testament of the Bible, Samson, an Israelite hero renowned for his strength, destroyed the Philistines by pulling down the pillars of the palace in which they were feasting. His suicidal triumph represented his recovery from his seduction by Delilah, who cut off his hair, the source of his strength.

p. 307. *Hypsipyle...Catherine.* Heroines and female martyrs. *Hypsipyle*: in Greek mythology, daughter of Thoas, king of Lemnos, who saved her father when the women of the island, from jealousy, decided to kill all the men; *Portia*: wife of Marcus Brutus, one of Julius Caesar's assassins, who wounded herself to prove she was to be trusted with information about the conspiracy; *Penelope*: a type of the faithful woman, the wife of Odysseus (Ulysses) who waited faithfully for twenty years for her husband's return from the Trojan War; *Daphne*: a type of chastity, in Greek mythology she was changed, at her own request, into a laurel tree

when pursued by Apollo; *Laodamia*: in Greek mythology, she committed suicide when her husband Protesilaus was killed in Troy. *Lucretia*: wife of Tarquinius Collatinus, she committed suicide after being raped by Sextus, the son of Tarquin, king of Rome; *Catherine*: St Catherine of Alexandria, Christian martyr, persecuted by the emperor Maxentius, saved by angels from torture and death on the wheel, and finally beheaded.

p. 308. *Cornelia*. A type of the accomplished and dedicated mother, she was the mother of 'the Gracchi', Roman tribunes. Asked to display her jewels, she produced her two sons.

WORKS CONSULTED

WORKS BY AUTHORS OF THE TEXTS
IN *The Parental Monitor*

Gregory, John, *A Father's Legacy to his Daughters*, London and Edinburgh, 1774.

_____, *A Comparative View of the Faculties of Man with those of the Animal World* [1765], 7th edition, London, 1777.

Lambert, Anne-Thérèse, Marchioness de, *Advice of a Mother to her Son and Daughter*, translated by Mr Tho. Carte [1727], 2nd edition, London, 1736.

_____, *New Reflexions on the Fair Sex*. Written originally in French by the celebrated Marchioness de Lambert, translated into English by J. Lockman, London, 1729.

Moore, Edward, *Fables for the Female Sex*, London, 1744.

_____, *The Poetical Works of Edward Moore*, London, 1797.

Pennington, Sarah, *An Unfortunate Mother's Advice to her Absent Daughters*, 1st edition, London, 1761; 4th edition, London, 1767; 5th edition, London, 1770; 6th edition, London, 1773.

_____, *Letters on Different Subjects, in four volumes; Amongst which are interspers'd the*

Adventures of Alphonso, After the Destruction of Lisbon. 2nd edition, London, 1767.

The Young Lady's Pocket Library, or Parental Monitor [1790], 3rd edition, Edinburgh and London, 1808.

OTHER REFERENCES

Allestree, Richard, *The Ladies Calling* [1673], in *The Works of the Learned and Pious Author of the Whole Duty of Man*, Second Part, Oxford and London, 1695.

Armstrong, Nancy, *Desire and Domestic Fiction: A Political History of the Novel*, New York and Oxford: Oxford University Press, 1987.

_____, and Leonard Tennenhouse (editors), *The Ideology of Conduct: Essays in Literature and the History of Sexuality*, New York and London: Methuen, 1987.

Astell, Mary, *A Serious Proposal to the Ladies, For the Advancement of their True and Greatest Interest* [1694], 3rd edition, 1696. Reprinted in *Sources of British Feminism*, Routledge/Thoemmes Press, 1993.

Austen, Jane, *Pride and Prejudice*, London, 1813.

Ballaster, Ros, *Seductive Forms: Women's Amatory Fiction from 1684 to 1740*, Oxford: Clarendon Press, 1992.

Brant, Clare, 'Speaking of Women: Scandal and Law in the Mid-Eighteenth Century', in *Women, Texts and Histories 1575–1760*, edited by Clare Brant and Diane Purkis, London and New York: Routledge, 1992, pp. 242–70.

Flynn, Carol Houlihan, 'Defoe's Idea of Conduct: Ideological fictions and fictional reality', in Armstrong and Tennenhouse, pp. 73–95.

Fordyce, James, *Sermons to Young Women*, 2 volumes, London, 1766.

Foucault, Michel, *The History of Sexuality. Volume I: An Introduction*, translated by Robert Hurley, Harmondsworth: Penguin, 1981.

Gay, John, *Fables* [1727, 1738], edited by Vinton A. Dearing, Los Angeles: Augustan Reprint Society, 1967.

_____, *John Gay: Poetry and Prose*, edited by Vinton A. Dearing, 2 volumes, Oxford: Clarendon Press, 1974.

The Gentleman's Magazine, volume 53, 1783.

Gisborne, Thomas, *An Enquiry into the Duties of the Female Sex* [1797], 6th edition, London, 1805.

Hagstrum, Jean, *Sex and Sensibility: Ideal and Erotic Love from Milton to Mozart*, Chicago and London: University of Chicago Press, 1980.

Halifax, George Savile, Marquis of, *The Lady's New-Year's Gift: or, Advice to a Daughter* [1688], 6th edition, London, 1699.

Jones, Vivien (editor), *Women in the Eighteenth Century: Constructions of Femininity*, London and New York: Routledge, 1990.

Ketcham, Michael G., *Transparent Designs: Reading, Performance and Form in the* Spectator *Papers*, Athens Georgia: University of Georgia Press, 1985.

Mullan, John, *Sentiment and Sociability: The Language of Feeling in the Eighteenth Century*, Oxford: Clarendon Press, 1988.

Nussbaum, Felicity, *The Brink of all We Hate: English Satires on Women 1660–1750*, Lexington: University of Kentucky Press, 1984.

_____, 'Heteroclites: The Gender of Character in the Scandalous Memoirs', in *The New Eighteenth Century: Theory Politics Literature*, edited by Felicity Nussbaum and Laura Brown, New York and London: Methuen, 1987, pp. 144–68.

Perry, Ruth, *Women, Letters and the Novel*, New York: AMS Press, 1980.

_____, *The Celebrated Mary Astell: An Early English Feminist*, Chicago and London: University of Chicago Press, 1986.

Poovey, Mary, *The Proper Lady and the Woman Writer: Ideology as Style in the Works of Mary Wollstonecraft, Mary Shelley, and Jane Austen*, Chicago and London: University of Chicago Press, 1984.

Pope, Alexander, *The Poems of Alexander Pope*, edited by John Butt, London: Methuen, 1963.

Richardson, Samuel, *Letters written to and for Particular Friends, On the Most Important Occasions*, London and Bath, 1741; reprinted as *Familiar Letters on Important Occasions*, edited by Brian W. Downs, London: Routledge, 1928.

Rowe, Elizabeth Singer, *Letters Moral and Entertaining in Prose and Verse* [1728–32], 3 volumes, 3rd edition, London, 1735.

Shevelow, Kathryn, *Women and Print Culture: The Construction of Femininity in the Early Periodical*, London and New York: Routledge, 1989.

Smith, Hilda, *Reason's Disciples: Seventeenth-Century English Feminists*, Urbana, Chicago, London: University of Illinois Press, 1982.

The Spectator, edited by Donald F. Bond, 5 volumes, Oxford: Clarendon Press, 1965.

Stone, Lawrence, *The Family, Sex and Marriage in England 1500–1800*, Harmondsworth: Penguin, 1979.

Todd, Janet, (editor), *A Dictionary of British and American Women Writers 1660–1800*, London: Methuen, 1984.

_____, *Sensibility: An Introduction*, London and New York: Methuen, 1986.

_____, *The Sign of Angellica: Women, Writing and Fiction, 1660–1800*, London, Virago, 1989.

The Whole Duty of a Woman: Or, an infallible Guide to the Fair Sex. Containing, Rules, Directions, and Observations, for their Conduct and Behaviour through all Ages and Circumstances of Life, as Virgins, Wives or Widows, London, 1737.

Wilkes, Rev. Mr Wetenhall, *A Letter of Genteel and Moral Advice to a Young Lady* [1740], 8th edition, London, 1766.

Wollstonecraft, Mary, *A Vindication of the Rights of Woman* [1792], edited by Barbara Taylor, London: Everyman's Library, 1992.

THE

YOUNG LADY'S

POCKET LIBRARY, OR

PARENTAL MONITOR;

CONTAINING,

I.
DR. GREGORY'S,
FATHER'S LEGACY TO HIS DAUGHTERS.

II.
LADY PENNINGTON'S,
UNFORTUNATE MOTHER'S ADVICE TO HER DAUGHTERS.

III.
MARCHIONESS DE LAMBERT'S.
ADVICE OF A MOTHER TO HER DAUGHTER.

IV.
MOORE'S,
FABLES FOR THE FEMALE SEX.

" ———— Every moral charm,
" That leads in sweet captivity the mind
" To virtue."————

THOMSON.

———DUBLIN;———

PRINTED BY GRAISBERRY AND CAMPBELL,
FOR JOHN ARCHER, NO. 80, DAME-STREET.

1790.

A

FATHER'S LEGACY

TO

HIS DAUGHTERS.

BY THE LATE
DR. GREGORY,
OF EDINBURGH.

"—— Be each paffion gratify'd,
"That tends to happinefs or eafe."
<p align="right">CARTWRIGHT.</p>

————DUBLIN;————

PRINTED BY GRAISBERRY AND CAMPBELL,
FOR JOHN ARCHER, NO. 80, DAME-STREET.
1790.

THE CONTENTS.

INTRODUCTION,	PAGE	1
RELIGION,		4
CONDUCT AND BEHAVIOUR,		11
AMUSEMENTS,		19
FRIENDSHIP, LOVE, MARRIAGE,		25

PREFACE.

THAT the subsequent Letters were written by a tender father, in a declining state of health, for the instruction of his daughters, and not intended for the Public, is a circumstance which will recommend them to every one who considers them in the light of admonition and advice. In such domestic intercourse, no sacrifices are made to prejudices, to customs, to fashionable opinions.

PREFACE.

Paternal love, paternal care, speak their genuine sentiments, undisguised and unrestrained. A father's zeal for his daughter's improvement, in whatever can make a woman amiable, with a father's quick apprehension of the dangers that too often arise, even from the attainment of that very point, suggest his admonitions, and render him attentive to a thousand little graces and little decorums, which would escape the nicest moralist who should undertake the subject on uninterested speculation. Every faculty is on the alarm when the objects of such tender affection are concerned.

In the writer of these Letters paternal tenderness and vigilance were doubled, as he was at that time sole parent; death having

before deprived the young ladies of their excellent mother. His own precarious state of health infpired him with the moft tender folicitude for their future welfare; and though he might have concluded, that the impreffions made by his inftructions and uniform example could never be effaced from the memory of his children, yet his anxiety for their orphan condition fuggefted to him this method of continuing to them thofe advantages.

The Editor is encouraged to offer this Treatife to the Public, by the very favourable reception which the reft of his father's works have met with. The Comparative View of the State of Man and other Animals, and the Effay on the Office and Du-

ties of a Phyſician, have been very generally read; and, if he is not deceived by the partiality of his friends, he has reaſon to believe they have met with general approbation.

In ſome of thoſe tracts, the Author's object was to improve the taſte and underſtanding of his reader; in others, to mend his heart; in others, to point out to him the proper uſe of philoſophy, by ſhewing its application to the duties of common life. In all his writings his chief view was the good of his fellow-creatures; and as thoſe among his friends, in whoſe taſte and judgment he moſt confided, think the publication of this ſmall work will contribute to that general deſign, and at the ſame time

do honour to his memory, the Editor can no longer hefitate to comply with their advice in communicating it to the Public.

A

FATHER'S LEGACY

TO

HIS DAUGHTERS.

―――――

MY DEAR GIRLS,

YOU had the misfortune to be deprived of your mother at a time of life when you were infenfible of your lofs, and could receive little benefit either from her inftruction or her example. Before this comes to your hands, you will likewife have loft your father.

I have had many melancholy reflections on the forlorn and helplefs fituation you muft be in, if it fhould pleafe God to remove me from you, before you arrive at that period of life when you will be able to think and act for yourfelves. I know mankind too well; I know their falfehood, their diffipation, their coldnefs to all the duties of friendfhip and humanity.

INTRODUCTION.

I know the little attention paid to helpless infancy. You will meet with few friends disinterested enough to do you good offices, when you are incapable of making them any return, by contributing to their interest or their pleasure, or even to the gratification of their vanity.

I have been supported under the gloom naturally arising from these reflections, by a reliance on the goodness of that Providence which has hitherto preserved you, and given me the most pleasing prospect of the goodness of your dispositions; and by the secret hope that your mother's virtues will entail a blessing on her children.

The anxiety I have for your happiness, has made me resolve to throw together my sentiments relating to your future conduct in life. If I live for some years, you will receive them with much greater advantage, suited to your different geniuses and dispositions. If I die sooner, you must receive them in this very imperfect manner,—the last proof of my affection.

You will all remember your father's fondness, when perhaps every other circumstance relating to him is forgotten. This remembrance, I hope, will induce you to give a serious attention to the advices I am now going to leave with you. I can request this attention with the greater confidence, as my sentiments on the most interesting points that regard life

INTRODUCTION.

and manners, were entirely correspondent to your mother's, whose judgment and taste I trusted much more than my own.

You must expect that the advices which I shall give you will be very imperfect, as there are many nameless delicacies in female manners, of which none but a woman can judge. You will have one advantage by attending to what I am going to leave with you; you will hear, at least for once in your lives, the genuine sentiments of a man who has no interest in flattering or deceiving you. I shall throw my reflections together without any studied order, and shall only, to avoid confusion, range them under a few general heads.

You will see, in a little Treatise of mine just published, in what an honourable point of view I have considered your sex; not as domestic drudges, or the slaves of our pleasures, but as our companions and equals; as designed to soften our hearts and polish our manners; and as Thomson finely says,

> To raise the virtues, animate the bliss,
> And sweeten all the toils of human life.

I shall not repeat what I have there said on this subject, and shall only observe, that from the view I have given of your natural character and place in society, there arises a certain propriety of conduct peculiar to your sex. It is this peculiar propriety of female manners of which I intend to give you my

sentiments, without touching on those general rules of conduct by which men and women are equally bound.

While I explain to you that system of conduct which I think will tend most to your honour and happiness, I shall, at the same time, endeavour to point out those virtues and accomplishments which render you most respectable and most amiable in the eyes of my own sex.

RELIGION.

THOUGH the duties of religion, strictly speaking, are equally binding on both sexes, yet certain differences in their natural character and education, render some vices in your sex particularly odious. The natural hardness of our hearts, and strength of our passions, inflamed by the uncontrouled licence we are too often indulged with in our youth, are apt to render our manners more dissolute, and make us less susceptible of the finer feelings of the heart. Your superior delicacy, your modesty, and the usual severity of your education, preserve you, in a great measure, from any temptation to those vices to which we are most subjected. The natural softness and sensi-

RELIGION. 5

bility of your difpofitions particularly fit you for the practice of thofe duties where the heart is chiefly concerned. And this, along with the natural warmth of your imagination, renders you peculiarly fufceptible of the feelings of devotion.

There are many circumftances in your fituation that peculiarly require the fupports of religion to enable you to act in them with fpirit and propriety. Your whole life is often a life of fuffering. You cannot plunge into bufinefs, or diffipate yourfelves in pleafure and riot, as men too often do, when under the preffure of misfortunes. You muft bear your forrows in filence, unknown and unpitied. You muft often put on a face of ferenity and cheerfulnefs, when your hearts are torn with anguifh, or finking in defpair. Then your only refource is in the confolations of religion. It is chiefly owing to thefe, that you bear domeftic misfortunes better than we do.

But you are fometimes in very different circumftances, that equally require the reftraints of religion. The natural vivacity, and perhaps the natural vanity of your fex, is very apt to lead you into a diffipated ftate of life that deceives you under the appearance of innocent pleafure; but which in reality waftes your fpirits, impairs your health, weakens all the fuperior faculties of your minds, and often fullies your reputations. Religion, by checking this diffipation, and rage for pleafure, enables you to draw

RELIGION.

more happiness, even from those very sources of amusement, which, when too frequently applied to, are often productive of satiety and disgust.

Religion is rather a matter of sentiment than reasoning. The important and interesting articles of faith are sufficiently plain. Fix your attention on these, and do not meddle with controversy. If you get into that, you plunge into a chaos, from which you will never be able to extricate yourselves. It spoils the temper, and, I suspect, has no good effect on the heart.

Avoid all books and all conversations that tend to shake your faith on those great points of religion which should serve to regulate your conduct, and on which your hopes of future and eternal happiness depend.

Never indulge yourselves in ridicule on religious subjects, nor give countenance to it in others by seeming diverted with what they say. This, to people of good-breeding, will be a sufficient check.

I wish to go no further than the Scriptures for your religious opinions. Embrace those you find clearly revealed. Never perplex yourselves about such as you do not understand, but treat them with silent and becoming reverence. I would advise you to read only such religious books as are addressed to the heart, such as inspire pious and devout affections,

RELIGION. 7

such as are proper to direct you in your conduct, and not such as tend to entangle you in the endless maze of opinions and systems.

Be punctual in the stated performance of your private devotions, morning and evening. If you have any sensibility or imagination, this will establish such an intercourse between you and the Supreme Being, as will be of infinite consequence to you in life. It will communicate an habitual cheerfulness to your tempers, give a firmness and steadiness to your virtue, and enable you to go through all the vicissitudes of human life with propriety and dignity.

I wish you to be regular in your attendance on public worship, and in receiving the communion. Allow nothing to interrupt your public or private devotions, except the performance of some active duty in life, to which they should always give place. In your behaviour at public worship observe an exemplary attention and gravity.

That extreme strictness which I recommend to you in these duties, will be considered by many of your acquaintance as a superstitious attachment to forms; but in the advices I give you on this and other subjects, I have an eye to the spirit and manners of the age. There is a levity and dissipation in the present manners, a coldness and listlessness in whatever relates to religion which cannot fail to infect you,

unless you purposely cultivate in your minds a contrary bias, and make the devotional taste habitual.

Avoid all grimace and ostentation in your religious duties. They are the usual cloaks of hypocrisy; at least they shew a weak and vain mind.

Do not make religion a subject of common conversation in mixed companies. When it is introduced, rather seem to decline it. At the same time, never suffer any person to insult you by any foolish ribaldry on your religious opinions, but shew the same resentment you would naturally do on being offered any other personal insult. But the surest way to avoid this, is by a modest reserve on the subject, and by using no freedom with others about their religious sentiments.

Cultivate an enlarged charity for all mankind, however they may differ from you in their religious opinions. That difference may probably arise from causes in which you had no share, and from which you can derive no merit.

Shew your regard to religion by a distinguishing respect to all its ministers, of whatever persuasion, who do not by their lives dishonour their profession; but never allow them the direction of your consciences, lest they taint you with the narrow spirit of their party.

The best effect of your religion will be a diffusive humanity to all in distress. Set apart a certain pro-

portion of your income as sacred to charitable purposes. But in this, as well as in the practice of every other duty, carefully avoid ostentation. Vanity is always defeating her own purposes. Fame is one of the natural rewards of virtue. Do not pursue her, and she will follow you.

Do not confine your charity to giving money. You may have many opportunities of shewing a tender and compassionate spirit where your money is not wanted. There is a false and unnatural refinement in sensibility, which makes some people shun the sight of every object in distress. Never indulge this, especially where your friends or acquaintances are concerned. Let the days of their misfortunes, when the world forgets or avoids them, be the season for you to exercise your humanity and friendship. The sight of human misery softens the heart, and makes it better: it checks the pride of health and prosperity, and the distress it occasions is amply compensated by the consciousness of doing your duty, and by the secret endearment which nature has annexed to all our sympathetic sorrows

Women are greatly deceived, when they think they recommend themselves to our sex by their indifference about religion. Even those men who are themselves unbelievers, dislike infidelity in you. Every man who knows human nature, connects a religious taste in your sex with softness and sensibility

of heart; at leaſt we always confider the want of it as a proof of that hard and maſculine ſpirit, which of all your faults we diſlike the moſt. Beſides, men confider your religion as one of their principal ſecurities for that female virtue in which they are moſt intereſted. If a gentleman pretends an attachment to any of you, and endeavours to ſhake your religious principles, be aſſured he is either a fool, or has deſigns on you which he dares not openly avow.

You will probably wonder at my having educated you in a church different from my own. The reaſon was plainly this: I looked on the differences between our churches to be of no real importance, and that a preference of one to the other was a mere matter of taſte. Your mother was educated in the Church of England, and had an attachment to it, and I had a prejudice in favour of every thing ſhe liked. It never was her deſire that you ſhould be baptiſed by a clergyman of the Church of England, or be educated in that Church. On the contrary, the delicacy of her regard to the ſmalleſt circumſtance that could affect me in the eye of the world, made her anxiouſly inſiſt it might be otherwiſe. But I could not yield to her in that kind of generoſity. When I loſt her, I became ſtill more determined to educate you in that Church, as I feel a ſecret pleaſure in doing every thing that appears to me to expreſs my affection and

veneration for her memory. I draw but a very faint and imperfect picture of what your mother was, while I endeavour to point out what you should be*

CONDUCT AND BEHAVIOUR.

ONE of the chief beauties in a female character, is that modest reserve, that retiring delicacy, which avoids the public eye, and is disconcerted even at the gaze of admiration.—I do not wish you to be insensible to applause; if you were, you must become, if not worse, at least less amiable women: but you may be dazzled by that admiration which yet rejoices your hearts.

When a girl ceases to blush, she has lost the most powerful charm of beauty. That extreme sensibility which it indicates, may be a weakness and incumbrance in our sex, as I have too often felt; but in yours it is peculiarly engaging. Pedants, who think themselves philosophers, ask why a woman should

* The reader will remember, that such observations as respect equally both the sexes, are all along as much as possibly avoided.

blush when she is conscious of no crime? It is a sufficient answer, that Nature has made you to blush when you are guilty of no fault, and has forced us to love you because you do so.—Blushing is so far from being necessarily an attendant on guilt, that it is the usual companion of innocence.

This modesty, which I think so essential in your sex, will naturally dispose you to be rather silent in company, especially in a large one.—People of sense and discernment will never mistake such silence for dullness. One may take a share in conversation without uttering a syllable. The expression in the countenance shews it, and this never escapes an observing eye.

I should be glad that you had an easy dignity in your behaviour at public places, but not that confident ease, that unabashed countenance, which seems to set the company at defiance. If, while a gentleman is speaking to you, one of superior rank addresses you, do not let your eager attention and visible preference betray the flutter of your heart: let your pride on this occasion preserve you from that meanness into which your vanity would sink you. Consider that you expose yourselves to the ridicule of the company, and affront one gentleman only to swell the triumph of another, who perhaps thinks he does you honour in speaking to you.

CONDUCT AND BEHAVIOUR. 13

Converse with men even of the first rank with that dignified modesty which may prevent the approach of the most distant familiarity, and consequently prevent them from feeling themselves your superiors.

Wit is the most dangerous talent you can possess. It must be guarded with great discretion and good nature, otherwise it will create you many enemies. Wit is perfectly consistent with softness and delicacy; yet they are seldom found united. Wit is so flattering to vanity, that they who possess it become intoxicated, and lose all self-command.

Humour is a different quality. It will make your company much solicited; but be cautious how you indulge it. It is often a great enemy to delicacy, and a still greater one to dignity of character. It may sometimes gain you applause, but will never procure you respect.

Be even cautious of displaying your good sense. It will be thought you assume a superiority over the rest of the company. But if you happen to have any learning, keep it a profound secret, especially from the men, who generally look with a jealous and malignant eye on a woman of great parts, and a cultivated understanding.

A man of real genius and candour is far superior to this meanness; but such a one will seldom fall in your way; and if by accident he should, do not be anxious to shew the full extent of your knowlege.

If he has any opportunities of feeing you, he will foon difcover it himfelf; and if you have any advan-vantages of perfon or manner, and keep your own fecret, he will probably give you credit for a great deal more than you poffefs. The great art of pleafing in converfation confifts in making the company pleafed with themfelves. You will more readily hear them talk yourfelves into their good graces.

Beware of detraction, efpecially where your own fex are concerned. You are generally accufed of being particularly addicted to this vice—I think, unjuftly. Men are fully as guilty of it when their interefts interfere. As your interefts more frequently clafh, and as your feelings are quicker than ours, your temptations to it are more frequent: for this reafon be particularly tender of the reputation of your own fex, efpecially when they happen to rival you in our regard. We look on this as the ftrongeft proof of dignity and true greatnefs of mind.

Shew a compaffionate fympathy to unfortunate woman efpecially to thofe who are rendered fo by the villany of men. Indulge a fecret pleafure, I may fay pride, in being the friends and refuge of the unhappy, but without the vanity of fhewing it.

Confider every fpecies of indelicacy in converfation, as fhameful in itfelf, and as highly difgufting to us. All double entendre is of this fort. The diffolutenefs of men's education allows them to be diverted

CONDUCT AND BEHAVIOUR. 15

with a kind of wit, which yet they have delicacy enough to be ſhocked at, when it comes from your mouths, or even when you hear it without pain and contempt.—Virgin purity is of that delicate nature, that it cannot bear certain things without contamination. It is always in your power to avoid theſe. No man but a brute or a fool, will inſult a woman with converſation which he ſees gives her pain; nor will he dare to do it, if ſhe reſent the injury with a becoming ſpirit. There is a dignity in conſcious virtue which is able to awe the moſt ſhameleſs and abandoned of men.

You will be reproached perhaps with prudery. By prudery is uſually meant an affectation of delicacy: Now I do not wiſh you to affect delicacy; I wiſh you to poſſeſs it: at any rate it is better to run the riſk of being thought ridiculous than diſguſting.

The men will complain of your reſerve. They will aſſure you that a franker behaviour would, make you more amiable. But, truſt me, they are not ſincere when they tell you ſo. I acknowledge, that on ſome occaſions it might render you more agreeable as companions, but it would make you leſs amiable as women—an important diſtinction, which many of your ſex are not aware of. After all, I wiſh you to have great eaſe and openneſs in your converſation; I only point out ſome conſiderations which ought to regulate your behaviour in that reſpect.

Have a sacred regard to truth. Lying is a mean and despicable vice. I have known some women of excellent parts, who were so much addicted to it, that they could not be trusted in the relation of any story, especially if it contained any thing of the marvellous, or if they themselves were the heroines of the tale. This weakness did not proceed from a bad heart, but was merely the effect of vanity, or an unbridled imagination. I do not mean to censure that lively embellishment of a humorous story, which is only intended to promote innocent mirth.

There is a certain gentleness of spirit and manners extremely engaging in your sex; not that indiscriminate attention, that unmeaning simper, which smiles on all alike. This arises either from an affectation of softness, or from perfect insipidity.

There is a species of refinement in luxury, just beginning to prevail among the gentlemen of this country, to which our ladies are yet as great strangers as any women upon earth; I hope, for the honour of the sex, they may ever continue so; I mean, the luxury of eating. It is a despicable selfish vice in men, but in your sex it is beyond expression indelicate and disgusting.

Every one who remembers a few years back, is sensible of a very striking change in the attention and respect formerly paid by the gentlemen to the ladies; their drawing-rooms are deserted, and after dinner

CONDUCT AND BEHAVIOUR. 17

and supper the gentlemen are impatient till they retire. How they came to lose this respect, which nature and politeness so well entitle them to, I shall not here particularly inquire. The revolutions of manners in any country depend on causes very various and complicated. I shall only observe, that the behaviour of the ladies in the last age was very reserved and stately. It would now be reckoned ridiculously stiff and formal. Whatever it was, it had certainly the effect of making them more respected.

A fine woman, like other fine things in nature, has her proper point of view, from which she may be seen to most advantage. To fix this point requires great judgment, and an intimate knowledge of the human heart. By the present mode of female manners, the ladies seem to expect that they shall regain their ascendency over us, by the fullest display of their personal charms, by being always in our eye at public places, by conversing with us with the same unreserved freedom as we do with one another; in short, by resembling us as nearly as they possibly can.—But a little time and experience will show the folly of this expectation and conduct.

The power of a fine woman over the hearts of men, of men of the finest parts, is even beyond what she conceives. They are sensible of the pleasing illusion, but they cannot, nor do they wish to dissolve it. But if she is determined to dispel the charm, it certainly

is in her power; she may soon reduce the angel to a very ordinary girl.

There is a native dignity in ingenuous modesty to be expected in your sex, which is your natural protection from the familiarities of the men, and which you should feel previous to the reflection that it is your interest to keep yourselves sacred from all personal freedoms. The many nameless charms and endearments of beauty should be reserved to bless the arms of the happy man to whom you give your heart, but who, if he has the least delicacy, will despise them if he knows that they have been prostituted to fifty men before him. The sentiment, that a woman may allow all innocent freedoms, provided her virtue is secure, is both grossly indelicate and dangerous, and has proved fatal to many of your sex.

Let me now recommend to your attention that elegance, which is not so much a quality itself, as the high polish of every other. It is what diffuses an ineffable grace over every look, every motion, every sentence you utter; it gives that charm to beauty, without which it generally fails to please. It is partly a personal quality, in which respect it is the gift of nature; but I speak of it principally as a quality of the mind. In a word, it is the perfection of taste in life and manners;—every virtue and every excellency in their most graceful and amiable forms.

AMUSEMENTS.

You may perhaps think that I want to throw every ſpark of nature out of your compoſition, and to make you entirely artificial. Far from it. I wiſh you to poſſeſs the moſt perfect ſimplicity of heart and manners. I think you may poſſeſs dignity without pride, affability without meanneſs, and ſimple elegance without affectation. Milton had my idea, when he ſays of Eve,

> Grace was in all her ſteps, Heaven in her eye,
> In every geſture dignity and love.

AMUSEMENTS.

EVERY period of life has amuſements which are natural and proper to it. You may indulge the variety of your taſtes in theſe, while you keep within the bounds of that propriety which is ſuitable to your ſex.

Some amuſements are conducive to health, as various kinds of exerciſe; ſome are connected with qualities really uſeful, as different kinds of women's work, and all the domeſtic concerns of a family; ſome are elegant accompliſhments, as dreſs, dancing,

music, and drawing. Such books as improve your understanding, enlarge your knowledge, and cultivate your taste, may be considered in a higher point of view than mere amusements. There are a variety of others, which are neither useful nor ornamental, such as play of different kinds.

I would particularly recommend to you those exercises that oblige you to be much abroad in the open air, such as walking and riding on horseback. This will give vigour to your constitutions, and a bloom to your complexions. If you accustom yourselves to go abroad always in chairs and carriages, you will soon become so enervated, as to be unable to go out of doors without them. They are like most articles of luxury, useful and agreeable when judiciously used; but when made habitual, they become both insipid and pernicious.

An attention to your health is a duty you owe to yourselves and to your friends. Bad health seldom fails to have an influence on the spirits and temper. The finest geniuses, the most delicate minds, have very frequently a correspondent delicacy of bodily constitution, which they are too apt to neglect. Their luxury lies in reading and late hours, equal enemies to health and beauty.

But though good health be one of the greatest blessings of life, never make a boast of it, but enjoy it in grateful silence. We so naturally associate the

AMUSEMENTS.

idea of female softness and delicacy with a correspondent delicacy of constitution, that when a woman speaks of her great strength, her extraordinary appetite, her ability to bear excessive fatigue, we recoil at a description in a way she is little aware of.

The intention of your being taught needle-work, knitting, and such like, is not on account of the intrinsic value of all you can do with your hands, which is trifling, but to enable you to judge more perfectly of that kind of work, and to direct the execution of it in others. Another principal end is to enable you to fill up, in a tolerably agreeable way, some of the many solitary hours you must necessarily pass at home. It is a great article in the happiness of life, to have your pleasures as independent of others as possible. By continually gadding abroad in search of amusement, you lose the respect of all your acquaintances, whom you oppress with those visits, which, by a more discreet management, might have been courted.

The domestic œconomy of a family is entirely a woman's province, and furnishes a variety of subjects for the exertion both of good sense and good taste. If you ever come to have the charge of a family, it ought to engage much of your time and attention; nor can you be excused from this by any extent of fortune, though with a narrow one the ruin that follows the neglect of it may be more immediate.

AMUSEMENTS.

I am at the greateſt loſs what to adviſe you in regard to books. There is no impropriety in your reading hiſtory, or cultivating any art or ſcience to which genius or accident lead you. The whole volume of Nature lies open to your eye, and furniſhes an infinite variety of entertainment. If I was ſure that Nature had given you ſuch ſtrong principles of taſte and ſentiment as would remain with you, and influence your future conduct, with the utmoſt pleaſure would I endeavour to direct your reading in ſuch a way as might form that taſte to the utmoſt perfection of truth and elegance. "But when I reflect how eaſy it is to warm a girl's imagination, and how difficult deeply and permanently to affect her heart; how readily ſhe enters into every refinement of ſentiment, and how eaſily ſhe can ſacrifice them to vanity or convenience;" I think I may very probably do you an injury by artificially creating a taſte, which, if Nature never gave it you, would only ſerve to embarraſs your future conduct. I do not want to *make* you any thing: I want to know what Nature has made you, and to perfect you on her plan. I do not wiſh you to have ſentiments that might perplex you; I wiſh you to have ſentiments that may uniformly and ſteadily guide you, and ſuch as your hearts ſo thoroughly approve, that you would not forego them for any conſideration this world could offer.

AMUSEMENTS.

Dress is an important article in female life. The love of dress is natural to you, and therefore it is proper and reasonable. Good sense will regulate your expence in it, and good taste will direct you to dress in such a way as to conceal any blemishes, and set off your beauties, if you have any, to the greatest advantage. But much delicacy and judgement are required in the application of this rule. A fine woman shews her charms to most advantage, when she seems most to conceal them. The finest bosom in nature is not so fine as what imagination forms. The most perfect elegance of dress appears always the most easy, and the least studied.

Do not confine your attention to dress to your public appearances. Accustom yourselves to an habitual neatness, so that in the most careless undress, in your most unguarded hours, you may have no reason to be ashamed of your appearance. You will not easily believe how much we consider your dress as expressive of your characters. Vanity, levity, slovenliness, folly, appear through it. An elegant simplicity is an equal proof of taste and delicacy.

In dancing, the principal points you are to attend to are ease and grace. I would have you to dance with spirit; but never allow yourselves to be so far transported with mirth, as to forget the delicacy of your sex. Many a girl dancing in the gaiety and in-

nocence of her heart, is thought to discover a spirit she little dreams of.

I know no entertainment that gives such pleasure to any person of sentiment or humour, as the theatre. But I am sorry to say there are few English comedies a lady can see, without a shock to delicacy. You will not readily suspect the comments gentlemen make on your behaviour on such occasions. Men are often best acquainted with the most worthless of your sex, and from them too readily form their judgement of the rest. A virtuous girl often hears very indelicate things with a countenance no-wise embarrassed, because in truth she does not understand them. Yet this is, most ungenerously, ascribed to that command of features, and that ready presence of mind, which you are thought to possess in a degree far beyond us; or, by still more malignant observers, it is ascribed to hardened effrontery.

Sometimes a girl laughs with all the simplicity of unsuspecting innocence, for no other reason but being infected with other people's laughing: she is then believed to know more than she should do. If she does happen to understand an improper thing, she suffers a very complicated distress, she feels her modesty hurt in the most sensible manner, and at the same time is ashamed of appearing conscious of the injury. The only way to avoid these inconveniencies, is never to go to a play that is particularly offensive to delicacy.

Tragedy subjects you to no such distress.—Its sorrows will soften and ennoble your hearts.

I need say little about gaming, the ladies in this country being as yet almost strangers to it. It is a ruinous and incurable vice; and as it leads to all the selfish and turbulent passions, is peculiarly odious in your sex. I have no objection to your playing a little at any kind of game, as a variety in your amusements, provided that what you can possibly lose is such a trifle as can neither interest you, nor hurt you.

In this, as well as in all important points of conduct, shew a determined resolution and steadiness. This is not in the least inconsistent with that softness and gentleness so amiable in your sex. On the contrary, it gives that spirit to a mild and sweet disposition, without which it is apt to degenerate into insipidity. It makes you respectable in your own eyes, and dignifies you in ours.

FRIENDSHIP, LOVE. MARRIAGE.

THE luxury and dissipation that prevails in genteel life, as it corrupts the heart in many respects, so renders it incapable of warm, sincere, and steady

friendship. A happy choice of friends will be of the utmost consequence to you, as they may assist you by their advice and good offices. But the immediate gratification which friendship affords to a warm, open, and ingenuous heart, is of itself a sufficient motive to court it.

In the choice of your friends, have your principal regard to goodness of heart and fidelity. If they also possess taste and genius, that will still make them more agreeable and useful companions. You have particular reason to place confidence in those who have shewn affection for you in your early days, when you were incapable of making them any return. This is an obligation for which you cannot be too grateful. When you read this, you will naturally think of your mother's friend, to whom you owe so much.

If you have the good fortune to meet with any who deserve the name of friends, unbosom yourself to them with the most unsuspicious confidence. It is one of the world's maxims, never to trust any person with a secret, the discovery of which could give you any pain; but it is the maxim of a little mind and a cold heart, unless where it is the effect of frequent disappointments and bad usage. An open temper, if restrained but by tolerable prudence, will make you, on the whole, much happier than a reserved suspicious one, although you may sometimes

suffer by it. Coldness and distrust are but the too certain consequences of age and experience; but they are unpleasant feelings, and need not be anticipated before their time.

But however open you may be in talking of your affairs, never disclose the secrets of one friend to another. These are secret deposits, which do not belong to you, nor have you any right to make use of them.

There is another case, in which I suspect it is proper to be secret, not so much from motives of prudence, as delicacy; I mean in love matters. Though a woman has no reason to be ashamed of an attachment to a man of merit, yet Nature, whose authority is superior to philosophy, has annexed a sense of shame to it. It is even long before a woman of delicacy dares avow to her own heart that she loves; and when all the subterfuges of ingenuity to conceal it from herself fail, she feels a violence done both to her pride and to her modesty. This, I should imagine, must always be the case where she is not sure of a return to her attachment.

In such a situation, to lay the heart open to any person whatever, does not appear to me consistent with the perfection of female delicacy. But perhaps I am in the wrong. At the same time I must tell you, that, in point of prudence, it concerns you to attend well to the consequences of such a discovery.

These secrets, however important in your own estimation, may appear very trifling to your friend, who possibly will not enter into your feelings, but may rather consider them as a subject of pleasantry. For this reason love secrets are of all others the worst kept. But the consequences to you may be very serious, as no man of spirit and delicacy ever valued a heart much hackneyed in the ways of love.

If, therefore, you must have a friend to pour out your heart to, be sure of her honour and secrecy. Let her not be a married woman, especially if she lives happily with her husband. There are certain unguarded moments, in which such a woman, though the best and worthiest of her sex, may let hints escape, which at other times, or to any other person than her husband, she would be incapable of; nor will a husband in this case feel himself under the same obligation of secrecy and honour, as if you had put your confidence originally in himself, especially on a subject which the world is apt to treat so lightly.

If all other circumstances are equal, there are obvious advantages in your making friends of one another. The ties of blood, and your being so much united in one common interest, form an additional bond of union to your friendship. If your brothers should have the good fortune to have hearts susceptible of friendship, to possess truth, honour, sense, and delicacy of sentiment, they are the fittest and most

unexceptionable confidants. By placing confidence in them, you will receive every advantage which you could hope for from the friendship of men, without any of the inconveniencies that attend such connexions with our sex.

Beware of making confidants of your servants. Dignity not properly understood very readily degenerates into pride, which enters into no friendship, because it cannot bear an equal, and is so fond of flattery as to grasp at it even from servants and dependants. The most intimate confidants, therefore, of proud people, are valets-de-chambre and waiting-women. Shew the utmost humanity to your servants; make their situation as comfortable to them as possible: but if you make them your confidants, you spoil them, and debase yourselves.

Never allow any person, under the pretended sanction of friendship, to be so familiar as to lose a proper respect to you. Never allow them to teaze you on any subject that is disagreeable, or where you have once taken your resolution. Many will tell you, that this reserve is inconsistent with the freedom which friendship allows: but a certain respect is as necessary in friendship as in love. Without it you may be liked as a child, but you will never be beloved as an equal.

The temper and disposition of the heart in your sex make you enter more readily and warmly into

friendships than men. Your natural propensity to it is so strong, that you often run into intimacies which you soon have sufficient cause to repent of; and this makes your friendships so very fluctuating.

Another great obstacle to the sincerity as well as steadiness of your friendships, is the great clashing of your interests in the pursuits of love, ambition, or vanity. For these reasons, it would appear at first view more eligible for you to contract your friendships with the men. Among other obvious advantages of an easy intercourse between the two sexes, it occasions an emulation and exertion in each to excel and be agreeable: hence their respective excellencies are mutually communicated and blended. As their interests in no degree interfere, there can be no foundation for jealousy, or suspicion of rivalship. The friendship of a man for a woman is always blended with tenderness, which he never feels for one of his own sex, even where love is in no degree concerned. Besides, we are conscious of a natural title you have to our protection and good offices, and therefore we feel an additional obligation of honour to serve you, and to observe an inviolable secrecy, whenever you confide in us.

But apply these observations with great caution. Thousands of women of the best hearts and finest parts have been ruined by men who approach them under the specious name of friendship. But supposing

a man to have the moſt undoubted honour, yet his friendſhip to a woman is ſo near a-kin to love, that if ſhe be very agreeable in her perſon, ſhe will probably very ſoon find a lover, where ſhe only wiſhed to meet a friend. Let me here, however, warn you againſt that weakneſs ſo common among vain women, the imagination that every man who takes particular notice of you is a lover. Nothing can expoſe you more to ridicule than the taking up a man on the ſuſpicion of being your lover, who perhaps never once thought of you in that view, and giving yourſelves thoſe airs ſo common among all ſilly women on ſuch occaſions.

There is a kind of unmeaning gallantry much practiſed by ſome men, which, if you have any diſcernment, you will find really very harmleſs. Men of this ſort will attend you to public places, and be uſeful to you by a number of little obſervances, which thoſe of a ſuperior claſs do not ſo well underſtand, or have not leiſure to regard, or perhaps are too proud to ſubmit to. Look on the compliments of ſuch men as words of courſe, which they repeat to every agreeable woman of their acquaintance. There is a familiarity they are apt to aſſume, which a proper dignity in your behaviour will be eaſily able to check.

There is a different ſpecies of men whom you may like as agreeable companions, men of worth, taſte, and genius, whoſe converſation, in ſome reſpects,

may be superior to what you generally meet with among your own sex. It will be foolish in you to deprive yourselves of an useful and agreeable acquaintance, merely because idle people say he is your lover. Such a man may like your company, without having any design on your person.

People whose sentiments, and particularly whose tastes correspond, naturally like to associate together, although neither of them have the most distant view of any further connection. But as this similarity of minds often gives rise to a more tender attachment than friendship, it will be prudent to keep a watchful eye over yourselves, lest your hearts become too far engaged before you are aware of it. At the same time, I do not think that your sex, at least in this part of the world, have much of that sensibility which disposes to such attachments. What is commonly called love among you is rather gratitude, and a partiality to the man who prefers you to the rest of your sex; and such a man you often marry, with little of either personal esteem or affection. Indeed, without an unusual share of natural sensibility, and very peculiar good fortune, a woman in this country has very little probability of marrying for love.

It is a maxim laid down among you, and a very prudent one it is. That love is not to begin on your part, but is entirely to be the consequence of our attachment to you. Now, supposing a woman to have

sense and taste, she will not find many men to whom she can possibly be supposed to bear any considerable share of esteem. Among these few it is very great chance if any of them distinguishes her particularly. Love, at least with us, is exceedingly capricious, and will not always fix where reason says it should. But supposing one of them should become particularly attached to her, it is still extremely improbable that he should be the man in the world her heart most approved of.

As, therefore, Nature has not given you that unlimited range in your choice which we enjoy, she has wisely and benevolently assigned to you a greater flexibility of taste on this subject. Some agreeable qualities recommend a gentleman to your common good liking and friendship. In the course of his acquaintance, he contracts an attachment to you. When you perceive it, it excites your gratitude: this gratitude rises into a preference, and this preference perhaps at last advances to some degree of attachment, especially if it meets with crosses and difficulties; for these, and a state of suspence, are very great incitements to attachment, and are the food of love in both sexes. If attachment was not excited in your sex in this manner, there is not one of a million of you that could ever marry with any degree of love.

A man of taste and delicacy marries a woman because he loves her more than any other. A woman

of equal taste and delicacy marries him because she esteems him, and because he gives her that preference. But if a man unfortunately becomes attached to a woman whose heart is secretly pre-engaged, his attachment, instead of obtaining a suitable return, is particularly offensive; and if he persists to teaze her, he makes himself equally the object of her scorn and aversion.

The effects of love among men are diversified by their different tempers. An artful man may counterfeit every one of them so easily as to impose on a young girl of an open, generous, and feeling heart, if she is not extremely on her guard. The finest parts in such a girl may not always prove sufficient for her security. The dark and crooked paths of cunning are unsearchable and inconceivable to an honourable and elevated mind.

The following, I apprehend, are the most genuine effects of an honourable passion among the men, and the most difficult to counterfeit. A man of delicacy often betrays his passion by his too great anxiety to conceal it, especially if he has little hopes of success. True love, in all its stages, seeks concealment, and never expects success. It renders a man not only respectful, but timid to the highest degree in his behaviour to the woman he loves. To conceal the awe he stands in of her, he may sometimes affect pleasantry, but it sits aukwardly on him, and he quickly

relapses into seriousness, if not into dullness. He magnifies all her real perfections in his imagination, and is either blind to her failings, or converts them into beauties. Like a person conscious of guilt, he is jealous that every eye observes his; and to avoid this, he shuns all the little observances of common gallantry.

His heart and his character will be improved in every respect by his attachment. His manners will become more gentle, and his conversation more agreeable; but diffidence and embarrassment will always make him appear to disadvantage in the company of his mistress. If the fascination continue long, it will totally depress his spirit, and extinguish every active, vigorous, and manly principle of his mind. You will find this subject beautifully and pathetically painted in Thomson's Spring.

When you observe in a gentleman's behaviour these marks which I have described above, reflect seriously what you are to do. If his attachment is agreeable to you, I leave you to do as nature, good sense, and delicacy shall direct you. If you love him, let me advise you never to discover to him the full extent of your love, no, not although you marry him. That sufficiently shews your preference, which is all he is intitled to know. If he has delicacy, he will ask for no stronger proof of affection for your sake; if he has sense, he will not ask it for his own. This

is an unpleafant truth, but it is my duty to let you know it. Violent love cannot fubfift, at leaft cannot be expreffed, for any time together on both fides; otherwife the certain confequence, however concealed, is fatiety and difguft. Nature in this cafe has laid the referve on you.

If you fee evident proofs of a gentleman's attachment, and are determined to fhut your heart againft him, as yon ever hope to be ufed with generofity by the perfon who fhall engage your own heart, treat him honourably and humanely. Do not let him linger in a miferable fufpenfe, but be anxious to let him know your fentiments with regard to him.

However people's hearts may deceive them, there is fcarcely a perfon that can love for any time without at leaft fome diftant hope of fuccefs. If you really wifh to undeceive a lover, you may do it in a variety of ways. There is a certain fpecies of eafy familiarity in your behaviour which may fatisfy him, if he has any difcernment left, that he has nothing to hope for. But perhaps your particular temper may not admit of this: you may eafily fhew that you want to avoid his company; but if he is a man whofe friendfhip you wifh to preferve, you may not chufe this method, becaufe then you lofe him in every capacity. You may get a common friend to explain matters to him, or fall on many other devices, if you are ferioufly anxious to put him out of fufpenfe.

But if you are resolved against every such method, at least do not shun opportunities of letting him explain himself. If you do this, you act barbarously and unjustly. If he brings you to an explanation, give him a polite, but resolute and decisive answer. In whatever way you convey your sentiments to him, if he is a man of spirit and delicacy, he will give you no further trouble, nor apply to your friends for their intercession. This last is a method of courtship which every man of spirit will disdain. He will never whine nor sue for your pity: That would mortify him almost as much as your scorn. In short, you may possibly break such a heart, but you can never bend it. Great pride always accompanies delicacy, however concealed under the appearance of the utmost gentleness and modesty, and is the passion of all others the most difficult to conquer.

There is a case where a woman may coquette justifiably to the utmost verge which her conscience will allow. It is where a gentleman purposely declines to make his addresses, till such time as he thinks himself perfectly sure of her consent. This at bottom is intended to force a woman to give up the undoubted privilege of her sex, the privilege of refusing; it is intended to force her to explain herself, in effect, before the gentleman deigns to do it, and by this means to oblige her to violate the modesty and delicacy of her sex, and to invert the clearest order

of nature. All this facrifice is propofed to be made merely to gratify a moft defpicable vanity in a man who would degrade the very woman whom he wifhes to make his wife.

It is of great importance to diftinguifh whether a gentleman, who has the appearance of being your lover, delays to fpeak explicitly, from the motive I have mentioned, or from a diffidence infeparable from true attachment. In the one cafe, you can fcarcely ufe him too ill; in the other, you ought to ufe him with great kindnefs: and the greateft kindnefs you can fhew him, if you are determined not to liften to his addreffes, is to let him know it as foon as poffible.

I know the many excufes with which women endeavour to juftify themfelves to the world, and to their own confciences, when they act otherwife. Sometimes they plead ignorance, or at leaft uncertainty, of the gentleman's real fentiments. That may fometimes be the cafe. Sometimes they plead the decorum of their fex, which enjoins an equal behaviour to all men, and forbids them to confider any man as a lover till he has directly told them fo. Perhaps few women carry their ideas of female delicacy and decorum fo far as I do. But I muft fay, you are not intitled to plead the obligation of thefe virtues, in oppofition to the fuperior ones of gratitude, juftice and humanity. The man is intitled to all

these, who prefers you to the rest of your sex, and perhaps whose greatest weakness is this very preference. The truth of the matter is, vanity, and the love of admiration, is so prevailing a passion among you, that you may be considered to make a very great sacrifice whenever you give up a lover, till every art of coquetry fails to keep him, or till he forces you to an explanation. You can be fond of the love, when you are indifferent to, or even when you despise the lover.

But the deepest and most artful coquetry is employed by women of superior taste and sense, to engage and fix the heart of a man whom the world and whom they themselves esteem, although they are firmly determined never to marry him. But his conversation amuses them, and his attachment is the highest gratification to their vanity: nay, they can sometimes be gratified with the utter ruin of his fortune, fame and happiness. God forbid I should ever think so of all your sex! I know many of them have principles, have generosity and dignity of soul that elevate them above the worthless vanity I have been speaking of.

Such a woman, I am persuaded, may always convert a lover, if she cannot give him her affections, into a warm and steady friend, provided he is a man of sense, resolution and candour. If she explains herself with a generous openness and freedom, he

must feel the stroke as a man; but he will likewise bear it as a man: what he suffers, he will suffer in silence. Every sentiment of esteem will remain; but love, though it requires very little food, and is easily surfeited with too much, yet it requires some. He will view her in the light of a married woman; and though paffion subsides, yet a man' of a candid and generous heart always retains a tendernefs for a woman he has once loved, and who has used him well, beyond what he feels for any other of her sex.

If he has not confided his own secret to any body, he has an undoubted title to ask you not to divulge it. If a woman chufes to truft any of her companions with her own unfortunate attachments, she may, as it is her own affair alone; but if she has any generofity or gratitude, she will not betray a secret which does not belong to her.

Male coquetry is much more inexcufable than female, as well as more pernicious; but it is rare in this country. Very few men will give themselves the trouble to gain or retain any woman's affections, unless they have views on them either of an honourable or dishonourable kind. Men employed in the pursuits of businefs, ambition or pleafure, will not give themfelves the trouble to engage a woman's affections, merely from the vanity of conqueft, and of triumphing over the heart of an innocent and defencelefs girl. Befides, people never value much what is

entirely in their power. A man of parts, sentiment and address, if he lays aside all regard to truth and humanity, may engage the hearts of fifty women at the same time, and may likewise conduct his coquetry with so much art, as to put it out of the power of any of them to specify a single expression that could be said to be directly expressive of love.

This ambiguity of behaviour, this art of keeping one in suspense, is the great secret of coquetry in both sexes. It is the more cruel in us, because we can carry it to what length we please, and continue it as long as we please, without your being so much as at liberty to complain or expostulate; whereas we can break our chain, and force you to explain, whenever we become impatient of our situation.

I have insisted the more particularly on this subject of courtship, because it may most readily happen to you at that early period of life when you can have little experience or knowledge of the world; when your passions are warm, and your judgments not arrived at such full maturity as to be able to correct them. I wish you to possess such high principles of honour and generosity as will render you incapable of deceiving, and at the same time to possess that acute discernment which may secure you against being deceived.

A woman, in this country, may easily prevent the first impressions of love; and every motive of prudence

and delicacy should make her guard her heart against them, till such time as she has received the most convincing proofs of the attachment of a man of such merit, as will justify a reciprocal regard. Your hearts indeed may be shut inflexibly and permanently against all the merit a man can possess. That may be your misfortune, but cannot be your fault. In such a situation, you would be equally unjust to yourself and your lover, if you gave him your hand when your heart revolted against him. But miserable will be your fate, if you allow an attachment to steal on you before you are sure of a return; or, what is infinitely worse, where there are wanting those qualities which alone can ensure happiness in a married state.

I know nothing that renders a woman more despicable, than her thinking it essential to happiness to be married. Besides the gross indelicacy of the sentiment, it is a false one, as thousands of women have experienced. But if it was true, the belief that it is so, and the consequent impatience to be married, is the most effectual way to prevent it.

You must not think from this that I do not wish you to marry; on the contrary, I am of opinion, that you may attain a superior degree of happiness in a married state, to what you can possibly find in any other. I know the forlorn and unprotected situation of an old maid, the chagrin and peevishness which are apt to infect their tempers, and the great difficulty

of making a tranfition, with dignity and cheerfulnefs, from the period of youth, beauty, admiration and refpect, into the calm, filent, unnoticed retreat of declining years.

I fee fome unmarried women, of active, vigorous minds, and great vivacity of fpirits, degrading themfelves; fometimes by entering into a diffipated courfe of life, unfuitable to their years, and expofing themfelves to the ridicule of girls, who might have been their grand-children; fometimes by oppreffing their acquaintances by impertinent intrufions into their private affairs; and fometimes by being the propagators of fcandal and defamation. All this is owing to an exuberant activity of fpirit, which, if it had found employment at home, would have rendered them refpectable and ufeful members of fociety.

I fee other women, in the fame fituation, gentle, modeft, bleffed with fenfe, tafte, delicacy, and every milder feminine virtue of the heart, but of weak fpirits, bafhful, and timid: I fee fuch women finking into obfcurity and infignificance, and gradually lofing every elegant accomplifhment; for this evident reafon, that they are not united to a partner who has fenfe, and worth, and tafte, to know their value; one who is able to draw forth their concealed qualities, and fhew them to advantage; who can give that fupport to their feeble fpirits which they ftand fo much in need of; and who, by his affection and ten-

derneſs, might make ſuch a woman happy in exerting every talent, and accompliſhing herſelf in every elegant art that could contribute to his amuſement.

In ſhort, I am of opinion, that a married ſtate, if entered into from proper motives of eſteem and affection, will be the happieſt for yourſelves, make you moſt reſpectable in the eyes of the world, and the moſt uſeful members of ſociety: but I confeſs I am not enough of a Patriot to wiſh you to marry for the good of the public;—I wiſh you to marry for no other reaſon but to make yourſelves happier. When I am ſo particular in my advices about your conduct, I own my heart beats with the fond hope of making you worthy the attachment of men who will deſerve you, and be ſenſible of your merit. But Heaven forbid you ſhould ever relinquiſh the eaſe and independence of a ſingle life, to become the ſlaves of a fool or a tyrant's caprice.

As theſe have always been my ſentiments, I ſhall do you but juſtice, when I leave you in ſuch independent circumſtances as may lay you under no temptation to do from neceſſity what you would never do from choice. This will likewiſe ſave you from that cruel mortification to a woman of ſpirit, the ſuſpicion that a gentleman thinks he does you an honour or a favour when he aſks you for his wife.

If I live till you arrive at that age when you ſhall be capable to judge for yourſelves, and do not ſtrange-

ly alter my sentiments, I shall act towards you in a very different manner from what most parents do. My opinion has always been, that when that period arrives, the parental authority ceases.

I hope I shall always treat you with that affection and easy confidence which may dispose you to look on me as your friend; in that capacity alone I shall think myself intitled to give you my opinion; in the doing of which, I should think myself highly criminal, if I did not to the utmost of my power endeavour to divest myself of all personal vanity, and all prejudices in favour of my particular taste. If you did not chuse to follow my advice, I should not on that account cease to love you as my children: though my right to your obedience was expired, yet I should think nothing could release me from the ties of nature and humanity.

You may perhaps imagine, that the reserved behaviour which I recommend to you, and your appearing seldom at public places, must cut off all opportunities of your being acquainted with gentlemen; I am very far from intending this. I advise you to no reserve, but what will render you more respected and beloved by our sex. I do not think public places suited to make people acquainted together: they can only be distinguished there by their looks and external behaviour; but it is in private companies alone where you can expect easy and agreeable conversation,

which I should never wish you to decline. If you do not allow gentlemen to become acquainted with you, you can never expect to marry with attachment on either side—Love is very seldom produced at first sight, at least it must have, in that case, a very unjustifiable foundation. True love is founded on esteem, in a correspondence of tastes and sentiments, and steals on the heart imperceptibly.

There is one advice I shall leave you, to which I beg your particular attention:—Before your affections come to be in the least engaged to any man, examine your tempers, your tastes, and your hearts, very severely, and settle in your own minds, what are the requisites to your happiness in a married state; and, as it is almost impossible that you should get every thing you wish, come to a steady determination what you are to consider as essential, and what may be sacrificed.

If you have hearts disposed by nature for love and friendship, and possess those feelings which enable you to enter into all the refinements and delicacies of these attachments, consider well, for Heaven's sake, and as you value your future happiness, before you give them any indulgence. If you have the misfortune (for a very great misfortune it commonly is to your sex) to have such a temper and such sentiments deeply rooted in you, if you have spirit and resolution to resist the solicitations of vanity, the persecution of

friends (for you will have loft the only friend that would never perfecute you), and can fupport the profpect of the many inconveniences attending the ftate of an old maid, which I formerly pointed out, then you may indulge yourfelves in that kind of fentimental reading and converfation which is moft correfpondent to your feelings.

But if you find on a ftrict felf-examination that marriage is abfolutely effential to your happinefs, keep the fecret inviolable in your own bofoms, for the reafons I formerly mentioned: but fhun as you would do the moft fatal poifon, all that fpecies of reading and converfation which warms the imagination, which engages and foftens the heart, and raifes the tafte above the level of common life; if you do otherwife, confider the terrible conflict of paffions this may afterwards raife in your breafts.

If this refinement once takes deep root in your minds, and you do not obey its dictates, but marry from vulgar and mercenary views, you may never be able to eradicate it entirely, and then it will embitter all your married days. Inftead of meeting with fenfe, delicacy, tendernefs, a lover, a friend, an equal companion, in a hufband, you may be tired with infipidity and dulnefs; fhocked with indelicacy, or mortified by indifference. You will find none to compaffionate, or even underftand your fufferings; for your hufbands may not ufe you cruelly, and may give you

as much money for your clothes, perfonal expence, and domeftic neceffaries, as is fuitable to their fortunes. The world would therefore look on you as unreafonable women, and that did not deferve to be happy, if you were not fo. To avoid thefe complicated evils, if you are determined at all events to marry, I would advife you to make all your reading and amufements of fuch a kind, as do not affect the heart nor the imagination, except in the way of wit or humour.

I have no view by thefe advices to lead your taftes; I only want to perfuade you of the neceffity of knowing your own minds, which, though feemingly very eafy, is what your fex feldom attain on many important occafions in life, but particularly on this of which I am fpeaking. There is not a quality I more anxioufly wifh you to poffefs, than that collective decifive fpirit, which refts on itfelf, which enables you to fee where your true happinefs lies, and to purfue it with the moft determined refolution. In matters of bufinefs, follow the advice of thofe who know them better than yourfelves, and in whofe integrity you can confide; but in matters of tafte that depend on your own feelings, confult no one friend whatever, but confult your own hearts.

If a gentleman makes his addreffes to you, or gives you reafon to believe he will do fo, before you allow your affections to be engaged, endeavour, in the moft

prudent and secret manner, to procure from your friends every necessary piece of information concerning him; such as his character for sense, his morals, his temper, fortune, and family; whether it is distinguished for parts and worth, or for folly, knavery, and loathsome hereditary diseases. When your friends inform you of these, they have fulfilled their duty. If they go farther, they have not that deference for you which a becoming dignity on your part would effectually command.

Whatever your views are in marrying, take every possible precaution to prevent their being disappointed. If fortune, and the pleasures it brings, are your aim, it is not sufficient that the settlements of a jointure and children's provisions be ample, and properly secured; it is necessary that you should enjoy the fortune during your own life. The principal security you can have for this will depend on your marrying a good-natured, generous man, who despises money, and who will let you live where you can best enjoy that pleasure, that pomp and parade of life, for which you married him.

From what I have said, you will easily see that I could never pretend to advise whom you should marry; but I can with great confidence advise whom you should not marry.

Avoid a companion that may entail any hereditary disease on your posterity, particularly (that most

dreadful of all human calamities) madnefs. It is the height of imprudence to run into fuch a danger, and, in my opinion, highly criminal.

Do not marry a fool; he is the moft intractable of all animals; he is led by his paffions and caprices, and is incapable of hearing the voice of reafon. It may probably too, hurt your vanity to have hufbands for whom you have reafon to blufh and tremble every time they open their lips in company. But the worft circumftance that attends a fool, is his conftant jealoufly of his wife being thought to govern him. This renders it impoffible to lead him, and he is continually doing abfurd and difagreeable things, for no other reafon but to fhew he dares do them.

A rake is always a fufpicious hufband, becaufe he has only known the moft worthlefs of your fex. He likewife entails the worft difeafes on his wife and children, if he has the misfortune to have any.

If you have a fenfe of religion yourfelves, do not think of hufbands who have none. If they have tolerable underftandings, they will be glad that you have religion, for their own fakes, and for the fake of their families; but it will fink you in their efteem. If they are weak men, they will be continually teazing and fhocking you about your principles.—If you have children, you will fuffer the moft bitter diftrefs, in feeing all your endeavours to form their minds to virtue and piety, all your endeavours to fecure their

present and eternal happiness, frustrated and turned into ridicule.

As I look on your choice of a husband to be of the greatest consequence to your happiness, I hope you will make it with the utmost circumspection. Do not give way to a sudden sally of passion. and dignify it with the name of love.—Genuine love is not founded in caprice; it is founded in nature, on honourable views, on virtue, on similarity of tastes and sympathy of souls.

If you have these sentiments, you will never marry any one, when you are not in that situation, in point of fortune, which is necessary to the happiness of either of you. What that competency may be, can only be determined by your own tastes. It would be ungenerous in you to take advantage of a lover's attachment, to plunge him into distress; and if he has any honour, no personal gratification will ever tempt him to enter into any connection which will render you unhappy. If you have as much between you as to satisfy all your demands, it is sufficient.

I shall conclude with endeavouring to remove a difficulty which must naturally occur to any woman of reflection on the subject of marriage. What is to become of all those refinements of delicacy, that dignity of manners, which checked all familiarities, and suspended desire in respectful and awful admiration? In answer to this, I shall only observe, that if

motives of intereſt or vanity have had any ſhare in your reſolutions to marry, none of theſe chimerical notions will give you any pain; nay, they will very quickly appear as ridiculous in your own eyes, as they probably always did in the eyes of your huſbands. They have been ſentiments which have floated in your imaginations, but have never reached your hearts. But if theſe ſentiments have been truly genuine, and if you have had the ſingular happy fate to attach thoſe who underſtand them, you have no reaſon to be afraid.

Marriage, indeed, will at once diſpel the enchantment raiſed by external beauty; but the virtues and graces that firſt warmed the heart, that reſerve and delicacy which always left the lover ſomething further to wiſh, and often made him doubtful of your ſenſibility or attachment, may and ought ever to remain. The tumult of paſſion will neceſſarily ſubſide; but it will be ſucceeded by an endearment, that effects the heart in a more equal, more ſenſible, and tender manner. But I muſt check myſelf, and not indulge in deſcriptions that may miſlead you, and that too ſenſibly awake the remembrance of my happier days, which, perhaps, it were better for me to forget for ever.

I have thus given you my opinion on ſome of the moſt important articles of your future life, chiefly calculated for that period when you are juſt entering

the world. I have endeavoured to avoid some peculiarities of opinion, which, from their contradiction to the general practice of the world, I might reasonably have suspected were not so well founded. But, in writing to you, I am afraid my heart has been too full, and too warmly interested, to allow me to keep this resolution. This may have produced some embarrassments and some seeming contradictions. What I have written has been the amusement of some solitary hours, and has served to divert some melancholy reflections.—I am conscious I undertook a task to which I was very unequal; but I have discharged a part of my duty.—You will at least be pleased with it, as the last mark of your father's love and attention.

AN

UNFORTUNATE MOTHER'S

ADVICE

TO HER

ABSENT DAUGHTERS,

IN A

LETTER

TO

MISS PENNINGTON.

BY THE LATE
LADY PENNINGTON.

————DUBLIN:————

PRINTED BY GRAISBERRY AND CAMPBELL,
FOR JOHN ARCHER, NO. 80, DAME-STREET.

1790.

AN

UNFORTUNATE MOTHER'S

A D V I C E

TO HER

ABSENT DAUGHTERS.

MY DEAR JENNY,

WAS there any probability that a letter from me would be permitted to reach *your hand alone*, I should not have chosen this least eligible method of writing to you. The public is no way concerned in family affairs, and ought not to be made a party in them; but my circumstances are such as lay me under the necessity of either communicating my sentiments to the world, or of concealing them *from you:* the latter would, I think, be the breach of an indispensable duty, which obliges me to waive the impropriety of the former.

A long train of events, of a moſt extraordinary nature, conſpired to remove you very early from the tender care of an affectionate mother. You were too young to be able to form any right judgment of her conduct; and ſince that time it is very probable that it has been repreſented to you in a moſt unfavourable light. The general prejudice againſt me I never gave myſelf the uſeleſs trouble of any endeavour to remove. I do not mean to infer from hence that the opinion of others is of no material conſequence; on the contrary, I would adviſe you always to remember, that, next to the conſciouſneſs of acting right, the public voice ſhould be regarded; and to endeavour by a prudent behaviour, even in the moſt trifling inſtances, to ſecure it in your favour. The being educated in a different opinion, was a misfortune to *me*. I was indeed early and wiſely taught, that virtue was the one thing neceſſary, and that without it no happineſs could be expected either in this, or in any future ſtate of exiſtence; but, with this good principle, a miſtaken one was at the ſame time inculcated, namely, That the ſelf-approbation ariſing from conſcious virtue was alone ſufficient; and, That the cenſures of an ill-natured world, ever ready to calumniate, when not founded on truth, were beneath the concern of a perſon whoſe actions were guided by the ſuperior motive of obedience to the will of Heaven.

ADVICE TO HER DAUGHTERS. 59

This notion, strongly imbibed before reason had gained sufficient strength to discover its fallacy, was the cause of an inconsiderate conduct in my subsequent life, which marked my character with a disadvantageous impression. To you I shall speak with the most unreserved sincerity, not concealing a fault which you may profit by the knowledge of; and therefore I freely own, that in my younger years, satisfied with keeping strictly within the bounds of virtue, I took a foolish pleasure in exceeding those of prudence, and was ridiculously vain of indulging a latitude of behaviour; into which others of my age were afraid of launching: but then, in justice to myself, I must at the same time declare, that this freedom was only taken in public company; and so extremely cautious was I of doing any thing which appeared to me a just ground for censure, that I call Heaven to witness, your father was the first man whom I ever made any private assignation with, or even met in a room alone; nor did I take that liberty with him till the most solemn mutual engagement, the matrimonial ceremony, had bound us to each other. My behaviour then, he has frequently since acknowledged, fully convinced him I was not only innocent of any criminal act, but of every vicious thought; and that the outward freedom of my deportment proceeded merely from a great gaiety of temper, and from a very high flow of spirits, never broke (if

the expreſſion may be allowed) into the formal rules of decorum. To ſum up the whole in a few words, my private conduct was what the ſevereſt prude could not condemn; my public, ſuch as the moſt finiſhed coquet alone would have ventured upon: the latter only could be known to the world, and conſequently, from thence muſt their opinion be taken. You will therefore eaſily be ſenſible, that it would not be favourable to me; on the contrary it gave a general prejudice againſt me: and this has been ſince made uſe of as an argument to gain credit to the malicious falſhoods laid to my charge. For this reaſon, convinced by long experience that the greater part of mankind are ſo apt to receive, and ſo willing to retain a bad impreſſion of others, that, when it is once eſtabliſhed, there is hardly a poſſibility of removing it through life; I have, for ſome years paſt, ſilently acquieſced in the diſpenſations of Providence, without attempting any juſtification of myſelf; and, being conſcious that the infamous aſperſions caſt on my character were not founded on truth, I have ſat down content with the certainty of an open and perfect acquittal of all vicious diſpoſitions, or criminal conduct, at that great day, when all things ſhall appear as they really are, and when both our actions, and the moſt ſecret motives for them, will be made manifeſt to men and angels.

Had your father been amongst the number of those who were deceived by appearances, I should have thought it my duty to leave no method unessay'd to clear myself in his opinion; but that was not the case. He knows that many of those appearances which have been urged against me, I was forced to submit to, not only from his direction, but by his absolute command; which, contrary to reason and to my own interest, I was, for more than twelve years, weak enough implicitly to obey; and that others, even since our separation, were occasioned by some particular instances of his behaviour, which rendered it impossible for me to act with safety in any other manner. To *him* I appeal for the truth of this assertion, who is conscious of the meaning that may hereafter be explained to you. Perfectly acquainted with my principles and with my natural disposition, his heart, I am convinced, never here condemned me. Being greatly incensed that my father's will gave to me an independent fortune; which will he imagined I was accessary to, or at least that I could have prevented; he was thereby laid open to the arts of designing men, who, having their own interest solely in view, worked him up into a desire of revenge, and from thence, upon probable circumstances, into a public accusation; though that public accusation was supported only by the single testimony of a person, whose known falsehood had made him a thousand times declare that he

would not credit her oath in the moſt trifling incident: yet, when he was diſappointed of the additional evidence he might have been flattered with the hope of obtaining, it was too late to recede. This I ſincerely believe to be the truth of the caſe, though I too well know his *tenacious* temper to expect a preſent juſtification; but, whenever he ſhall arrive on the verge of eternity, if Reaſon holds her place at that awful moment, and if Religion has then any power on his heart, I make no doubt, he will at that time acquit me to his children; and with truth he muſt then confeſs, that no part of my behaviour to him ever deſerved the treatment I have met with.

Sorry am I to be under the neceſſity of pointing out faults in the conduct of another, which are, perhaps, long ſince repented of, and ought in that caſe to be as much forgotten as they are moſt truly forgiven. Heaven knows, that, ſo far from retaining any degree of reſentment in my heart, the perſon breathes not whom I wiſh to hurt, or to whom I would not this moment render every ſervice in my power. The injuries which I have ſuſtained, had I no children, ſhould contentedly be buried in ſilence till the great day of retribution; but, in juſtice to you, to them, and to myſelf, it is incumbent on me, as far as poſſible, to efface the falſe impreſſions, which, by ſuch ſilence, might be fixed on your mind, and on thoſe of your brothers and ſiſters, whom I include

with you. To this end, it will be neceffary to enter into a circumftantial hiftory of near fifteen years, full of incidents of a nature fo uncommon as to be fcarcely credible. This, I am convinced, will effectually clear me, in your opinions, of the imputations I now lie under, and it will prove, almoft to a demonftration, the true caufe of thofe proceedings againft me that were couched under pretended motives, as injurious to my reputation as they were falfe in themfelves.

But this muft be deferred fome time longer. You are all yet too young to enter into things of this kind, or to judge properly of them. When a few years fhall, by ripening your underftandings, remove this objection, you fhall be informed of the whole truth, moft impartially and without difguife. 'Till then fufpend your belief of all that may have reached your ears with regard to me, and wait the knowledge of thofe facts, which my future letters will reveal for your information.

Thus much I thought it neceffary to premife concerning myfelf, tho' foreign to the defign of *this epiftle*, which is only to remind you that you have ftill an affectionate mother, who is anxious for your welfare, and defirous of giving you fome advice with regard to your conduct in life. I would lay down a few precepts for you, which, if attended to, will fupply, as far as it is in my power to fupply, the de-

F

privation of a constant and tender maternal care. The address is *to you* in particular, your sisters being yet too young to receive it, but my intention is for the equal service of you all.

You are just entering, my dear girl, into a world full of deceit and falshood, where few persons or things appear in their true character. Vice hides her deformity with the borrowed garb of virtue; and, though discernible to an intelligent and careful observer, by the unbecoming awkwardness of her deportment under it, she passes on thousands undetected. Every present pleasure usurps the name of happiness, and as such deceives the unwary pursuer. Thus one general mask disguises the whole face of things, and it requires a long experience, and a penetrating judgment, to discover the truth. Thrice happy they, whose docile tempers improve from the instructions of maturer age, and who thereby attain some degree of this necessary knowledge, while it may be useful in directing their conduct!

The turn which your mind may now take, will fix the happiness or misery of your future life; and I am too nearly concerned for your welfare, not to be most solicitously anxious that you may be early led into so just a way of thinking as will be productive to you of a prudent, rational behaviour, and which will secure to you a lasting felicity. You were old enough before our separation, to convince me that

Heaven had not denied you a good natural understanding. This, if properly cultivated, will set you above that trifling disposition, too common among the female world, which makes youth ridiculous, maturity insignificant, and old age contemptible. It is therefore needless to enlarge on that head, since good sense is there the best adviser; and, without it, all admonitions or directions on the subject would be as fruitless as to lay down rules for the conduct or for the actions of an ideot.

There is no room to doubt but that sufficient care will be taken to give you a polite education; but a religious one is still of greater consequence. Necessary as the former is for your making a proper figure in the world, and for your being well accepted in it, the latter is yet more so to secure to you the approbation of the greatest and best of Beings; on whose favour depends your everlasting happiness. Let therefore your duty to God be ever the first and principal object of your care. As your Creator and Governor, he claims adoration and obedience; as your father and friend, he demands submissive duty and affection. Remember that from this common Parent of the universe you received your life; that to His general providence you owe the continuance of it; and to his bounty you are indebted for all the health, ease, advantages, or enjoyments, which help to make that life agreeable. A sense of benefits received na-

turally infpires a grateful difpofition, with a defire of making fuitable returns. All that can here be made, for innumerable favours every moment beftowed, is a thankful acknowledgement, and a willing obedience. In thefe be never wanting. Make it an invariable rule to begin and end the day with a folemn addrefs to the Deity, I mean not by this, what is commonly, with too much propriety, called *faying of prayers*, namely, a cuftomary repetition of a few good words, without either devotion or attention; than which nothing is more inexcufable and affrontive to the Deity; it is the homage of the heart that can alone be accepted by him. Expreffions of our abfolute dependence on, and of our entire refignation to him; thankfgivings for the mercies already received; petitions for thofe bleffings it is fit for us to pray for; and interceffions for all our fellow-creatures, compofe the principal parts of this duty; which may be comprized in a very few words, or may be more enlarged upon, as the circumftances of time and difpofition may render moft fuitable; for it is not the length, but the fincerity and attention of our prayers that will make them efficacious. A good heart, joined to a tolerable underftanding, will feldom be at a lofs for proper words with which to clothe thefe fentiments; and all perfons, being beft acquainted with their own particular circumftances, may reafonably be fuppofed beft qualified for adapting their petitions and acknow-

ledgements to them; but for those who are of a different opinion, there are many excellent forms of prayer already composed. Among these, none that I know of, are equal to Doctor Hoadly's, the late Bishop of Winchester, which I recommend to your perusal and use. In the preface to them, you will find better instructions on this head than I am capable of giving, and to these I refer you.

It is acknowledged that our petitions cannot in any degree alter the intention of a Being, who is in himself invariable, and without a possibility of change; all that can be expected from them is, that, by bettering ourselves, they will render us more proper objects of His favourable regard; and this must necessarily be the result of a serious, regular, and constant discharge of this branch of our duty; for it is scarcely possible to offer up our sincere and fervent devotions to Heaven every morning and evening, without leaving on our minds such useful impressions as will naturally dispose us to a ready and cheerful obedience, and will inspire a filial fear of offending, the best security virtue can have. As you value your own happiness, let not the force of bad examples ever lead you into an habitual disuse of secret prayer; nor let an unpardonable negligence so far prevail on you, as to make you rest satisfied with a formal, customary, inattentive repetition of some well-chosen words: let your heart and attention always go with your lips,

and experience will soon convince you, that this permission of addressing the Supreme Being is the most valuable prerogative of human nature; the chief, nay the only support under all the distresses and calamities to which this state of sin and misery is liable; the highest rational satisfaction the mind is capable of on this side the grave; and the best preparative for everlasting happiness beyond it. This is a duty ever in your own power, and therefore you only will be culpable by the omission of it.

Public worship may not allways be so, but whenever it is, do not wilfully neglect the service of the church, at least on Sundays; and let your behaviour there be adapted to the solemnity of the place, and to the intention of the meeting. Regard neither the actions nor the dress of others: let not your eyes rove in search of acquaintance, but in the time of divine service avoid, as much as possible, all complimental civilities, of which there art too great an intercourse, in most of our churches. Remember that your only business there is to pay a solemn act of devotion to Almighty God, and let every part of your conduct be suitable to this great end. If you hear a good sermon, treasure it in your memory, that you may reap all the benefit it was capable of imparting; if you should hear but an indifferent one, some good things must be in it; retain those, and let the remainder be buried in oblivion. Ridicule not the

preacher, who no doubt has done his beſt, and who is rather the object of pity than of contempt, for having been placed in a ſituation of life, to which his talents were not equal; he may perhaps be a good man, though he is not a great orator.

I would alſo recommend to you the early and frequent participation of the Communion, or what is commonly called Receiving the Sacrament, as the indiſpenſible duty of every chriſtian. There is no inſtitution of our religion more ſimple, plain, and intelligible than this, as delivered to us by our Saviour; and moſt of the elaborate treatiſes written on the ſubject have ſerved only to puzzle and to diſturb weak minds, by throwing the dark veil of ſuperſtition and of human invention over a plain poſitive command, given by him in ſo explicit a manner as to be eaſily comprehended by the meaneſt capacity, and which is doubtleſs in the power of all his ſincere followers to pay an acceptable obedience to. Nothing has more contributed to the neglect of this duty, than the numerous well-meaning books that have been written to enjoin a month's or a week's preparation, as previouſly neceſſary to the due performance of it; by theſe means filling the minds of many with needleſs terror, putting it even out of the power of ſome to receive it at all, and inducing great numbers to reſt ſatisfied with doing it only once or twice a year, on ſome high feſtival; whereas it was certainly the

constant custom of the apostles and primitive christians on every Sunday; and it ought to be received by us as often as it is administered in the church we frequent, which in most places is but once in a month. Nor do I think it excusable, at any time, to turn our backs upon the table we see prepared for that purpose, on pretence of not being fit to partake worthily of it. The best, the only true preparation for this, and for every other part of religious duty, is a good and virtuous life, by which the mind is constantly kept in such a devotional frame, as to require but a little recollection to be suited to any particular act of worship or of obedience that may occasionally offer: and without a good and virtuous life, there cannot be a greater or more fatal mistake than to suppose that a few days or weeks spent in humiliation and prayer will render us at all the more acceptable to the Deity, or that we should be thereby better fitted for any one instance of that duty which we must universally pay, to be either approved by him, or to be advantageous to ourselves: I would not therefore advise you to read any of those weekly preparatives, which are too apt to lead the mind into error, by teaching it to rest in a mere shadow of piety, wherein there is nothing rationally satifactory. The best books which I have ever met with on this subject, are Bishop HOADLY's *Plain Account of the Nature and End of the Sacrament of the Lord's Supper,* and NELSON's *Great Duty of*

frequenting the Chriſtian Sacrifice. To the former are annexed the prayers which I before mentioned: theſe are well worth your attentive peruſal; the deſign of the inſtitution is therein fully explained, agreeable both to ſcripture and to reaſon; ſtript of that veil of myſtery which has been induſtriouſly thrown over it by deſigning or by miſtaking men; and it is there laid as plainly open to every capacity as it was at firſt left us by our great Maſter. Read *theſe books* with due attention: you will there find every neceſſary inſtruction concerning the right, and every reaſonable inducement to the conſtant and to the conſcientious performance of it.

The ſincere practice of religious duties naturally leads to the proper diſcharge of the ſocial, which may be all comprehended in that one great general rule of *doing unto others as you would they ſhould do unto you;* but of theſe more particularly hereafter.— I ſhall firſt give you my advice concerning EMPLOYMENT, it being of great moment to ſet out in life in ſuch a method as may be uſeful to yourſelf and beneficial to others.

Time is invaluable, its loſs is irretrievable! The remembrance of having made an ill uſe of it muſt be one of the ſharpeſt tortures to thoſe who are on the brink of eternity! and what can yield a more unpleaſing retroſpect than whole years idled away in an irrational inſignificant manner, examples of which

are continually before our eyes! Look on every day as a blank sheet of paper put into your hands to be filled up; remember the characters will remain to endless ages, and that they never can be expunged; be careful therefore not to write any thing but what you may read with pleasure a thousand years after. I would not be understood in a sense so strict as might debar you from any innocent amusement, suitable to your age, and agreeable to your inclination. Diversions, properly regulated, are not only allowable, they are absolutely necessary to youth, and are never criminal but when taken to excess; that is, when they engross the whole thought, when they are made the chief business of life: they then give a distaste to every valuable employment, and, by a sort of infatuation, leave the mind in a state of restless impatience from the conclusion of one 'till the commencement of another. This is the unfortunate disposition of many; guard most carefully against it, for nothing can be attended with more pernicious consequences. A little observation will convince you, that there is not, amongst the human species, a set of more miserable beings than those who cannot live out of a constant succession of diversions. These people have no comprehension of the more satisfactory pleasure to be found in retirement: thought is insupportable, and consequently solitude must be intolerable to them; they are a burthen to themselves,

and a peſt to their acquaintance, by vainly ſeeking for happineſs in company, where they are ſeldom acceptable: I ſay vainly, for true happineſs exiſts only in the mind, nothing foreign can give it. The utmoſt to be attained by what is called a gay life, is a ſhort forgetfulneſs of miſery, to be felt with accumulated anguiſh in every interval of reflection. This reſtleſs temper is frequently the product of a too eager purſuit of pleaſure in the early part of life, to the neglect of thoſe valuable improvements which would lay the foundation of a more ſolid and permanent felicity. Youth is the ſeaſon for diverſions, but it is alſo the ſeaſon for acquiring knowledge, for fixing uſeful habits, and for laying in a ſtock of ſuch well-choſen materials, as may grow into a ſerene happineſs, which will encreaſe with every added year of life, and will bloom in the fulleſt perfection in the decline of it. The great art of education conſiſts in aſſigning to each its proper place, in ſuch a manner that the one ſhall never become irkſome by intrenching on the other.—Our ſeparation having taken from me the pleaſing taſk of endeavouring, to the beſt of my ability, to ſuit them occaſionally, as might be moſt conducive both to your profit and pleaſure, it only remains for me to give you general rules, which indeed accidents may make it neceſſary ſometimes to vary; thoſe however muſt be left to your own diſcretion, and I am con-

vinced you have a sufficient share of understanding to be very capable of making advantageously such casual regulations to yourself, if the inclination is not wanting.

It is an excellent method to appropriate the morning wholly to improvement; the afternoon may then be allowed to diversions. Under this last head, I place company, books of the amusing kind, and entertaining productions of the needle, as well as plays, balls, cards, &c. which more commonly go by the name of diversions: the afternoon, and evening till supper, may by these be employed with innocence and propriety; but let not one of them ever be suffered to intrude on the former part of the day, which should be always devoted to more useful employments. One half hour, or more, either before or immediately after breakfast, I would have you constantly give to the attentive perusal of some rationally pious author, or to some part of the New Testament, with which, and indeed with the whole Scripture, you ought to make yourself perfectly acquainted, as the basis on which your religion is founded. From this practice you will reap more real benefit than can be supposed by those who have never made the experiment. The other hours may be divided amongst those necessary and polite acquisitions which are suitable to your *sex*, age, and to your rank in life.— Study *your own language* thoroughly, that you may

ADVICE TO HER DAUGHTERS.

speak correctly, and write grammatically: do not content yourself with the common use of words, which custom has taught you from the cradle, but learn from whence they are derived, and what are their proper significations.—*French* you ought to be as well acquainted with as with *English*, and *Italian* might, without much difficulty, be added.—Acquire a good knowledge of history; that of your own country first, then of the other European nations: read them not with a view to amuse, but to improve your mind; and to that end make reflections on what you have read, which may be useful to yourself, and will render your conversation agreeable to others.—Learn so much of *Geography* as to form a just idea of the situation of places, mentioned in any author; and this will make history more entertaining to you.

It is necessary for you to be perfect in *the first four rules of Arithmetic:* more you can never have occasion for, and the mind should not be burthened with needless application.—*Music* and *Drawing* are accomplishments well worth the trouble of attaining, if your inclination and genius lead to either: if not, do not attempt them; for it will be only much time and great labour unprofitably thrown away; it being next to impossible to arrive at any degree of perfection in those arts, by the dint of perseverance only, if a good ear and a native genius be wanting.—The study of *Natural Philosophy*, you will find both pleasing

and inftructive; pleafing, from the continual new difcoveries to be made of the innumerably various beauties of nature, a moft agreeable gratification of that defire of knowledge wifely implanted in the human mind; and highly inftructive, as thofe difcoveries lead to the contemplation of the great Author of Nature, whofe wifdom and goodnefs fo confpicuoufly fhine through all His works, that it is impoffible to reflect ferioufly on them, without admiration and gratitude.

These, my dear, are but a few of thofe mental improvements I would recommend to you. Indeed there is no branch of knowledge that your capacity is equal to, and which you have an opportunity of acquiring, that, I think, ought to be neglected. It has been objected againft all female learning, beyond that of houfehold œconomy, that it tends only to fill the minds of the fex with a conceited vanity, which fets them above their proper bufinefs; occafions an indifference to, if not a total neglect of, their family affairs; and ferves only to render them ufelefs wives, and impertinent companions. It muft be confeffed, that fome reading ladies have given but too much caufe for this objection; and could it be proved to hold good throughout the fex, it would certainly be right to confine their improvements within the narrow limits of the nurfery, of the kitchen, and the confectionary: but, I believe, it will, upon examination,

be found, that such ill consequences proceed chiefly from too great an imbecility of mind to be capable of much enlargement, or from a mere affectation of knowledge, void of all reality. Vanity is never the result of understanding. A sensible woman will soon be convinced, that all the learning her utmost application can make her mistress of, will be from the difference of education, in many points, inferior to that of a school boy: this reflection will keep her always humble, and will be an effectual check to that loquacity which renders some women such insupportable companions.

The management of all domestic affairs is certainly the proper business of woman; and, unfashionably rustic as such an assertion may be thought, it is not beneath the dignity of any lady, however high her rank, to know *how* to educate her children, to govern her servants; how to order an elegant table with œconomy, and to manage her whole family with prudence, regularity and method. If in these she is defective, whatever may be her attainments in any other kinds of knowledge, she will act out of character; and, by not moving in her proper sphere, she will become rather the object of ridicule than of approbation. But I believe it may with truth be affirmed, that the neglect of these domestic concerns has much more frequently proceeded from an exorbitant love of diversions, from a ridiculous fondness

for drefs and gallantry, or from a miftaken pride, that has placed fuch duties in a fervile light, from whence they have been confidered as fit only for the employment of dependents, and below the attention of a fine lady, than from too great an attachment to mental improvements; yet, from whatfoever caufe fuch a neglect proceeds, it is equally unjuftifiable. If any thing can be urged in vindication of a cuftom unknown to our anceftors, which the prevalence of fafhion has made fo general amongft the modern ladies; I mean, that of committing to the care and difcretionary power of different fervants, the fole management of family affairs; nothing certainly can be alledged in defence of fuch an ignorance, in things of this nature, as renders a lady incapable of giving proper directions on all occafions; an ignorance, which, in ever fo exalted a ftation, will render her contemptible, even to thofe fervants on whofe underftanding and fidelity fhe, in fact, becomes dependent for the regularity of her houfe, for the propriety, elegance, and frugality of her table; which laft article is feldom regarded by fuch fort of people, who too frequently impofe on thofe by whom they are thus implicitly trufted. Make yourfelf, therefore, fo thoroughly acquainted with the moft proper method of conducting a family, and with the neceffary expence which every article, in proportion to their number, will occafion, that you may come to a rea-

sonable certainty of not being materially deceived, without the ridiculous drudgery of following your servants continually, and meanly peeping into every obscure corner of your house: nor is this at all difficult to attain, as it requires nothing more than an attentive observation.

It is of late, in most great families, become too much the custom to be long upon the books of every tradesman they employ. To assign a reason for this is foreign to my purpose; but I am certain it would, in general, be better both for themselves, and for the people they deal with, never to be on them at all; and what difficulty or inconvenience can arise, in a well regulated family, from commissioning the steward or house-keeper to pay for every thing at the time when it is brought in? This obsolete practice, though in itself very laudable, is not at present, and perhaps never may be again, authorised by fashion; however, let it be a rule with you to contract as few debts as possible: most things are to be purchased both better in their kind, and at a lower price, by paying for them at the time of purchasing. But if, to avoid the supposed trouble of frequent trifling disbursements, you chuse to have the lesser articles thrown together in a bill, let a note of the quantity and price be brought with every such parcel: file these notes, compare them with the bill when delivered in, and let such bills be regularly paid every quarter: for it is

not reasonable to expect that a tradesman should give longer credit, without making up the interest of his money by an advanced price on what he sells: and be assured, if you find it inconvenient to pay at the end of three months, that inconvenience must arise from living at too great an expence, and will consequently increase in six months, and grow still greater at the end of the year. By making short payments, you will become the sooner sensible of such a mistake, and you will find it at first more easy to retrench any supernumeries than after having been long habituated to them.

If your house is superintended by an house-keeper, and your servants are accountable to her, let your housekeeper be accountable to yourself, and let her be entirely governed by your directions. Carefully examine her bills, and suffer no extravagancies or unnecessary articles to pass unnoticed. Let these bills be brought to you every morning; what they contain will then be easily recollected without burthening your memory; and your accounts being short will be adjusted with less trouble and with more exactness. Should you at any time have an upper servant, whose family and education were superior to that state of subjection to which succeeding misfortunes may have reduced her, she ought to be treated with peculiar indulgence: if she has understanding enough to be conversible, and humility enough always to keep her

proper diſtance, leſſen, as much as poſſible, every painful remembrance of former proſpects, by looking on her as an humble friend, and making her an occaſional companion. But never deſcend to converſe with thoſe whoſe birth, education and early views in life were not ſuperior to a ſtate of ſervitude: their minds being in general ſuited to their ſtation, they are apt to be intoxicated by any degree of familiarity, and to become uſeleſs and impertinent. The habit which very many ladies have contracted of talking to and conſulting with their women, has ſo ſpoiled that ſet of ſervants, that few of them are to be met with, who do not commence their ſervice by giving their unaſked opinion of your perſon, dreſs, or management, artfully conveyed in the too generally accepted vehicle of flattery; and, if they are allowed in this, they will next proceed to offer their advice on any occaſion that may happen to diſcompoſe or ruffle your temper: check therefore the firſt appearance of ſuch impertinence, by a reprimand ſufficiently ſevere to prevent a repetition of it.

Give your orders in a plain diſtinct manner, with good-nature joined to a ſteadineſs that will ſhew they muſt be punctually obeyed. Treat all your domeſtics with ſuch mildneſs and affability, that you may be ſerved rather out of affection than fear. Let them live happily under you. Give them leiſure for their own buſineſs, time for innocent recreation, and more

especially for attending the public service of the church, to be instructed in their duty to God; without which you have no right to expect the discharge of that owing to yourself. When wrong, tell them calmly of their faults; if they amend not after two or three such rebukes, dismiss them; but never descend to passion and scolding, which is inconsistent with a good understanding, and beneath the dignity of a gentlewoman.

Be very exact in your hours, without which there can be no order in your family, I mean those of rising, eating, &c. Require from your servants punctuality in these, and never be yourself the cause of breaking through the rules you have laid down, by deferring breakfast, putting back the dinner, or letting it grow cold on the table, to wait your dressing; a custom by which many ladies introduce confusion, and bring their orders into neglect. Be always dressed at least half an hour before dinner. Having mentioned this important article, I must be allowed a little digression on the subject.

Whatever time is taken up in dress beyond what is necessary to decency and cleanliness, may be looked upon, to say no worse, as a vacuum in life. By decency, I mean such a habit as is suitable to your rank and fortune: an ill-placed finery, inconsistent with either, is not ornamental but ridiculous. A compliance with fashion, so far as to avoid the affectation

ADVICE TO HER DAUGHTERS.

of singularity, is necessary; but to run into the extreme of fashions, more especially those which are inconvenient, is the certain proof of a weak mind. Have a better opinion of yourself than to suppose you can receive any additional merit from the adventitious ornaments of dress. Leave the study of the toilet to those who are adapted to it; I mean that insignificant set of females, whose whole life, from the cradle to the coffin, is but a varied scene of trifling, and whose intellectuals fit them not for any thing beyond it. Such as these may be allowed to pass whole mornings at their looking-glass, in the important business of suiting a set of ribbands, adjusting a few curls, or determining the position of a patch; one, perhaps, of their most innocent ways of idling. But let as small a portion of your time as possible be taken up in dressing. Be always perfectly clean and neat, both in your person and clothes; equally so when alone, as in company. Look upon all beyond this as immaterial in itself, any further than as the different ranks of mankind have made some distinction in habit generally esteemed necessary; and remember, that it is never the dress, however sumptuous, which reflects dignity and honour on the person: it is the rank and merit of the person that gives consequence to the dress. But to return:—

It is your own steadiness and example of regularity that alone can preserve uninterrupted order in

your family. If, by forgetfulness or inattention, you at any time suffer your commands to be disobeyed with impunity, your servants will grow upon such neglect into a habit of carelessness, till repeated faults, of which this is properly the source, rouse you into anger, which an even hand would never have made necessary. Be not whimsical or capricious in your likings: approve with judgment, and condemn with reason; that acting right may be as certainly the means of obtaining your favour, as the contrary of incurring your displeasure.

From what has been said you will see, that in order to the proper discharge of your domestic duties, it is absolutely necessary for you to have a perfect knowledge of every branch of household œconomy, without which you can neither correct what is wrong, approve what is right, nor give directions with propriety. It is the want of this knowledge that reduces many a fine lady's family to a state of the utmost confusion and disorder, on the sudden removal of a managing servant, till the place is supplied by a successor of equal ability. How much out of character, how ridiculous must a mistress of a family appear, who is entirely incapable of giving practical orders on such an occasion. Let that never be *your* case! Remember, my dear, this is the only proper temporal business assigned you by Providence, and in a thing so indispensably needful, so easily at-

tained, where so little study or application is necessary to arrive at the most commendable degree of it, the want even of perfection is almost inexcusable. Make yourself mistress of the theory, that you may be able the more readily to reduce it into practice; and when you have a family to command, let the care of it always employ your principal attention, and let every part of it be subjected to your own inspection. If you rise early, a custom I hope you have not left off since you was with me, if you waste no unnecessary time in dressing, and if you conduct your house in a regular method, you will find many vacant hours unfilled by this material business; and no objection can be made to your employing those in such improvements of the mind, as are most suitable to your genius and inclination. I believe no man of understanding will think that, under such regulations, a woman will either make a less agreeable companion, a less useful wife, a less careful mother, or a worse mistress of a family, for all the additional knowledge her industry and application can acquire.

The morning being always thus advantageously engaged, the latter part of the day, as I before said, may be given to relaxation and amusement. Some of these hours may be very agreeably and usefully employed by entertaining books; a few of which, in the English language I will mention to you, as a specimen of the kind I would recom-

86 AN UNFORTUNATE MOTHER'S

mend to your perusal; and I shall include some others, religious and instructive.

Mason on Self Knowledge
Œconomy of Human Life
Seneca's Morals
Epictetus Morals
Cicero's Offices
Collier's Antoninus
Hoadly's ⎫
Seed's ⎪
Sherlock's ⎬ Sermons
Sterne's ⎪
Fordyce's ⎭
Rollin's Belles Lettres
Nature Display'd
The Spectator
The Guardian
The Female Spectator
The Rambler
The Idler
The Adventurer
The World
Cicero's Familiar Letters
Pliny's Letters

Fitzosborne's Letters
Telemachus
The Vicar of Wakefield
Guthrie's Geographical Grammar
Potter's Antiquities of Greece
Rollin's Ancient History
Kennett's Antiquities of Rome
Hooke's Roman History
Hume's History of England
Robertson's Works
Milton's Poetical Works
Pope's Works
———— Homer
Thomson's Works
Young's Works
Mrs. Rowe's Works
Langhorne's Works
Moore's Fables for the Female Sex
Tales of the Genii
Dodsley's Collection of Poems

☞ To the above List the Editor of this volume begs leave to add the following books, most of which have appeared since Lady P.'s Letter was first printed:

Blair's ⎫
Franklin's ⎬ Sermons
White's ⎪
Walker's ⎭
West on the Resurrection
Lord Lyttleton on the Conversion of St. Paul
Miss Talbot's Reflections and Essays
Dr. Watts on the Improvement of the Mind

Mrs. Chapone's Letters and Miscellanies
The Mirror, 2 vols.
The Lounger, 3 vols
The Observer, 4 vols.
Hayley's Triumphs of Temper
Rasselas, Prince of Abyssinia
Female Reader
Speaker, 2 vols.
Mrs. Trimmer's Works

Works of Madame De Genlis	Shakefpeare's Plays
Marchionefs de Lambert's Works, 2 vols.	Johnfon's Poets, 75 vols. with their Lives
Mifs Burney's Evelina, 2 vols. and Cecilia, 3 vols.	Mifs More' Poems, and Profe Pieces
Mrs. Smith's Emmeline, 2 vols.	Ethelinde, 3 vols.
	Mifs Bodler's Effay, &c.
General Biographical Dictionary, 12 vols. 8vo.	Elegant Extracts, in Profe and Verfe, 2 vols.

From thefe you may form a judgment of that fort of reading which will be both ufeful and entertaining to you. I have named only thofe *Practical Sermons*, which, I thought, would more directly influence your conduct in life—*Our rule of faith* fhould be taken from the fcripture alone, which we muft underftand for ourfelves; therefore the controverted opinions of others ferve in general rather to puzzle than to improve the mind.

Of *Novels and Romances*, very few are worth the trouble of reading: fome of them perhaps do contain a few goods morals, but they are not worth the finding where fo much rubbifh is intermixed. Their moral parts indeed are like fmall diamonds amongft mountains of dirt and trafh, which, after you have found them, are too inconfiderable to anfwer the pains of coming at; yet, ridiculous as thefe fictitious tales generally are, they are fo artfully managed as to excite an idle curiofity to fee the conclufion, by which means the reader is drawn on, through a tirefome length of foolifh adventures, from which neither

knowledge, pleafure, or profit, feldom can accrue, to the common cataftrophe of a wedding. The moft I have met with of thefe writings, to fay no worfe, it is little better than the lofs of time to perufe. But fome of them have more pernicious confequences. By drawing characters that never exift in life, by reprefenting perfons and things in a falfe and extravagant light, and by a feries of improbable caufes bringing on impoffible events, they are apt to give a romantic turn to the mind, which is often productive of great errors in judgment, and of fatal miftakes in conduct. Of this I have feen frequent inftances, and therefore advife you fcarce ever to meddle with any of them.

In juftice however to a late ingenious author, this Letter muft not be reprinted, without my acknowledging that, fince the laft edition was publifhed, I have accidentally met with one exception to my general rule, namely, *The Vicar of Wakefield*. That novel is equally entertaining and inftructive, without being liable to any of the objections that occafioned the above reftriction. This poffibly may not be the only unexceptionable piece of the kind, but as I have not met with any other, amongft a number I have perufed, a fingle inftance does not alter my opinion of that fort of writing; and I ftill think, the chance is perhaps a thoufand to one againft the probability of obtaining the fmalleft degree of advantage from

the reading any of them, as well as that very few are to be found from which much injury may not be received.

Works of the Needle that employ the fancy, may, if they suit your inclination, be sometimes a pretty amusement; but let this employment never extend to large pieces, beyond what can be accomplished by yourself without assistance. There is not a greater extravagance, under the specious name of good housewifery, than the furnishing of houses in this manner. Whole apartments have been seen thus ornamented by the supposed work of a lady, who, perhaps, never shaded two leaves in the artificial forest, but has paid four times its value to the several people employed in bringing it to perfection. The expence of these tedious pieces of work I speak of experimentally, having, many years past, undertaken one them, which, when finished, was not worth fifteen pounds; and by a computation since made, it did not cost less than fifty, in the hire and maintenance of the people employed in it. This indeed was at the age of seventeen, when the thoughtless inexperience of youth could alone excuse such a piece of folly.—*Embroideries in gold, silver, or shades of silk,* come within a narrower compass. Works of that kind which may, without calling in expensive assistance, or tiring the fancy, be finished in a summer, will be a well-chosen change of amusement,

and may, as there are three of you, be made much more agreeable, by one alternately reading aloud, while the other two are thus employed.—All kinds of what is called *plain-work*, though no very polite accomplishment, you must be so well versed in, as to be able to cut out, make, or mend your own linen. Some fathers, and some husbands, chuse to have their daughters and their wives thus attired in the labour of their own hands, and, from a mistaken notion, believe this to be the great criterion of frugal œconomy. Where that happens to be the inclination or opinion of either, it ought always to be readily complied with: but, exclusive of such a motive, I see no other that makes the practical part necessary to any lady; excepting, indeed, where there is such a narrowness of fortune as admits not conveniently the keeping a servant, to whom such exercises of the needle much more properly appertain.

THE THEATRE, which, by the indefatigable labour of the inimitable Mr. Garrick, has been brought to very great perfection, will afford you an equally rational and improving entertainment. Your judgment will not now be called in question, your understanding affronted, nor will your modesty be offended by the indecent ribaldry of those authors, who, to their defect in wit, have added the want of good sense and of good manners. Faults of this kind, which, from a blameful compliance with a corrupted taste,

have sometimes crept into the works of good writers, are by his prudent direction generally rectified or omitted on the stage. You may now see many of the best plays performed in the best manner. Do not, however, go to any that you have not before heard the character of; be present only at those which are approved by persons of understanding and virtue, as calculated to answer the proper ends of the theatre, namely, that of conveying instruction in the most pleasing method. Attend to the sentiment, apply the moral, and then you cannot, I think, pass an evening in a more useful, or in a more entertaining diversion.

DANCING may also take its turn as a healthful exercise, as it is generally suitable to the taste and gaiety of young minds.

PART of the hours appropriated to relaxation must of necessity be less agreeably taken up in the paying and receiving visits of mere ceremony and civility; a tribute, by custom authorized, by good manners enjoined. In *these*, when the conversation is only insignificant, join in it with an apparent satisfaction. Talk of the elegance of a birth-day suit, the pattern of a lace, the judicious assortment of jewels, the cut of a ruffle, or the set of a sleeve, with an unaffected ease; not according to the rank they hold in your estimation, but proportioned to the consequence they may be of in the opinion of those you are conversing

with. The great art of pleasing is to appear pleased with others; suffer not then an ill-bred absence of thought, or a contemptuous sneer, ever to betray a conscious superiority of understanding, always productive of ill-nature and dislike. Suit yourself to the capacity and to the taste of your company, when that taste is confined to harmless trifles; but where it is so far depraved as to delight in cruel sarcasms on the absent, to be pleased with discovering the blemishes in a good character, or in repeating the greater faults of a bad one, religion and humanity in that case forbid the least degree of assent. If you have not any knowledge of the persons thus unhappily sacrificed to envy or to malice, and consequently are ignorant as to the truth or falshood of such aspersions, always suspect them to be ill grounded, or, at least, greatly exaggerated. Shew your disapprobation by a silent gravity, and by taking the first opportunity to change the subject. But where any acquaintance with the character in question gives room for defending it, let not an ill-timed complaisance prevail over justice: vindicate injured innocence with all the freedom and warmth of an unrestrained benevolence; and where the faults of the guilty will admit of palliation, urge all that truth can allow in mitigation of error. From this method, besides the pleasure arising from the consciousness of a strict conformity to the great rule of *doing as you would be done*

ly, you will also reap to yourself the benefit of being less frequently pestered with themes ever painful to a humane disposition. If, unfortunately, you have some acquaintance whose malevolence of heart no sentiment of virtue, no check of good-manners, can restrain from these malicious sallies of ill-nature, to them let your visits be made as seldom, and as short, as decency will permit; there being neither benefit nor satisfaction to be found in such company, amongst whom only cards may be introduced with any advantage. On this account, it will be proper for you to know how to play at the games most in use, because it is an argument of great folly to engage in any thing without doing it well; but this is a diversion which I hope you will have no fondness for, as it is in itself, to say no worse, a very insignificant amusement.

With persons for whom you can have no esteem, good-breeding may oblige you to keep up an intercourse of ceremonious visits, but politeness enjoins not the length or frequency of them. Here inclination may be followed without a breach of civility: there is no tax upon intimacy but from choice; and that choice should ever be founded on merit, the certainty whereof you cannot be too careful in previously examining. Great caution is necessary not to be deceived by specious appearances. A plausible behaviour often, upon a superficial knowledge, creates a prepossession in favour of particulars, who, upon a

nearer view, may be found to have no claim to efteem. The forming a precipitate judgment sometimes leads into an unwary intimacy, which it may prove abfolutely neceffary to break off; and yet that breach may be attended with innumerable inconveniences; nay, perhaps, with very material and lafting ill confequences: prudence, therefore, here enjoins the greateft circumfpection.

Few people are capable of friendfhip, and ftill fewer have all the qualifications one would chufe in a friend. The fundamental point is a virtuous difpofition; but to that fhould be added a good underftanding, a folid judgment, fweetnefs of temper, fteadinefs of mind, freedom of behaviour, and fincerity of heart. Seldom as thefe are to be found united, never make a bofom friend of any one greatly deficient in either. Be flow in contracting friendfhip, and invariably conftant in maintaining it. Expect not many friends, but think yourfelf happy, if, through life, you meet with one or two who deferve that name, and have all the requifites for the valuable relation. This may juftly be deemed the higheft bleffing of mortality. Uninterrupted health has the general voice; but, in my opinion, fuch an intercourfe of friendfhip as much deferves the preference, as the mental pleafures, both in nature and degree, exceed the corporeal. The weakneffes, the pains of the body may be inexpreffibly alleviated by the converfa-

tion of a person, by affection endeared, by reason approved; whose tender sympathy partakes your afflictions, and shares your enjoyments; who is steady in the correction, but mild in the reproof of your faults; like a guardian angel, ever watchful to warn you of unforeseen danger, and, by timely admonitions, to prevent the mistakes incident to human frailty and to self-partiality: this is the true office of friendship. With such a friend, no state of life can be absolutely unhappy; but, destitute of some such connection, Heaven has so formed our natures for this intimate society, that amidst the affluence of fortune, and in the flow of uninterrupted health, there will be an aching void in the solitary breast, which can never otherwise know a plenitude of happiness.

Should the Supreme Disposer of all events bestow on you this superlative gift, to such a friend let your heart be ever unreservedly open. Conceal no secret thought, disguise no latent weakness, but bare your bosom to the faithful probe of honest friendship, and shrink not if it smarts beneath the touch; nor with tenacious pride dislike the person who freely dares to condemn some favourite foible; but, ever open to conviction, hear with attention, and receive with gratitude, the kind reproof that flows from tenderness. When sensible of a fault, be ingenuous in the confession—be sincere and steady in the correction of it.

Happy is her lot, who in a husband finds this invaluable friend! Yet so great is the hazard, so disproportioned the chances, that I could almost wish the dangerous die was never to be thrown for any of you: but as probably it may, let me conjure ye all, my dear girls, if ever any of you take this most important step in life, to proceed with the utmost care and with deliberate circumspection. Fortune and Family it is the sole province of your father to direct in: he certainly has always an undoubted right to a negative voice, though not to a compulsive one. As a child is very justifiable in the refusal of her hand, even to the absolute command of a father, where her heart cannot go with it, so is she extremely culpable in giving it contrary to his approbation. Here I must take shame to myself; and for this unpardonable fault, I do justly acknowledge that the subsequent ill consequences of a most unhappy marriage were the proper punishment. This, and every other error in my own conduct, I do, and shall, with the utmost candour, lay open to you; sincerely praying that you may reap the benefit of my experience, and that you may avoid those rocks, which, either by carelesness, or sometimes, alas, by too much caution, I have split against! But to return:—

The chief point to be regarded in the choice of *a companion for life*, is a really virtuous principle, an unaffected goodness of heart. Without this, you will

be continually shocked by indecency, and pained by impiety. So numerous have been the unhappy victims to the ridiculous opinion, "*A reformed libertine makes the best husband,*" that, did not experience daily evince the contrary, one would believe it impossible for a girl who has a tolerable degree of common understanding to be made the dupe of so erroneous a position, which has not the least shadow of reason for its foundation, and which a small share of observation will prove to be false in fact. A man who has been long conversant with the worst sort of women, is very apt to contract a bad opinion of, and a contempt for, the sex in general. Incapable of esteeming any, he is suspicious of all, jealous without cause, angry without provocation, and his own disturbed imagination is a continual source of ill humour. To this is frequently joined a bad habit of body, the natural consequence of an irregular life, which gives an additional sourness to the temper. What rational prospect of happiness can there be with such a companion? And that this is the general character of those who are called reformed rakes, observation will certify—But, admit there may be some exceptions, it is a hazard upon which no considerate woman would venture the peace of her whole future life. The vanity of those girls who believe themselves capable of working miracles of this kind, and who give up their persons to men of libertine principles, upon the

wild expectation of reclaiming them, justly deserves the disappointment which it will generally meet with; for, believe me, a wife is, of all persons, the least likely to succeed in such an attempt. Be it your care to find that virtue in a lover which you must never hope to form in a husband. Good-sense and good-nature are almost equally requisite. If the former is wanting, it will be next to impossible for you to esteem the person of whose behaviour you may have cause to be ashamed; and mutual esteem is as necessary to happiness in the married state as mutual affection: without the latter, every day will bring with it some fresh cause of vexation; 'till repeated quarrels produce a coldness, which will settle into an irreconcileable aversion, and you will become not only each other's torment, but the object of contempt to your family and to your acquaintance.

This quality of Good-Nature is, of all others, the most difficult to be ascertained, on account of the general mistake of blending it with Good-Humour, as if they were in themselves the same; whereas, in fact, no two principles of action are more essentially different. And this may require some explanation. —By Good-Nature I mean, that true benevolence which partakes the felicity of all mankind; which promotes the satisfaction of every individual within the reach of its ability; which relieves the distressed, comforts the afflicted, diffuses blessings, and commu-

nicates happiness, as far as its sphere of action can extend; and which, in the private scenes of life, will shine conspicuous in the dutiful son, the affectionate husband, the indulgent father, the faithful friend, and the compassionate master both to man and beast: whilst Good-Humour is nothing more than a cheerful, pleasing deportment, arising either from a natural gaiety of mind, or from an affectation of popularity, joined to an affability of behaviour, the result of good-breeding, and a ready compliance with the taste of every company. This kind of mere good-humour is, by far, the most striking quality; 'tis frequently mistaken for, and complimented with, the superior name of real good-nature. A man by this specious appearance has often acquired that appellation, who, in all the actions of his private life, has been a morose, cruel, revengeful, sullen, haughty tyrant. Let them put on the cap whose temples fit the galling wreath! On the contrary, a man of a truly benevolent disposition, and formed to promote the happiness of all round him, may sometimes, perhaps from an ill habit of body an accidental vexation, or from a commendable openness of heart above the meanness of disguise, be guilty of little sallies of peevishness, or of ill-humour, which, carrying the appearance of ill-nature, may be unjustly thought to proceed from it, by persons who are unacquainted with his true character, and who take ill-humour and ill-nature to be synoni-

mous terms, though in reality they bear not the leaſt analogy to each other. In order to the forming a right judgment, it is abſolutely neceſſary to obſerve this diſtinction, which will effectually ſecure you from the dangerous error of taking the ſhadow for the ſubſtance; an irretrievable miſtake, pregnant with innumerable conſequent evils!

From what has been ſaid it plainly appears, that the criterion of this amiable virtue is not to be taken from the general opinion; mere good-humour being, to all intents and purpoſes, ſufficient in this particular to eſtabliſh the public voice in favour of a man utterly devoid of every humane and benevolent affection of heart. It is only from the leſs conſpicuous ſcenes of life, the more retired ſphere of action, from the artleſs tenor of domeſtic conduct, that the real character can with any certainty be drawn. Theſe undiſguiſed proclaim the man; but, as they ſhun the glare of light, nor court the noiſe of popular applauſe, they paſs unnoticed, and are ſeldom known 'till after an intimate acquaintance. The beſt method, therefore, to avoid the deception in this caſe, is to lay no ſtreſs on outward appearances, which are too often fallacious, but to take the rule of judging from the ſimple, unpoliſhed ſentiments of thoſe, whoſe dependent connections give them an undeniable certainty; who not only ſee, but hourly feel the good or bad effects of that diſpoſition to which they are ſubjected.

By this I mean, that if a man is equally respected, esteemed, and beloved by his tenants, by his dependents and domestics; from the substantial farmer to the laborious peasant; from the proud steward to the submissive wretch, who, thankful for employment, humbly obeys the menial tribe; you may justly conclude he has that true good-nature, that real benevolence, which delights in communicating felicity, and enjoys the satisfaction it diffuses. But if by these he is despised and hated, served merely from a principle of fear, devoid of affection—which is very easily discoverable—whatever may be his public character, however favourable the general opinion, be assured, that his disposition is such as can never be productive of domestic happiness.—I have been the more particular on this head, as it is one of the most essential qualifications to be regarded, and of all others the most liable to be mistaken.

Never be prevailed with, my dear, to give your hand to a person defective in these material points. Secure of virtue, of good-nature, and understanding in a husband, you may be secure of happiness. Without the two former, it is unattainable: without the latter, in a tolerable degree, it must be very imperfect.

Remember, however, that infallibility is not the property of man, or you may entail disappointment on yourself, by expecting what is never to be found.

The best men are sometimes inconsistent with themselves. They are liable to be hurried by sudden starts of passion into expressions and actions which their cooler reason will condemn. They may have some oddities of behaviour, some peculiarities of temper; they may be subject to accidental ill-humour, or to whimsical complaints: blemishes of this kind often shade the brightest character, but they are never destructive of mutual felicity, unless when they are made so by an improper resentment, or by an ill-judged opposition. Reason can never be heard by passion; the offer of it tends only to enflame the more. When cooled, and in his usual temper, the man of understanding, if he has been wrong, will suggest to himself all that could be urged against him: the man of good-nature will, unupbraided, own his error: immediate contradiction is, therefore, wholly unserviceable, and highly imprudent; an after repetition equally unnecessary and injudicious. Any peculiarities in the temper or behaviour ought to be properly represented in the tenderest and in the most friendly manner, and if the representation of them is made discreetly, it will generally be well taken: but if they are so habitual as not easily to be altered, strike not too often upon the unharmonious string; rather let them pass as unobserved: such a chearful compliance will better cement your union; and they may be made easy to yourself, by reflecting on the

superior good qualities by which thefe trifling faults are fo greatly over-balanced.—You muft remember, my dear, thefe rules are laid down, on the fuppofition of your being united to a perfon who poffeffes the three effential qualifications for happinefs beforementioned. In this cafe, no farther direction is neceffary, but that you ftrictly perform the duty of a wife, namely, to love, to honour, and obey. The two firft articles are a tribute fo indifpenfibly due to merit, that they muft be paid by inclination; and they naturally lead to the performance of the laft, which will not only be an eafy, but a pleafing tafk, since nothing can ever be enjoined by fuch a perfon that is in itfelf improper, and few things will, that can with any reafon be difagreeable to you.

Here fhould this fubject end, were it not more than poffible for you, after all that has been urged, to be led by fome inferior motive to the neglect of the primary caution; and that, either from an opinion too haftily entertained, from an unaccountable partiality, or from the powerful prevalence of perfuafion, you may be unfortunately induced to give your hand to a man whofe bad heart and morofe temper, concealed by a well practifed diffimulation, may render every flattering hope of happinefs abortive.—May Heaven, in mercy, guard you from this fatal error! Such a companion is the worft of all temporal ills; a deadly potion, that imbitters every focial fcene of

life, damps every rising joy, and banishes that chearful temper which alone can give a true relish to the blessings of mortality. Most sincerely do I pray that this may never be your lot! and I hope your prudent circumspection will be sufficient to guard you from the danger. But the bare possibility of the event makes it not unnecessary to lay down a few rules for the maintaining some degree of ease, under such a deprivation of happiness. This is by far the most difficult part of my present undertaking; it is hard to advise here, and still harder to practise the advice: the subject also is too extensive to be minutely treated within the compass of *a letter*; which must confine me to the most material points only; in these I shall give you the best directions in my power, very ardently wishing that you may never have occasion to make use of them.

The being united to a man of irreligious principles makes it impossible to discharge a great part of the proper duty of a wife. To name but one instance, obedience will be rendered impracticable by frequent injunctions inconsistent with and contrary to the higher obligations of morality. This is not supposition, but is founded upon facts, which I have too often seen and can attest. Where this happens, the reasons for non-compliance ought to be offered in a plain, strong, good-natured manner; there is at least the chance of success from being heard; but should those reasons be rejected, or the hearing of them be refused, and silence

on the subject enjoined—which is most probable, few people caring to hear what they know to be right, when determined not to appear convinced by it—obey the injunction, and urge not the argument farther: keep, however, steady to your principles, and suffer neither persuasion not threats to prevail on you to act contrary to them. All commands repugnant to the laws of christianity, it is your indispensible duty to disobey; all requests that are inconsistent with prudence, or incompatible with the rank and character which you ought to maintain in life, it is your interest to refuse. A compliance with the former would be criminal; a consent to the latter highly indiscreet; and it might thereby subject you to general censure: for a man capable of requiring from his wife what he knows to be in itself wrong, is equally capable of throwing the whole blame of such misconduct on her, and of afterwards upbraiding her for a behaviour to which he will, upon the same principle, disown that he has been accessary. Many similar instances have come within the compass of my own observation. In things of a less material nature, that are neither criminal in themselves nor pernicious in their consequences, always acquiesce, if insisted on, however disagreeable they may be to your own temper and inclination. Such a compliance will evidently prove that your refusal, in the other cases, proceeds not from a spirit of contradiction, but merely from a just regard

to that superior duty, which can never be infringed with impunity. Passion may resent, but reason must approve this conduct; and therefore it is the most likely method, in time, to make a favourable impression. But, if you should fail of such success, you will at least enjoy that satisfactory self-approbation, which is the inseparable attendant of a truly religious and rational deportment.

Should the painful task of dealing with a morose tyrannical temper be assigned you, there is little more to be recommended than a patient submission to an evil which admits not of a remedy. Ill-nature is increased, obstinacy confirmed, by opposition: the less such a temper is contradicted, the more supportable will it be to those who are under its baneful influence. When all endeavours to please are ineffectual, and when a man seems determined to find fault with every thing, as if his chief pleasure consisted in tormenting those about him, it requires a more than common degree of patience and resolution to forbear uttering reproaches, which such a behaviour may be justly allowed to deserve: yet it is absolutely necessary to the maintaining any tolerable degree of ease, not only to restrain all expressions of resentment, but to withhold even those disdainful looks which are apt to accompany a contemptuous silence; and they both equally tend only to encrease the malady. This infernal delight in giving pain is most unwearied in the search of

matter for its gratification, and can either find, or unaccountably can form it, in almost all the occurrences of life; but, when suffered unobstructed and unreguarded to run its malicious course, it will quickly vent its blunted arrows, and will die of disappointment; whilst all endeavours to appease, all complaints of unkindness will but sharpen against yourself the weapon's edge, and, by proving your sensibility of the wound, will give the wished-for satisfaction to him who inflicts it. Prudence, in this case, directs more than ordinary circumspection, that every part of your behaviour may be as blameless as possible, even to the abstaining from the least appearance of evil; and after you have, to the utmost of your power, strove to merit approbation, expect not to meet with it: by these means you will escape the mortification of being disappointed, which, often repeated, is apt to give a gloomy sourness to the temper, incompatible with any degree of contentment. You must, so situated, learn to be satisfied with the consciousness of acting right, according to your best abilities, and, if possible, you should look with an unconcerned indifference on the reception of every succesful attempt to please.

This, it must be owned, is a hard lesson of philosophy; it requires no less than an absolute command over the passions; but let it be remembered, that such a command will itself most amply recompense every

difficulty; it will compenſate every pain, which it may coſt you to obtain it: beſides, it is, I believe, the only way to preſerve any tranquillity of mind, under ſo diſagreeable a connection.

As the want of underſtanding is by no art to be concealed, by no addreſs to be diſguiſed, it might be ſuppoſed impoſſible for a woman of ſenſe to unite herſelf to a perſon whoſe defect, in this inſtance, muſt render that ſort of rational ſociety which conſtitutes the chief happineſs of ſuch an union, impoſſible; yet, here, how often has the weakneſs of female judgment been conſpicuous! The advantages of great ſuperiority in rank of fortune have frequently proved ſo irreſiſtible a temptation, as, in opinion, to outweigh not only the folly but even the vices of its poſſeſſor: a grand miſtake, ever tacitly acknowledged by a ſubſequent repentance, when the expected pleaſures of affluence, equipage, and all the glittering pomp of uſeleſs pageantry have been experimentally found inſufficient to make amends for the want of that conſtant ſatisfaction, which reſults from the ſocial joy of converſing with a reaſonable friend! But however weak this motive muſt be acknowledged, it is more excuſable than another, which, I fear, has ſometimes had an equal influence on the mind; I mean, ſo great a love of ſway, as to induce her to give the preference to a perſon of weak intellectuals, in hopes thereby of holding, uncontrouled, the reins

of government. The expectation is, in fact, ill-grounded obstinacy; and pride being generally the companion of folly, the silliest people are usually the most tenacious of their opinions, and consequently, the hardest of all others to be managed: but admit the contrary, the principle is in itself bad; it tends to invert the order of nature, and to counteract the design of Providence.

A woman can never be seen in a more ridiculous light than when she appears to govern her husband. If, unfortunately, the superiority of understanding is on her side, the apparent consciousness of that superiority betrays a weakness that renders her contemptible in the sight of every considerate person, and it may, very probably, fix in his mind a dislike never to be eradicated. In such a case, if it should ever be your own, remember that some degree of dissimulation is commendable, so far as to let your husband's defect appear unobserved. When he judges wrong, never flatly contradict, but lead him insensibly into another opinion, in so discreet a manner that it may seem entirely his own; and let the whole credit of every prudent determination rest on him without indulging the foolish vanity of claiming any merit to yourself. Thus a person of but an indifferent capacity may be so assisted as, in many instances, to shine with a borrowed lustre, scarce distinguishable from the native, and, by degrees, he may be brought into

a kind of mechanical method of acting properly, in all the common occurrences of life. Odd as this position may seem, it is founded in fact; and I have seen the method succesfully practised by more than one person, where a weak mind, on the governed side, has been so prudently set off as to appear the sole director; like the statue of the Delphic god, which was thought to give forth its own oracles, whilst the humble priest, who lent his voice, was by the shrine concealed, nor sought a higher glory than a supposed obedience to the power he would be thought to serve.

From hence it may be inferred, that by a perfect propriety of behaviour, ease, and contentment, at least, are attainable with a companion who has not the most exalted understanding; but then, virtue and good-nature are presupposed, or there will be nothing to work upon.

A vicious ill-natured fool being so untractable and tormenting an associate, there needs only to add jealousy to the composition, to make the curse compleat. This passion, once suffered to get footing in the heart, is hardly ever to be extirpated: it is a constant source of torment to the breast that gives it reception, and is an inexhaustible fund of vexation to the object of it. With a person of this unfortunate disposition, it is prudent to avoid the least appearance of concealment. A whisper in a mixed company, a message

given in a low voice to a servant, have, by the power of a disturbed imagination, being magnified into a material injury. Whatever has the air of secrecy raises terror in a mind naturally distrustful. A perfect unreserved openness, both in conversation and behaviour, starves the anxious expectation of discovery, and may very probably lead into an habitual confidence, the only antidote against the poison of suspicion. It is easier to prevent than remove a received ill impression; and, consequently, it is much wiser to be sometimes deficient in little points of civility, which, however indifferent in themselves, may happen unaccountably to clash with the ease of a person, whose repose it is both your duty and interest to promote. It is much more commendable, contentedly to incur the censure of a trifling disposition, by a circumstantial unasked relation of insignificant incidents, than to give any room for apprehending the least degree of reserve. Such a constant method of proceeding, together with a reasonable compliance, is the most likely to cure this painful turn of mind; for, by with-holding every support that could give strength to it, the want of matter to feed on may probably in time cause its extinction. If, unhappily, it is so constitutional, so interwoven with the soul as to become, in a manner, inseparably united with it, nothing remains but to submit patiently to the Will of Heaven, under the pressure of an unalterable evil; to guard

carefully against the natural consequence of repeated undeserved suspicions, namely, a growing indifference, which too frequently terminates in aversion; and, by considering such a situation as a trial of obedience and resignation, to receive the comfort that must arise from properly exercising one of the most exalted of the christian virtues. I cannot dismiss this subject without adding a particular caution *to yourself* concerning it.

Jealousy, is, on several accounts, still more inexcusable in a woman. There is not any thing that so much exposes her to ridicule, or so much subjects her to the insult of affrontive addresses: it is an inlet to almost every possible evil, the fatal source of innumerable indiscretions, the sure destruction of her own peace, and is frequently the bane of her husband's affection. Give not a momentary harbour to its shadow in your heart; fly from it, as from the face of a fiend, that would lead your unwary steps into a gulph of unalterable misery. When once embarked in the matrimonial voyage, the fewer faults you discover in your partner, the better. Never search after what it will give you no pleasure to find; never desire to hear what you will not like to be told; therefore avoid that tribe of impertinents, who, either from a malicious love of discord, or from the meaner, tho' less criminal motive of ingratiating themselves by gratifying the blameable curiosity of others, sow dissen-

tion wherever they gain admittance; and by telling unwelcome truths, or, more frequently, by infinuating invented falfhoods, injure innocent people, difturb domeftic union, and deftroy the peace of families. Treat thefe emiffaries of Satan with the contempt they deferve; hear not what they offer to communicate, but give them at once to underftand, that you can never look on thofe as your friends who fpeak in a difadvantageous manner of that perfon whom you would always chufe to fee in the moft favourable light. If they are not effectually filenced by fuch rebukes, be inacceffible to their vifits, and break off all acquaintance with fuch incorrigible pefts of fociety, who will be ever upon the watch to feize an unguarded opportunity of difturbing your repofe.

Should the companion of your life be guilty of fome fecret indifcretions, run not the hazard of being told by thefe malicious meddlers, what, in fact, it is better for you never to know; but if fome unavoidable accident betrays an imprudent correfpondence, take it for a mark of efteem, that he endeavours to conceal from you what he knows you muft, upon a principle of reafon and religion, difapprove; and do not, by difcovering your acquaintance with it, take off the reftraint which your fuppofed ignorance lays him under, and thereby, perhaps, give a latitude to undifguifed irregularities. Be affured, whatever accidental fallies the gaiety of inconfiderate youth may lead him into,

you can never be indifferent to him, whilft he is careful to preferve your peace, by concealing what he imagines might be an infringement of it. Reft then fatisfied, that time and reafon will moft certainly get the better of all faults which proceed not from a bad heart; and that, by maintaining the firft place in his efteem, your happinefs will be built on too firm a foundation to be eafily fhaken.

I have been thus particular on the choice of a hufband, and on the material parts of conduct in a married life, becaufe thereon depends not only the temporal, but often the eternal felicity of thofe who enter into that ftate; a conftant fcene of difagreement, of ill-nature and quarrels, neceffarily unfitting the mind for every religious and focial duty, by keeping it in a difpofition directly oppofite to that chriftian piety, to that practical benevolence and rational compofure, which alone can prepare it for everlafting happinefs.

Inftructions on this head, confidering your tender age, may feem premature, and fhould have been deferred 'till occafion called for them, had our fituation allowed me frequent opportunities of communicating my fentiments to you; but that not being the cafe, I chufe, in this epiftle, at once to offer you my beft advice in every circumftance of great moment to your well being, both here and hereafter, left at a more proper feafon it may not happen to be in my power. You may defer the particular confideration of this

part, 'till the defign of entering into a new fcene of life may make it ufeful to you; which, I hope, will not be for fome years; an unhappy marriage being more generally the confequence of a too early engagement, before reafon has gained fufficient ftrength to form a folid judgment, on which only a proper choice can be determined. Great is the hazard of a miftake, and irretrievable the effects of it! Many are the degrees between happinefs and mifery! Abfolute mifery, I will venture to affirm, is to be avoided by a proper behaviour, even under all the complicated ills of human life; but to arrive at that proper behaviour, requires the higheft degree of chriftian philofophy. And who would voluntarily put themfelves upon a ftate of trial fo fevere, in which not one of a thoufand has been found able to come off victorious? Betwixt this and pofitive happinefs there are innumerable fteps of comparative evil; each has its feparate conflict, varioufly difficult, differently painful, under all which a patient fubmiffion and a confcious propriety of behaviour is the only attainable good. Far fhort indeed of poffible temporal felicity is the eafe arifing from hence! Reft not content with the profpect of fuch eafe, but fix on a more eligible point of view, by aiming at true happinefs; and, take my word, *that* can never be found in a married ftate, without the three effential qualifications already mentioned, Virtue, Good-Nature, and Good-Senfe, in a hufband.

Remember, therefore, my dear girl, this repeated caution, if you ever resolve on marriage, never to give your hand to a man who wants either of them, whatever other advantages he may be possessed of; so shall you not only escape all those vexations which thousands of unthinking mortals hourly repent of having brought upon themselves; but, most assuredly, if it is not your own fault, you will enjoy that uninterrupted domestic harmony, in the affectionate society of a virtuous companion, which constitutes the highest satisfaction of human life. Such an union, founded on reason and religion, cemented by mutual esteem and tenderness, is a kind of faint emblem, if the comparison may be allowed, of the promised reward of virtue in a future state; and most certainly, it is an excellent preparative for it, by preserving a perfect equanimity, by keeping a constant composure of mind, which naturally lead to the proper discharge of all the religious and social duties of life, the unerring road to everlasting peace—The first have been already spoken to; it remains only to mention some few of the latter.

Amongst these Œconomy may, perhaps, be thought improperly placed; yet many of the duties we owe to society being often rendered impracticable by the want of it, there is not so much impropriety in ranking it under this head, as may at first be imagined. For instance, a man who lives at an expence

beyond what his income will support, lays himself under a necessity of being unjust, by with-holding from his creditors what they have a right to demand from him as their due, according to all laws both human and divine; and thereby he often entails ruin on an innocent family, who, but for the loss sustained by his extravagance, might have comfortably subsisted on the profits of their industry. He likewise puts it out of his own power to give that relief to the indigent, which, by the laws of humanity, they have a right to expect; the goods of fortune being given, as a great Divine excellently observes, for the use and support of others, as well as for the person on whom they are bestowed. These are surely great breaches of that duty we owe to our fellow-creatures, and are effects very frequently and naturally produced by the want of œconomy.

You will find it a very good method, so to regulate your stated expences as to bring them always one-fourth part within your certain annual income: by these means you will avoid being at any time distressed by unforeseen accidents, and you will have it more easily in your power materially to relieve those who deserve assistance. But the giving trifling sums, *indiscriminately*, to such as appear necessitous, is far from being commendable; it is an injury to society; it is an encouragement to idleness, and helps to fill the streets with lazy beggars, who live upon misap-

plied bounty, to the prejudice of the induſtrious poor. Theſe are uſeful members of the commonwealth; and on them ſuch benefactions might be ſerviceably beſtowed. Be ſparing therefore in this kind of indiſcriminate donations; they are too conſtantly an inſignificant relief to the receivers, ſuppoſing them really in want; and frequently repeated, they amount to a conſiderable ſum in the year's account. The proper objects of charity are thoſe, who, by unavoidable misfortunes, have fallen from affluent circumſtances into a ſtate of poverty and diſtreſs; thoſe alſo, who, by unexpected diſappointments in trade, are on the point of being reduced to an impoſſibility of carrying on that buſineſs, on which their preſent ſubſiſtence and their future proſpect in life depend, from the incapacity of raiſing an immediate ſum to ſurmount the difficulty; and thoſe who, by their utmoſt induſtry, can hardly ſupport their families above the miſeries of want; or who, by age or by illneſs, are rendered incapable of labour. Appropriate a certain part of your income to the relief of theſe real diſtreſſes. To the firſt, give as largely as your circumſtances will allow; to the ſecond, after the example of an excellent Prelate of our own church, lend, if it is in your power, a ſufficient ſum to prevent the threatened ruin, on condition of being repaid the loan, without intereſt, if Providence enables them, by future ſucceſs, to do it with convenience. The

same method may be used where indigence renders industry unavailable, by depriving it of the means to lay in a small original stock to be improved. Never take a note of hand or any acknowledgement of such loan, lest what you intended for a benefit should be afterwards made the instrument of ruin to the receiver, by a different disposition in your successor. But such assistance ought not to be given to any, without a thorough knowledge of their character, and from having good reason to believe them not only industrious but strictly honest, which will be a sufficient obligation on them for the repayment; and the sums so repaid ought to be laid by, 'till an opportunity again offers of making them in like manner serviceable to others. The latter sort, who are able to work, may, by a small addition to the profits of their own labour, be rescued from misery, and may be put into a comfortable way of subsistence. Those who, by age or by infirmity, are rendered utterly incapable of supporting themselves, have an undoubted right, not only to the necessaries, but even to some of the conveniencies of life from all whom Providence has placed in the more happy state of affluence and independence.

As your fortune and situation are yet undetermined, I have purposely laid down such rules as may be adapted to every station. A large fortune gives greater opportunity of doing good, and of communi-

cating happiness in a more extensive degree; but a small one is no excuse for with-holding a proportionate relief from real and deserving objects of compassion. To assist them is an indispensible duty of christianity. The first and great commandment is, To love God with all your heart; the second, To love your neighbour as yourself: *Whoso seeth his brother in need, and shutteth up his bowels of compassion, how dwelleth the love of God in him?* or how the love of his neighbour? If deficient in these primary duties, vain are the hopes of acceptance built on a partial obedience to the lesser branches of the law!—Inability is often pleaded as an excuse for the want of charity, by persons who make no scruple of daily lavishing on their pleasures, what, if better applied, might have made an indigent family happy through life. These persons lose sight of real felicity, by the mistaken pursuit of its shadow: the pleasures which engross their attention die in the enjoyment, are often succeeded by remorse, and always by satiety; whereas the true joy, the sweet complacency resulting from benevolent actions, encreases by reflection, and must be immortal as the soul. So exactly, so kindly is our duty made to coincide with our present as well as future interest, that incomparably more satisfaction will accrue to a considerate mind from denying itself even some of the agreeables of life, in order the more effectually to relieve the unfortunate, than could arise

ADVICE TO HER DAUGHTERS.

from a full indulgence of every temporal gratification.

However small your income may be, remember that a part of it is due to merit in distress. Set by an annual sum for this purpose, even though it should oblige you to abate some unnecessary expence to raise the fund: By this method persons of slender fortune have been enabled to do much good, and to give happiness to many. If your stock will not admit of frequent draughts upon it, be the more circumspect with regard to the merit of those you relieve, that bounties not in your power to repeat often, may not be misapplied. But if Providence, by a more ample fortune, should bless you with a larger ability of being serviceable to your fellow-creatures, prove yourself worthy of the trust reposed in you by making a proper use of it. Wide as your influence can extend, turn the cry of distress and danger into the song of joy and safety; feed the hungry, clothe the naked, comfort the afflicted, give medicine to the sick, and, with either, bestow all the alleviation their unfortunate circumstances can admit of. Thus may you truly make a friend of the unrighteous Mammon. Thus you may turn the perishable goods of fortune into everlasting blessings. Upon earth you will partake that happiness you impart to others, and you will lay up for yourself *Treasures in Heaven, where*

neither moth nor ruſt can corrupt, and where thieves do not break through nor ſteal.

A perſon who has once experienced the advantages of a right action, will be led by the motive of preſent ſelf-intereſt, as well as by future expectation, to the continuance of it. There is no injunction of chriſtianity that a ſincere chriſtian, by obedience, will not find ſo calculated as to be directly, in ſome meaſure, its own reward.

The forgiveneſs of injuries, to which is annexed the promiſe of pardon for our own offences, and which is required by the goſpel, not only ſo far as to forbear all kinds of retaliation, but alſo to render us equally diſpoſed to ſerve with our utmoſt power thoſe perſons who have wilfully injured us, as if no ſuch injury had been received from them, has by ſome been accounted a hard precept; yet the difficulty of it ariſes merely from, and is proportionable to, the badneſs of the heart by which it is ſo eſteemed. A good diſpoſition finds a ſuperlative pleaſure in returning good for evil; and, by an inexpreſſible ſatisfaction of mind in ſo doing, feels the preſent reward of obedience: whereas a ſpirit of revenge is incompatible with happineſs, an implacable temper being a conſtant torment to its poſſeſſor; and the man who returns an injury, feels more real miſery from the rancour of his own heart, than it is in his power to inflict upon another.

Should a friend wound you in the moſt tender part, by betraying a confidence repoſed, prudence forbids the expoſing yourſelf to a ſecond deception, by placing any future truſt in ſuch a perſon. But though here all obligations of intimacy ceaſe, thoſe of benevolence and humanity remain ſtill in full force, and are equally binding, alſo every act of ſervice and aſſiſtance, even to the ſuffering a leſſer evil yourſelf, in order to ſecure a much greater good to the perſon by whom you have been thus ill-uſed. This is in general allowed to be the duty of every individual to all, as a member of ſociety; but it is particularly inſtanced in the preſent caſe to ſhew, that not even a breach of friendſhip, the higheſt of all provocations, will cancel the duty, at all times equally and unalterably binding—the duty of promoting both the temporal and eternal happineſs of all your fellow-creatures by every method in your power.

It has been by many thought impertinent at any time to offer unaſked advice; the reaſon of which may be chiefly owing to its being too frequently tendered with a ſupercilious air that implies a conceited conſciouſneſs of ſuperior wiſdom: it is the manner, therefore, more than the thing itſelf which gives diſguſt.

If thoſe with whom you have any degree of intimacy are guilty of what to you appears either wrong or indiſcreet, ſpeak your opinion to them with free-

dom, though you should even lose a nominal friend by so doing. Silence makes you, in some measure, an accessary to the fault; but having thus once discharged your duty, rest there—they are to judge for themselves: to repeat such admonitions is both useless and impertinent, and they will then be thought to proceed rather from pride than from good nature. To the persons concerned only are you to speak your disapprobation of their conduct: when they are censured by others, say all that truth or probability will permit in their justification.

It often happens, that upon an accidental quarrel between friends, they separately appeal to a third person. In such case, alternately take the opposite side, alledging every argument in favour of the absent party, and placing the mistakes of the complainer in the strongest light. This method may probably at first displease, but is always right, as it is the most likely to procure a reconciliation. If that takes place, each, equally obliged, will thankfully approve your conduct: if not, you will have the satisfaction of, at least, endeavouring to have been the restorer of peace. A contrary behaviour, which generally proceeds from the mean desire of pleasing by flattery at the expence of truth, often widens a trifling breach into open and irreconcileable enmity. People of this disposition are the worst sort of incendiaries, the greatest plague of human society, because the most difficult to be

guarded againſt, from their always wearing the ſpecious diſguiſe of pretended approbation and friendſhip to the preſent, and equally deceitful reſentment againſt the abſent perſon or company.

To enumerate all the ſocial duties would lead me too far; ſuffice it, therefore, my dear, in few words to ſum up what remains.

Let truth ever dwell upon your tongue.

Scorn to flatter any, and deſpiſe the perſon who would practiſe ſo baſe an art upon yourſelf.

Be honeſtly open in every part of your behaviour and converſation.

All, with whom you have any intercourſe, even down to the meaneſt ſtation, have a right to civility and good-humour from you. A ſuperiority of rank or fortune is no licence for a proud ſupercilious behaviour: the diſadvantages of a dependent ſtate are alone ſufficient to labour under; 'tis both unjuſt and cruel to encreaſe them, either by a haughty deportment, or by the unwarrantable exerciſe of a capricious temper.

Examine every part of your conduct towards others by the unerring rule of ſuppoſing a change of places. This will certainly lead to an impartial judgment. Do then what appears to you right, or in other words, *what you would they ſhould do unto you;* which comprehends every duty relative to ſociety.

Aim at perfection, or you will never reach to an attainable height of virtue.

Be religious without hypocrisy, pious without enthusiasm.

Endeavour to merit the favour of God by a sincere and uniform obedience to whatever you know, or believe, to be his will; and should afflictive evils be permitted to cloud the sun-shine of your brightest days, receive them with submission; satisfied that a Being equally wise, omniscient, and beneficent, at once sees and intends the good of his whole creation; and that every general or particular dispensation of His providence towards the rational part of it, is so calculated as to be productive of ultimate happiness, which nothing but the misbehaviour of individuals can prevent to themselves.

This truth is surely an unanswerable argument for absolute resignation to the Will of God; and such a resignation, founded upon reason and choice, not enforced by necessity, is unalterable peace of mind, fixed on too firm a basis to be shaken by adversity. Pain, poverty, ingratitude, calumny, and even the loss of those we hold most dear, may each transiently affect, but united cannot mortally wound it. Upon this principle, you will find it possible not only to be content, but cheerful, under all the disagreeable circumstances this state of probation is liable to; and, by making a proper use of them, you may effectually

remove the garb of terror from the laſt of all temporal evils. Learn then, with grateful pleaſure, to meet approaching death as the kind remover of every painful ſenſation, the friendly guide to perfect and to everlaſting happineſs.

Believe me this is not mere theory. My own experience every moment proves the fact undeniably true. My conduct in all thoſe relations which ſtill ſubſiſt with me, nearly as human imperfection will allow, is governed by the rules here laid down for you; and it produces the conſtant rational compoſure which conſtitutes the moſt perfect felicity of human life: for with truth I can aver, that I daily feel incomparably more real ſatisfaction, more true contentment in my preſent retirement, than the gayeſt ſcenes of feſtive mirth ever afforded me. I am pleaſed with this life, without an anxious thought for the continuance of it, and am happy in the hope of hereafter exchanging it for a life infinitely better. My ſoul, unſtained by the crimes unjuſtly imputed to me, moſt ſincerely forgives the malicious authors of theſe imputations; it anticipates the future pleaſure of an open acquittal, and in that expectation loſes the pain of preſent undeſerved cenſure. By this is meant the inſtance that was made the ſuppoſed foundation for the laſt of innumerable injuries which I have received through him from whom I am conſcious of having deſerved the kindeſt treatment. Other faults, no

doubt, I might have many; to him I had very few: nay, for several years, I cannot, upon reflection, accuse myself of any thing but of a too absolute, too unreserved obedience to every injunction, even where plainly contrary to the dictates of my own reason. How wrong such a compliance was, has been clearly proved by many instances, in which it has been since most ungenerously and most ungratefully urged as a circumstantial argument against me.

It must indeed be owned, that for the two or three last years, tired with a long series of repeated insults, of a nature almost beyond the power of imagination to conceive, my temper became soured: a constant fruitless endeavour to oblige was changed into an absolute indifference about it; and ill humour, occasioned by frequent disappointment—a consequence I have experimentally warned you against—was perhaps sometimes too much indulged. How far the unequalled provocations may be allowed as an excuse for this, Heaven only must determine, whose goodness has thought fit to release me from the painful situation; though by a method, at present, not the most eligible, as it is the cause of a separation *from my children also,* and thereby has put it out of my power to attend in the manner I could have wished to their education; a duty that inclination would have led me with equal care and pleasure more amply to fulfill, had they continued under my

direction. But as Providence has thought fit otherwise to determine, contented I submit to every dispensation, convinced that all things are ordered for the best, and that they will in the end work together for good to them that fear GOD, and who sincerely endeavour to keep his commandments. If in these I err, I am certain it is owing to a mistake in the judgement, not to a defect of the will.

Thus have I endeavoured, my dear girl, in some measure, to compensate both to you and to your sisters the deprivation of a constant maternal care, by advising you, according to my best ability, in the most material parts of your conduct through life, as particularly as the compass of a letter would allow me. May these few instructions be as serviceable to you as my wishes would make them! and may that Almighty Being, to whom my daily prayers ascend for your preservation, grant you His heavenly benediction! May he keep you from all moral evil, lead you into the paths of righteousness and peace, and may He give us all a happy meeting in that future state of unalterable felicity, which is *prepared for those who, by patient continuance in well-doing, seek after glory and immortality!*

ADVICE

OF A

MOTHER

TO

HER DAUGHTER.

BY THE
MARCHIONESS DE LAMBERT.

" —— The dearest task a parent knows."
<div align="right">CARTWRIGHT.</div>

——DUBLIN;——
PRINTED BY GRAISBERRY AND CAMPBELL,
FOR JOHN ARCHER, NO. 80, DAME-STREET,
1790.

ADVICE

OF A

MOTHER

TO

HER DAUGHTER.

―――――――――

THE world has in all ages been very negligent in the education of daughters; all their care is laid out entirely upon the men; and as if the women were a diſtinct ſpecies, they leave them to themſelves without any helps, without thinking that they compoſe one half of the world; that the two ſexes are neceſſarily united together by alliances; that the women make either the happineſs or miſery of the men, who always feel the want of having them reaſonable; that they are a great means of the riſe and ruin of families;

that they are entrusted with the education of the children in their early youth, a season of life in which they receive the liveliest and deepest impressions. What would they have them inspire into their children, when from their very infancy they are left themselves in the hands of governantes, who, as they are generally taken out of the low world, inspire them with low sentiments, encourage all the timorous passions, and form them to superstition instead of religion. 'Twould be a subject worthier of their thoughts to contrive how to make certain vices hereditary to their families, by conveying them down from the mother to the children, than how to secure their estates by entails. Nothing therefore is so much mistaken as the education which they give to young women: they design them to please; they give them no instructions but for the ornament and graces of the body; they flatter their self-love; they give them up to effeminacy, to the world, and to false opinions; they give them no lectures of virtue and fortitude: surely it is unreasonable or rather downright madness to imagine that such an education should not turn to their prejudice.

It may be necessary, my Daughter, to observe all the outward rules of *Decorum;* but this is not enough to gain you the esteem of the world; 'tis the sentiments of the mind that form the character of a person; that lead the understanding; that govern the

TO HER DAUGHTER.

will; that secure the reality and duration of all our virtues: but religion should be the principle and foundation of these sentiments. When religion is once engraven on our heart, all the virtues will naturally flow from that source; all the duties of life will be regularly practised in their respective order. 'Tis not enough for the conduct of young persons to oblige them to do their duty; they must be brought to love it. Authority is a tyrant only over the outward behaviour, it has no sway over the inward sentiments. When one prescribes a conduct, we should represent the reasons and the motives of it, and give them a relish for what we advise them.

'Tis so much for our interest to practise virtue, that we should never consider it as our enemy, but rather as the source of happiness, of glory, and of peace.

You are just coming into the world; enter it, my daughter, with some principles; you cannot fortify yourself too much against what you will meet with there: bring along with you all your religion: nourish it in your heart by your sentiments; confirm it in your mind by proper reflections, and by reading adapted to encourage it.

There is nothing more necessary, and indeed more happy for us than to keep up a sentiment that makes us love and hope; that gives us a prospect of an agreeable futurity; that reconciles all times; that

infures all the duties of life; that anfwers for us to ourfelves, and is our guarantee with regard to others. What a fupport will you find from religion under the misfortunes that threaten you! for a certain number of misfortunes muft fall to your fhare. 'Twas a faying of one of the Antients, " That he wrapped himfelf up in the mantle of his Virtue:" Wrap yourfelf up in that of your Religion; it will be a great help to you againft the weaknefs of youth, and a fure refuge in your riper years.

Women that have cultivated all their underftanding with nothing but the maxims of the world, are prefented at laft with an univerfal blank, and find themfelves in a terrible want of thought and employment, the moft irkfome fituation in life. As they advance in age the world quits them, and reafon tells them they fhould quit the world; but where muft they go for relief? The time paft furnifhes us with regrets, the prefent with inquietudes, and the time to come with fears. Religion alone calms all our uneafinefs, and comforts us under all misfortunes; by uniting you to God, it reconciles you with the world, and yourfelf too.

A young perfon when fhe comes into the world frames to herfelf an high notion of the happinefs referved for her. She fets herfelf to obtain it; 'tis the fource of all her cares. She is always on the hunt

after her notion, and in hopes of finding a perfect happiness: this is the occasion of lightness and inconstancy.

The pleasures of the world are deceitful; they promise more than they perform; the quest of them is full of anxiety: their enjoyment is far from yielding any true satisfaction, and their loss is attended with vexation.

To fix your desires, think that no solid or lasting happiness is to be found any where but in your own breast. Honours and riches have no charms that are lasting for any length of time; their possession extends our view, and gives us new desires. Pleasures when they grow familiar, lose their relish. Before you have tasted them, you may do without them; whereas enjoyment makes that necessary to you, which was once superfluous, and you are worse at your ease than you were before; by enjoying them you grow used to them, and when you lose them, they leave you nothing but emptiness and want. What affects us sensibly is the passage from one circumstance of life to another; the interval between a miserable season and a happy one. The sense of pleasure wears off as soon as we grow habituated to it. 'Twould be a great advantage if reason could at once lay before us all that is necessary for our happiness. Experience brings us back to ourselves; spare yourself that expence, and lay it early down for a maxim, with a

firmnefs and refolution to determine your conduct, that "true felicity confifts in peace of mind, in reafon, and in the difcharge of our duty." Let us not fancy ourfelves happy, my Daughter, till we feel our pleafures of this fort flow from the bottom of our foul.

These reflections seem too ftrong for a young perfon, and are proper for a riper age: however, I believe you capable of them; and befides, I am inftructing myfelf. We cannot engrave the precepts of wifdom too deeply in our hearts; the impreffions that they make are always too light; but it can't be denied that fuch as ufe themfelves to make reflections, and fortify their hearts with principles, are in a fairer way to virtue than fuch as neglect them. If we are unhappy enough to be defective in the practice of our duty, let us at leaft not be wanting in our affections to it: let us then, my Daughter, make ufe of thefe precepts for a continual help to our virtue.

'Tis commonly faid there are two prejudices with which every body muft comply: Religion and Honour. 'Tis a wrong expreffion to call Religion a prejudice. A prejudice is an opinion that may be fubfervient to error as well as truth; the term ought never to be applied but to things that are uncertain; and Religion is not fo.

Honour is indeed an invention merely human; yet nothing is more real than the evils that people fuffer

who would get rid of it; 'twould be dangerous to shake it off; we should rather do all we can to fortify a sentiment that ought to be a rule to our conduct, since nothing is more destructive of our quiet, or makes our life more unequal, than to think one way and act another. Possess your heart as much as is possible with sentiments for the conduct that you ought to observe; fortify this prejudice of Honour in your mind; you cannot be too scrupulously nice on this subject.

Never warp in the least from these principles; never entertain a notion, as if the virtue of women was a virtue only enjoined by custom; nor allow yourself to think you have sufficiently discharged your obligations, if you can but escape the eyes of the world. There are two courts before which you must inevitably appear in judgment, your Conscience and the World; you may possibly get clear of the World, but you can never get clear of Conscience. Secure her testimony in favour of your honesty; 'tis what you owe to yourself; but withal do not neglect the approbation of the public, for a contempt of reputation naturally leads to a contempt of virtue.

When you are a little acquainted with the world, you will find that there is no need of the sanctions and terror of laws to keep you within the bounds of your duty; the example of such as have deviated from it, and the calamities that have ever attended them,

is enough to ſtop any inclination in the midſt of its career; for there is no coquet but muſt own, if ſhe would be ſincere, that is is the greateſt misfortune in the world to be forgot and neglected.

Shame is a paſſion that might be of excellent advantage to us, if we managed it well: I do not mean that falſe ſhame which only ſerves to diſturb our quiet, without being of any ſervice to our behaviour; I ſpeak of that which keeps us from evil out of fear of diſhonour: we muſt confeſs this ſhame is ſometimes the ſureſt guard of the women's virtue; there are very few virtuous for virtue itſelf.

There are ſome great virtues, which, when they are carried to a certain degree, make a great many defects be over-looked; ſuch as extraordinary valour in the men, and extreme modeſty in the women. Agrippina, the wife of Germanicus, was excuſed of all her faults on account of her chaſtity. This Princeſs was ambitious and haughty; but, ſays Tacitus, " all her paſſions were conſecrated by her chaſ-" tity."

If you are ſenſible and nice in the point of reputation, if you are apprehenſive of being attacked as to eſſential virtues, there is one ſure means to calm your fears and ſatisfy your nicety; 'tis to be virtuous. Be ſure always to keep well with yourſelf; 'tis a ſure income of pleaſures; and will gain you praiſe, and

a good reputation to boot; in a word, be but truly virtuous, and you'll find admirers enough.

The virtues that make a figure in the world do not fall to the women's share; there virtues are of a simple and peaceable nature: Fame will have nothing to do with us. 'Twas a saying of one of the Antients, that " the great virtues are for the men!" he allows the women nothing but the single merit of being unknown; and " such as are most praised, " (says he) are not always the persons that deserve " it best; but rather such as are not talked of at all." The notion seems to me to be wrong; but to reduce this maxim into practice, I think it best to avoid the world, and making a figure, which always strike at modesty, and be contented with being one's own spectator.

The virtues of the women are difficult, because they have no help from glory to practise them. To live at home; to meddle with nothing but one's self and family; to be simple, just, and modest, are painful virtues, because they are obscure. One must have a great deal of merit to shun making a figure, and a great deal of courage to bring one's self to be virtuous only to one's own eyes. Grandeur and reputation serve for supports to our weakness, for such in reality is our desire to distinguish and raise ourselves. The mind rests in the public approbation, but true glory consists in being satisfied without it. Let it not enter

then into the motives of your actions; 'tis enough that it is the recompence of them.

Be assured, my Daughter, that perfection and happiness cling together; that you can never be happy but by virtue, and scarce ever unhappy but by ill conduct. Whoever examines themselves strictly, will find that they never had any grievous affliction, but they occasioned it themselves by some fault, or by being wanting in some duty. Anxiety always follows the loss of innocence; but virtue is ever attended with an inward satisfaction, that is a constant spring of felicity to all its votaries.

Do not however imagine that your only virtue is modesty; there are abundance of women that have no notion of any other, and fancy, that by practising it they discharge all the duties of society: they think they have a right to neglect all the rest, and to be as proud and censorious as they please. Anne of Bretagne, a proud and imperious Princess, made Lewis XII suffer exceedingly; and the good Prince was used to say, when he submitted to her humour, "we must pay dear for the women's chastity." Make nobody pay for yours; think rather that it is a virtue which regards only yourself, and loses its greatest lustre, if it be not attended with the other virtues.

We should be very tender in our modesty; inward corruption passes from the heart to the mouth,

and occasions loose discourse. The most violent passions have need of modesty to shew themselves in a seducing form; it should distinguish itself in all your actions; it should set off and embellish all your person.

They say that when Jove formed the passions, he assigned every one of them its distinct abode. Modesty was forgot; and when she was introduced to him, he could not tell where to place her: she was therefore allowed to consort with all the rest. Ever since that time she is inseparable from them; she is the friend of Truth, and betrays the lie that dares attack it; she is in a strict and intimate union with Love; she always attends, and frequently discovers and proclaims it: Love, in a word, loses his charms, whenever he appears without her; there is not a more glorious ornament for a young lady than modesty.

Let the chief part of your finery then be modesty it has great advantages; it sets off beauty, and serves for a veil to uglinesss: modesty is the supplement of beauty. The great misfortune of ugliness is, that it smothers and buries the merit of women. People do not go to look in a forbidding figure for the engaging qualities of the mind and heart; 'tis a very difficult affair when merit must make its way, and shine through a disagreeable outside.

You do not want Graces to make you agreeable, but you are no Beauty: this obliges you to lay up a

stock of merit: the world will compliment you with nothing. Beauty has great advantages. One of the Antients said of it, that it was "a short tyranny, and the greatest privilege in Nature; that handsome persons carry letters of recommendation in their looks."

Beauty inspires a pleasing sentiment which prepossesses people in its favour. If you have made no such impressions, you must expect to be taken to pieces. Take care that there be nothing in your air or manners to make any body think that you do not know yourself: an air of confidence in an ordinary figure is shocking enough. Let nothing in your discourse or dress look like art, at least let it not be easy to find it out; the most refined art never lets itself be seen.

You are not to neglect the accomplishments and ornaments proper to make you agreeable, for women are designed to please; but you should rather think of acquiring a solid merit, than of employing yourself in trifling things. Nothing is shorter than the reign of beauty; nothing is more melancholy than the latter part of the lives of women who never knew any thing but that they were handsome. If any body makes their court to you for the sake of your agreeable accomplishments, make their regards center in friendship, and secure the continuance of that friendship by your merits.

'Tis a difficult matter to lay down any sure rules to please. The Graces without merit cannot please long; and merit without the Graces may command the esteem of men, but can never move them. Women therefore must have an amiable merit, and join the Graces to the Virtues. I do not confine the merit of women merely to modesty; I give it much a larger extent. A valuable woman exerts the manly virtues of friendship, probity, and honour, in the punctual discharge of all her obligations. An amiable woman should not only have the exterior graces, but all the graces of the heart and fine sentiments of the mind. There is nothing so hard as to please without being so intent upon it, that it shall look a little like coquetry. Women generally please the men of the world more by their faults than their good qualities. The men are for making their advantages of the weaknesses of amiable women: they would have nothing to do with their virtues; they do not care to esteem them; they had much rather be amused by persons of little or no merit, than be forced to admire such as are virtuous.

One must know human nature if one designs to please. The men are much more affected with what is new, than with what is excellent: but the flower of novelty soon fades; what pleased when it was new, soon displeases when it grows common. To keep up this taste of novelty, we must have a great many

resources and various kinds of merit within ourselves; we must not stick only at the agreeable accomplishments: we must strike their fancy with a variety of graces and merits to keep up their inclinations, and make the same object afford them all the pleasures of inconstancy.

Women are born with a violent desire to please; as they find themselves barred from all the ways that lead to glory and authority, they take another road to arrive at them, and make themselves amends by their agreeableness. Beauty imposes on the person that has it, and infatuates the soul; yet remember that there is but a very small number of years difference between a fine woman and one that is no longer so. Get over this excessive desire to please; at least keep from shewing it. We must not be extravagant in our dress, or let it take up all our time; the real Graces do not depend on a studied finery; we must submit to the mode as a troublesome sort of slavery, but comply with it no more than we are obliged in decency. The mode would be reasonable if it could be fixed to a point of perfection, convenience, and gracefulness; but to be always changing is inconstancy, rather than politeness and a good taste.

A good taste avoids all excessive niceness; it treats little things as little ones, and gives itself very little trouble about them. Neatness is indeed agreeable, and deserves to be ranked among things that are graceful,

but it commences littleness, when it is carried to an excess; it is a much better temper to be careless in things of little consequence than to be too nice about them.

Young persons are very subject to the spleen; as they are quite destitute of knowledge, they run with eagerness towards sensible objects; the spleen, however, is the least evil they have to dread: excessive joys are no part of the train of virtue. All violent and moving pleasures are dangerous. Though one is discreet enough not to break through the rules of decency, and to keep within the bounds of modesty; yet when the heart is once moved with the pleasure it feels, a sort of softness diffuses itself over the soul, and takes away its relish for every thing that is called virtue: it stops and makes you cool in the practice of your duty. A young person does not see the consequences of this flattering poison, the least mischief of which is to disturb the quiet of life, to deprave the taste, and render all simple pleasure insipid. When one sees a young person happy enough not to have had her heart touched (as there is a natural disposition in us to a union, and this disposition has not been exercised), she easily complies, and gives herself naturally to the person designed for her.

Be very cautious on the article of plays, and the like public diversions. There is no dignity in shewing one's self continually, nor is it an easy matter to

preserve a ſtrict modeſty in a conſtant hurry of diverſions. It is miſtaking one's intereſt to frequent them: if you have beauty, you muſt not wear out the taſte of the world by ſhewing yourſelf continually: you muſt be ſtill more reſerved if you want graces to ſet you off; beſides, the conſtant uſe of diverſions leſſens the reliſh of them.

When all your life has been ſpent in pleaſures, and they come to leave you, either becauſe your taſte for them is over, or becauſe your reaſon forbids you the enjoyment of them, your mind finds itſelf in a moſt uneaſy ſituation for want of employment. If you would therefore have your pleaſures and amuſements laſt, uſe them only as diverſions to relieve you after more ſerious occupations. Entertain yourſelf with your own reaſon; keep up that correſpondence, and the abſence of pleaſures will not leave you any time upon your hands, nor any hankering after them.

It behoves us therefore to huſband our taſtes; there is no reliſhing life without them, but innocence only can preſerve them in their integrity; irregularity is ſure to deprave them.

When we have found a heart, we make an advantage of every thing, and turn it into a ſource of pleaſure. We come frequently to pleaſures with a ſick's man's palate: we fancy ourſelves nice, when we are only ſurfeited and out of taſte. When we

have not spoiled our mind and heart by sentiments that seduce the fancy, or by any flaming passion, it is easy to find delight: health and innocence are the true fountains of joy. But when we have had the misfortune to habituate ourselves to vehement pleasures, we become insensible to moderate ones. We spoil our taste by diversions, and use ourselves so much to violent pleasures, that we cannot take up with such as are simple and regular.

We should always dread such great emotions of the soul as leave us flat and out of sorts. Young persons have the greater reason to fear them, in that they are less capable of resisting what flatters their sense. " Temperance," said one of the Antients, " is the best caterer for luxury." With this temperance, which makes the health both of mind and body, one has always a pleasing and an equal joy; one has no need of diversions and expence; reading, work, and conversation, afford a purer joy than all the train of the greatest pleasures. In a word, innocent delights are of most advantage; they are always ready at hand; they are beneficent, and are never purchased at too dear a rate. Other pleasures flatter, but they do mischief: they alter the constitution of the mind, and spoil it like that of the body.

Be regular in all your views and in all your actions; it would be happy if our fortune was such as

to make computations of our income unneceffary; but as yours is narrow, it obliges us to be regular. Be difcreet in the article of your expences; if you do not obferve a moderation in them, you will foon fee your affairs in diforder; as foon as you lay afide œconomy, you can anfwer for nothing.

Pompous living is the high road to ruin, and the ruin of people's fortune is almoft always followed with corruption of manners: but in order to be regular, it is no way neceffary to be covetous. Remember that avarice is of little fervice, and difhonours a perfon infinitely. All that one fhould aim at in a regular management, is to avoid the fhame and injuftice that always attend an irregular conduct. We muft retrench fuperfluous expences only to be in a better condition to afford fuch as decency, friendfhip and charity engage us to make.

It is good order, and not the looking into little matters, that turns to any great account. Pliny, when he fent his friend back a bond for a confiderable fum which his father owed him, with a general acquittance, told him, " I have but a fmall eftate, " and am obliged to be at great expences; but my " frugality ferves for a fund to fupply me wherewith " to do the fervice that I render to my friends." Borrow from your fancies and diverfions, that you may have fomething to gratify the fentiments of ge-

nerofity, which every perfon of a genteel fpirit ought to have.

Never mind the wants that vanity creates. "We "muft be," they fay, "like others;" this *like* goes a vaft way. Have a nobler emulation, and allow nobody to have more honour, probity, and integrity than yourfelf. Be always fenfible of the neceffity of virtue: poornefs of foul is worfe than poverty of fortune.

Whilft you are young, form your reputation, raife your credit: put your affairs in order: you would have more trouble about it in another feafon of life. Charles the Fifth ufed to fay, that "Fortune loved "young folks." In the time of youth, all the world offer themfelves to you, and lend you a helping hand: young people govern without thinking of it. But in more advanced age, you have no helps from any quarter; you have no longer that bewitching charm which has an influence on every body: you have nothing for you but reafon and truth, which do not ordinarily govern the world.

"You are going," faid Montagne to fome young people, "towards reputation and credit; but I am "returning back." When you ceafe to be young, you have no acquifition left you to make, but in point of virtue. In all your undertakings and actions, always aim at the higheft perfection; form no project, and fet about nothing without faying to yourfelf,

"Could not I do better?" By this means you will insensibly contract a habit of justice and virtue, which will make the practice thereof easier to you. Do what Seneca advised his friend Lucilius: "Choose," said he to him, "among great men "some one that you think is most to be admired: "do nothing but in his presence; give him an account "of all your actions." Happy the man that is esteemed enough to be pitched on for this purpose! This is the more easy, because young folks have a natural disposition to imitation. They run less hazard when they choose their patterns from antiquity, where we generally meet with none but great examples. Among the moderns it may have its inconveniences; the copies of them very rarely succeed. It has been said long ago, that every copy ought to tremble before its original; they never follow it but at a distance; and yet it takes away your natural character, which is generally the truest and the most simple. You are apt to grow negligent as to yourself, when you fix yourself to a model; besides, a great part of our faults come from imitation. Learn then to reverence and stand in awe of yourself: let your scrupulousness be your own censor.

Use all your application to make yourself happy in your station of life; improve all the means you have; you lose a thousand advantages for want of it. It

is our attention, and comparing of things, that makes us happy.

The more addrefs and capacity you have, the more will you make of your circumstances, and the more will you extend your pleasures. It is not possession that makes us happy, it is enjoyment, and enjoyment lies in attention.

If people knew how to hug and enjoy themselves in their condition, they would not be troubled either with ambition or envy, and would be blessed with a perfect tranquillity; but we do not live enough in the present moment, our desires and hopes are always pushing us on towards futurity.

There are two sorts of madmen in the world; the one always live upon futurity, and feed themselves with nothing but hopes; and as they are not wise enough to calculate them rightly, they pass their lives in a continual mistake. Reasonable persons are never taken up with any desires but such as are within their reach; they often gain their point, and though they should be mistaken, they would easily console themselves under the disappointment, they know likewise that our fondness for things wears off upon the possession of them, or ceases upon seeing the impossibility of obtaining what we desire: wise men always make themselves easy with such reflections. There is another sort of madmen that make too much of the present, and take no manner of care for futurity;

they ruin their fortune. their reputation, and their taste of life, by not managing them discreetly. Men of sense join these two times together; they enjoy the present, and yet do not neglect the future.

It is a duty, my Daughter, to employ our time, but what use do we make of it? Few people know how to value it as it deserves. "Account to your- "self," says one of the Antients, "for every mo- "ment of your time; that after making a just use of "the present, you may have less occasion for the "future." Time flies with rapidity: learn to live, that is, to make a good use of your time; but life is spent too often in vain hopes, in quest of fortune, or in waiting for it. All mankind feel the vanity of their condition, always taken up without being ever satisfied. Remember that life does not consist in the space of time that you live, but in the use you should make of it: consider that you have a mind to cultivate and feed with truth; a heart to purify and regulate; and a religious worship to pay to the Deity.

As the first years of life are precious, remember, Daughter, to make an advantageous use of them. Whilst the mind easily receives impressions, embellish your memory with valuable things, and consider that you are laying in a provision for your whole life. The memory is formed and improved by exercising it.

Curiosity is a sentiment that you should not stifle, it wants only to be managed, and placed on a right

object. Curiosity is a knowledge begun, which makes you advance farther and quicker in the road of truth; it is a natural disposition that meets instruction half-way; it should not be stopped by laziness and love of ease.

It is very useful for young persons to employ their time in solid sciences; the Greek and Roman History elevate the mind, and raises the courage by the great actions that we see there related. We ought to know the History of France; nobody should be ignorant of the history of their own country. I should not even blame a little philosophy, especially the new, if one has a capacity for it: it helps to give you a clear judgment, to distinguish your ideas, and teach you to think justly. I would likewise have a little morality: by the bare reading of Cicero, Pliny, and others, one gets a taste for virtue: it makes an insensible impression on us, that is of great advantage to our morals. The inclination to vice is corrected by the example of so many virtues, and you will rarely find an evil disposition have any relish for this sort of reading. We do not love to see what is always upbraiding and condemning us.

As for languages, though a woman ought to be satisfied with speaking that of her own country, I should not thwart the inclination one might have for Latin. It is the language of the Church: it opens you a gate to all the sciences: it lets you into conver-

sation with the best part of the world in all ages. Women are ready enough to learn Italian; but I think it dangerous; it is the language of love: the Italian writers are not very correct; you see in all their works a gingle of words, and a loose imagination inconsistent with a just way of thinking.

Poetry may produce some inconveniences; I should however be loth to forbid the reading of the fine tragedies of Corneille: but the best of them often give you lectures of virtue, and leave you an impression of vice.

The reading of romances is still more dangerous: I would not have them much used; they inure the mind to falshoods. Romances having no foundation of truth to support them, warm the imagination, impair modesty, put the heart in disorder, and let a young person have but the least disposition to tenderness, they hurry on and fire her inclination. One should not increase the charms and delusions of love; the more it is softened, and the more modest it appears, the more dangerous it is. I would not forbid them; all prohibitions intrench upon liberty, and raise the desire: but we should, as much as we are able, use ourselves to solid readings, which improve the understanding and fortify the heart: we cannot too carefully avoid such as leave impressions hard to be effaced.

Moderate your fondness for extraordinary sciences; they are dangerous, and generally teach one nothing but a vast deal of vanity: they depress the activity of the soul. If you have a very warm and active imagination, and a curiosity which nothing can stop, it is much better to employ these dispositions in the sciences, than to run the hazard of their being turned to serve your passions: but remember, that a young lady should have almost as nice a modesty in the article of sciences, as she has with regard to vice.

Guard yourself therefore against the inclination of setting up for a virtuoso; do not amuse yourself in running after vain sciences, and such as are above your reach. Our soul is much better qualified for enjoyment than it is for knowledge; we have all the knowledge that is proper and necessary for our well being; but we will not stick there, we are still running after truths that were not designed for us.

Before we engage in enquiries that are above our capacities, we should know the just extent of our understanding, and what rule we should have for determining our persuasion: we should learn to distinguish between opinion and knowledge, and should have resolution enough to doubt, when we have no clear notion of things, as well as courage to be ignorant of what surpasses us.

The better to prevent a vain opinion of our capacity, and abate a confidence in our understanding,

let us consider that the two principles of all our knowledge, reason and the senses, want sincerity, and often deceive us. The senses impose on reason, and reason misleads them in its turn. These are our two guides, and both of them lead us out of the way. Such reflections should naturally put us out of conceit with abstracted sciences; it is much better for us to employ our time in useful points of knowledge.

Docility is a quality very necessary for a young person, who should never have much confidence in herself: but this docility must not be carried too far. In point of religion, indeed, it must submit to authority; but on any other subject it must receive nothing but from reason and evidence. By carrying docility too far, you do an injury to your reason; you make no use of your own judgment and understanding, which are impaired for want of exercise. You set too narrow bounds to your ideas, when you confine them to to those of other people. The testimony of men only deserves credit in proportion to the degree of certainty which they have acquired by examining into facts. There lies no prescription against truth: it is for all persons and of all times. In a word, as a great man says, " To be a Christian, one must be" lieve implicitly: but to be a wise man, one must " see clearly."

Accustom yourself to exercise your understanding, and make more use of it than of your memory. We

fill our heads with the notions of other people, and take no care to form any of our own. We fancy that we have made a great progress, when we load our memory with histories and facts; but this is of very little service to perfect our understanding. We must use ourselves to thinking. The understanding extends and improves itself by exercise; yet few persons take care to exert it.

Among our sex the art of thinking is a sort of dormant talent. Historical facts, and the opinions of philosophers, will not defend you against a calamity that presses you: you will not find yourself much the stronger for them. When an affliction comes upon you, you have recourse to Seneca and Epictetus: Is it for their reason to give you consolation? Is it not rather the business of your own? Make use of your own stock; in the calm of life make a proper provision against the time of affliction, which you are sure to meet with: you will find yourself much better supported by your own reason than by that of other people.

If you can govern your imagination, and make it submit to reason and truth, it will be a great step towards your perfection and happiness. Women are generally governed by their imagination; as they are not employed in any thing solid, and are not in the course of their lives troubled either with the care of their fortune, or the management of their affairs,

K

they give themselves up entirely to their pleasures. Plays, dress, romances, and inclinations, all depend upon imagination. I know well enough that if you keep it within due bounds, you take so much off from your pleasures; for Imagination is the source of them; and the things that please us most, derive from her the charm and illusion in which all their agreeableness consists: but for one pleasure of her creating, what evils doth she not make us suffer? She stands continually between Truth and us: Reason dares not shew herself where Imagination bears the sway. We see only as she pleases, and those that are led by her know what they suffer from her by woeful experience. It would be a very happy composition to make with her, to give her back all her pleasures, on condition that she made you feel none of her pains: in a word, there is nothing so inconsistent with happiness, as a fine lively and too heated imagination.

Possess yourself with a true notion of things, and take not up with the sentiments of the people: form your own judgment without giving into received opinions, and get over the prejudices of your infancy. When you feel yourself under any uneasiness, take the following method: I have found the use of it: Examine into the occasion of your trouble; strip it of all the disguise that is about it, and of all the embroidery of imagination, and you will find that it is

generally nothing at all, or at leaſt great allowances are to be made. Value things only according to their real worth. We have a great deal more reaſon to complain of our falſe notions than of our fortune; it is very frequently not ſo much things that hurt us, as the opinion that we have of them.

In order to be happy, we muſt think rightly: we owe a great reſpect to the common opinions, when they concern religion; but we ought to think very differently from the vulgar in what regards morality and the happineſs of life. By the vulgar, I mean every body that has a low and vulgar way of thinking; the court is filled with ſuch ſort of creatures; and the world talks of nothing but fortune and credit: all the cry there is, " Go on, make haſte " forwards;" whereas Wiſdom ſays, " Take up " with ſimple things; chooſe an obſcure but quiet " life; get out of the hurry of the world; avoid a " croud." Fame is not all the recompence of virtue; the main part of it lies in the teſtimony of your own conſcience. A great virtue is ſurely enough to comfort you for the loſs of a little glory.

Be aſſured, that the greateſt ſcience is to know how to be independent. " I have learnt," ſaid one of the Antients, " to be my own friend, ſo I ſhall " never be alone." You muſt provide yourſelf ſome reſources againſt the inquietudes of life, and ſome equivalent for the goods you had depended on.

K 2

Secure yourself a retreat and place of refuge in your own breast; you can always return thither, and be sure to find yourself again. When the world is less necessary to you, it will have less power over you: when you do not, by some solid inclinations, place your dependance on yourself, you depend upon every thing else.

Use yourself to solitude: there is nothing more useful and necessary to weaken the impression that sensible objects make upon us. You should therefore from time to time retire from the world to be alone. Assign some hours in the day for reading, and for making your own reflections. "Reflection," says a Father of the Church, "is the eye of the soul; it "lets light and truth into it."—" I will lead him "into solitude," says Wisdom, "and there I will "speak to his heart." It is there indeed where Truth gives her instructions; where prejudices vanish, where prepossession wears off, and where opinion, that governs all, begins to lose its influence. When one considers the uselessness and insignificancy of life, one is forced to say with Pliny, " It is much better " to pass one's life in doing nothing at all, than in " doing trifles of nothing."

I have told you already, Daughter, that happiness consists in peace of mind: you cannot enjoy the pleasures of the mind without health of mind: every thing almost is a pleasure to a sound mind. If you

would live with tranquillity, thefe are the rules you are to obferve. The firft is, not to give yourfelf up to things that pleafe; to ufe them only occafionally; not to expect too much from the men, for fear of being difappointed; to be your own principal friend. Solitude too will enfure you tranquillty, and is a friend to wifdom: it is within you that Peace and Truth take up their abode. Avoid the great world, there is no fecurity in it; it always awakens fome fentiment or other that we had almoft crufhed; there are but too many people in it that encourage loofenefs; the more one converfes with it, the more authority do one's paffions gain; it is hard to refift the attack of vice when it comes fo well attended: in a word, one comes back from it much weaker, lefs modeft, and more unjuft, for having been among the men. The world eafily inftills its poifon into tender fouls. We fhould likewife fhut up all the avenues to the Paffions; it is much eafier to keep them off, than vanquifh them; and though one fhould be happy enough to banifh them, yet from the time that they made their impreffion, they make us pay dear for their abode. The firft motions of them is what cannot be refufed to Nature, but fhe often carries her influence too far; and when you come to yourfelf again, you find abundant reafon to repent.

One fhould always have fome refources and laft fhifts: calculate your ftrength and your courage; and

for this end, in all cafes where you have any apprehensions, confider every thing at the worft. Wait for the misfortune that may happen to you with firmnefs: look it bravely in the face; view it in all its moft terrible circumftances, and do not let yourfelf fink under it.

A favourite raifed to the height of grandeur was fhewing his riches to a friend. As he took out a box, he faid to him, " Here it is that my treafure " lies." His friend preffed him to fhew it him, and he allowed him to open the box: there was nothing in it but an old ragged coat. His friend feemed furprized at it: the favourite faid to him, " When for- " tune fhall fend me back to my original condition, " I am ready for it." What a noble refource is it to confider every thing at the worft, and feel fortitude enough in one's felf to ftand the fhock.

How ftrongly foever you wifh for any thing, begin with examining the thing you wifh: fet before your eyes the good which it promifes you, and the evils that follow it: remember the paffage of Horace, " Pleafure goes before you, but keeps her retinue " out of fight." You will ceafe to fear, as foon as ever you ceafe to defire. Depend upon it, a wife man does not run after felicity, but makes his own happinefs; it muft be your own doing, and it is in your own power. Remember that a very fmall matter will ferve for all the real needs of life, but there

muſt be an infinite deal to ſatisfy the imaginary needs of opinion; and that you will much ſooner reduce your deſires to the level of your fortune, than raiſe your fortune to the level of your deſires. If honours and riches could ſatiate us, we might heap them up; but the thirſt of them increaſes by acquiring them: he that deſires moſt, is certainly the moſt indigent.

Young perſons live upon hope, M. de la Rochefoucault ſays, " that it carries one an agreeable road " to the end of life." It would be indeed ſhort enough, if hope did not lengthen it; it is a very comfortable ſentiment, but may prove dangerous, by occaſioning you often a great many diſappointments. The leaſt evil that happens from it is, that we often loſe what we poſſeſs, by waiting for what we deſire.

Our ſelf-love makes us blind to ourſelves, and diminiſhes all our defects. We live with them as we do with the perfumes that we wear, we do not ſmell them; they only incommode others: to ſee them in their right light, we muſt ſee them in other people. View your own imperfections with the ſame eyes with which you view thoſe of others: be always exact in keeping to this rule, it will accuſtom you to equity. Examine your own nature, and make the beſt of your defects: there is none of them but may be tacked to ſome virtues, and be made to favour them. Morality does not propoſe to deſtroy nature, but to perfect it. Are you vain-glorious? Make uſe of that ſentiment

to raife yourfelf above the weakneffes of your fex, and to avoid the faults that abafe it. Every unruly paffion has a pain and fhame annexed to it, which folicit you to quit it. Are you timorous? Turn that weaknefs into prudence; let it keep you from expofing yourfelf. Are you lavifh? Do you love to give? It is eafy to turn prodigality into generofity. Give with choice and judgment; but do not neglect indifferent people: lend when it is neceffary; but give to fuch as cannot return your kindnefs; by fo doing you ftrike in with your inclination, and do good actions: there is no weaknefs, but, if you pleafe, virtue can make a good ufe of it.

In the afflictions which befal you, and which make you fenfible of your little ftock of merit, inftead of fretting and oppofing the opinion that you have of yourfelf to the injuftice which you pretend has been done you, confider that the perfons who are the authors of it are better able to judge of you than you are yourfelf; that you fhould fooner believe them than felf-love, which always flatters; and that with regard to what concerns yourfelf, your enemy is nearer truth than you are; that you fhould have no merit in your own eyes, but what you have in other people's. One has too great a difpofition to flatter one's felf, and men are too near themfelves to judge impartially in the cafe.

These are general precepts for opposing the vices of the mind; but your first care should be to perfect your heart and your sentiments: it depends on your heart to make your virtue sure and lasting; it is properly that which forms your character; and to make yourself mistress of it, observe this method. When you feel yourself agitated with a strong and violent passion, desire it to allow you a little time, and compound with your weakness; if without hearing it a moment, you are for sacrificing every thing to your reason and your duty, there is room to fear that your passion may rebel, and grow stronger than ever. You are under its command, and must manage it with address: you will receive more help than you think of from such a conduct: you will find some sure remedies even in your passion. If it be that of hatred, you will see that you have not altogether so much reason to hate and revenge yourself, as you at first imagined. If by misfortune it be the contrary sentiment that has seized you, there is no passion which furnishes you surer remedies against itself.

If your heart has the misfortune to be attacked by love, these are the remedies to stop its progress: Think that its pleasures are neither solid nor constant; they quit you; and if this was all the harm they would do you, 'tis enough. In passions the soul proposes itself an object, and is more intimately united to it either by desire or enjoyment, than it is to its own

being; it places all its felicity in its poffeffion, and all its mifery in the lofs of the object. Yet this felicity of the imagination, this good of the foul's choice, is neither folid nor lafting: it depends upon others; it depends upon yourfelf; and you cannot anfwer either for others or for yourfelf.

Love in the beginning offers you nothing but flowers, and hides all the danger from you; it impofes on you; it always takes fome form which is not its own: the heart being in fecret intelligence with it conceals its inclination from you, for fear of alarming your reafon and modefty. You fancy it a mere amufement; it is only the perfon's wit or good fenfe that pleafes us. In a word, Love is almoft always unknown till he has got the maftery. As foon as he comes to be felt, fly that inftant, and hearken not to the complaints of your heart: Love is not rooted out of the foul with ordinary efforts, it has too many partizans within us: as foon as it has furprized you, every thing is on its fide againft you, and nothing will ferve you againft Love. It is the moft cruel fituation a rational perfon can be in; where there is nothing to fupport you; where you have no fpectator but yourfelf. You muft fummon up your courage immediately, and remember that you muft make a much more forrowful ufe of it, if you yield to your paffion in the leaft.

TO HER DAUGHTER.

Reflect upon the fatal consequences of passions, and you will find but too many examples to instruct you; but we are often convinced of our mistake, without being cured of our passion. Reckon up, if possible, the evils that flow from Love: it imposes on the reason; it fills the soul and the senses with trouble; it takes away the flower of innocence; it stuns virtue; it blasts the reputation, shame being almost always the consequence of Love. Nothing debases you to such a degree, and sinks you so much below yourself, as the Passions: they degrade you: there is nothing but reason that can maintain your dignity. It is far more unhappy to stand in need of one's courage to bear a misfortune, than to avoid it; the pleasure of doing one's duty is a comfort to you; but never applaud yourself, for fear of being humbled. Remember that you carry your enemy about with you; stick strictly to a conduct that may answer for you to yourself. Avoid plays and passionate representations; you must not see what you would not feel; music, poetry, all this is of the retinue of sensual pleasure. Use yourself to reading on solid subjects, to fortify your reason.

Do not converse with your Imagination; it will paint Love to you with all its charms; it is all seduction and illusion, when she makes the representation: there is always a great drawback when you quit her to come to the reality. St. Augustine has given us

a description of his condition, when he was minded to quit love and pleasures. He says, that what he loved presented itself to him under a charming figure; he represents what passed in his heart in such moving terms, that there is no reading it without danger. One must pass slightly over the pictures of Pleasure; she is always to be feared, even at the very time we are taking measures against her; and when we are fullest of the disasters she has occasioned, we are still to mistrust ourselves. The passion is apt to get ground by the examining of one's self; forgetfulness is the only security to be taken against Love: you must call yourself seriously to account, and say, " What do I " mean to do with the inclination that is seizing me? " Are not such and such misfortunes sure to attend " me, if I have the weakness to yield to it."

Borrow forces and succour from your enemy and the very nature of Love; if you would not flatter him, he will supply you with them. Strip him of all the charms that your fancy gives him; lend him nothing, give him no favour, and you will see he will have but little left. After this, think no more of him; take a firm resolution to fly from him; and depend upon it, we are as strong as we resolve to be. Diversion and simple amusements are necessary; but we must shun all pleasures that affect the heart.

It is not always our faults that ruin us, but the manner of our conduct after we have committed them.

An humble acknowledgment of our faults difarms refentment, and ftops the violence of anger. Women that have had the misfortune to deviate from their duty, to break through decorum, to part with their virtue and modefty, owe fo much regard to cuftom, and ought to have fuch a fenfe of their breach of chaftity, as to appear with a mortified air; it is a fort of fatisfaction that the public expects from them; it is fure to remember your faults whenever you appear to forget them. Repentance infures a change of your conduct; prevent the malignity which is natural to mankind; put yourfelf in the place that their pride allots you, they would have you humbled; and when you have made yourfelf fo to their hands, they will have no more to fay to you: but fhe that is proud after commiting faults, calls them to mind, and makes them immortal.

Let us now pafs, my Daughter, to the Social Duties. I thought I was in the firft place to draw you out of the common education and the prejudices of childhood, and that it was neceffary to fortify your reafon, and give you fome folid principles to fupport you. I thought moft of the diforders of life were owing to falfe opinions; that falfe opinions produced loofe fentiments; and that when the underftanding is not enlightened, the heart is expofed to paffions: that there muft be fome truths fixed in the mind to preferve us from error, and that one muft have fome

sentiments in the heart to keep out the paffions. When you have once a knowledge of truth, and a love for juftice, there is no danger of all the other virtues.

The firft duty of civil life is to take care of others; such as live only for themfelves fall into contempt, and are neglected by every body. If you are for requiring too much from others, they will refuse you every thing, their friendfhip, their affections, and their fervices. Civil life is a mutual intercourfe of good offices: the moft valuable part of mankind go ftill further: by promoting the hapinefs of others, you infure your own; 'tis the trueft politics to think in this manner.

Nothing can be more odious than people that make every body fee that they live only for themfelves. An extravagant felf-love is the fource of great crimes; fome degrees lower it occafions vices; but let there be never fo little a fpice of it in a perfon, it impairs all the virtues and charms of fociety.

'Tis impoffible to make a friendfhip with perfons who have a predominant felf-love, and take care to fhew it; and yet we can never ftrip ourfelves of it entirely; as long as we are attached to life, we fhall be attached to ourfelves.

But there is a qualified felf-love, that is not exercifed at the expence of others.

We fancy we exalt ourfelves by depreffing our equals: this makes us cenforious and envious. Good-

nature turns to more account than malignity. Do good when it is in your power; speak well of all the world, and never judge with rigour. Such acts of goodness and generosity frequently repeated will gain you at last a great and excellent reputation. All the world is engaged to commend you, to extenuate your defects, and enhance your good qualities. You should found your reputation upon your own virtues, and not upon the demerit of others: consider that their good qualities take nothing at all from you, and that the diminution of your reputation can be imputed to no body but yourself.

One of the things that contributes most to make us unhappy is, that we depend too much upon the men; 'tis the source too of our injustice. We pick quarrels with them, not on account of what they owe us, or of what they have promised us, but on account of what we have hoped from them. We depend absolutely upon our hopes, which occasion us abundance of disappointments.

Be not rash in your judgments, and give no ear to calumnies: never give in to the first appearance of things, nor be in haste to condemn any body. Remember that there are things probable which are not true, as there are things true which are not probable.

We should, in our private judgments, imitate the equity of solemn judgments. Judges never decide

without having examined, heard and confronted the witnesses with the parties concerned ; but we, without any commission, set up for umpires of reputation ; and every proof is sufficient, every authority appears good, when the business is to condemn. Prompted by our natural malignity, we fancy that we give ourselves what we take away from others : hence arises animosities and enmities ; for every thing is sure to be known.

Be equitable therefore in your judgments ; the same justice that you do to others, they will return to you. Would you have them think and speak well of you, never speak ill of any body.

Civility, which is an imitation of charity, is another of the social virtues : it puts you above others when you have it in a more eminent degree ; but it is practised and maintained at the expence of self-love. Civility is always borrowing something from yourself, and turning it to the advantage of others. 'Tis one of the great bonds of society, and the only quality that makes one safe and easy in the intercourse of life.

We naturally love to govern ; 'tis an unjust inclination. Whence have we our right to pretend to exalt ourselves above others ? There is but one just and allowable superiority, 'tis that which virtue gives you ; have more goodness and generosity than others : be beforehand with them more in services than bene-

fits; 'tis the way to raife yourfelf. A great difintereftednefs makes you as independent, and raifes you higher than the ampleft fortune: nothing finks us fo much as a fondnefs for our own intereft.

The qualities of the heart have the greateft concern in the commerce of life: the underftanding does not endear us to others, and you frequently fee men very odious with great parts; they are for giving you a good opinion of themfelves; they are for getting an afcendant over and depreffing others.

Though humility has only been confidered as a chriftian virtue, it muft be owned to be a focial virtue; and fo neceffary a one, that without it 'tis a very ticklifh matter to have to do with you. 'Tis the conceit that you have of yourfelf which makes you maintain your rights with fo much arrogance, and intrench on thofe of other people.

We muft never be ftrict in calling any body to account. Exact civility does not infift on all that is due to you. Do not be afraid of being before-hand with your friends: if you have a mind to be a true friend, never infift on any thing too ftiffly; but that your behaviour may not be inconfiftent, as it expreffes your inward difpofition, make often ferious reflections on your weakneffes, and take yourfelf to pieces. This examination will make you entertain fentiments of humility for yourfelf, and of indulgence with regard to others.

Be humble without being bashful. Shame is a secret pride; and pride is an error with regard to one's own worth, and an injustice with regard to what one has a mind to appear to others.

Reputation is an advantage very desirable; but it is a weakness to court it with too much ardor, and do nothing but with a view to it; we ought to content ourselves with deserving it. We should not discourage sensibility for glory; 'tis the surest help we have to virtue; but the business is to make choice of true glory.

Accustom yourself to see what is above you without either admiration or envy; and what is below you without contempt. Do not let the pomp of greatness impose on you; none but little souls fall down and worship grandeur; admiration is only due to virtue.

To use yourself to value men by their proper qualities, consider the condition of a person loaded with honours, dignities and riches, who seems to want nothing at all, but really wants every thing, by being destitute of true goods, of those internal qualities that are necessary to the enjoyment and use of them: he suffers as much as if his poverty was real, so long as he has the sense of poverty, and is wishing for more. "There is nothing worse," says one of the Antients, "than poverty in the midst of riches, because the "evil lies in the mind." The man that is in this

situation feels all the evils of opinion, without enjoying the goods of fortune; he is blinded by error, and tormented by his passions: whilst a reasonable person who has nothing at all, but substitutes wise and solid reflections to supply the place of riches and honours, enjoys a tranquillity which nothing can equal: the happiness of the one, and the misery of the other, come only from their different manner of thinking.

If you find yourself disposed to resentment and revenge, strive to keep down that sentiment; there is nothing so mean as to revenge one's self. If you meet with ill-treatment from any body, you owe them only contempt; 'tis a debt easy to be paid. If they have offended you only in slight matters, you owe them indulgence; but there are certain seasons in life when you must meet with injuries; seasons when the friends for whom you have done most, fall foul upon and condemn you: in such a case, after having done all you can to undeceive them, do not be obstinate in disputing with them. One ought to court the esteem of one's friends; but when you find people that will only view you through their prejudices, when you have disputes with such hot and fiery imaginations as will admit of nothing but what favours their injustice, you have nothing to do but retire and set your heart at rest. Do what you will, you'll get nothing from them but discontent. When you thus

suffer from their ill-usage and shame of recanting, comfort yourself in your innocence, and the assurance that you have not offended. Think that if your worth was not greater at the time they raised you, it is not at all less now they are for crushing you: you should, without being more mortified at it, pity them, and not be exasperated if possible, but say, "They see "in a wrong light." Consider that with good qualities one may at last get over resentment and envy. Let the hopes you draw from virtue keep up your courage, and be your consolatic...

Do not think of revenging yourself any way but by using more moderation in your conduct, than those that attack you have malice. None but sublime souls are touched with the glory of pardoning injuries.

Set yourself to deserve your own esteem, the better to console yourself for the esteem which others deny you. You can allow yourself but one sort of vengeance; 'tis that of doing good to such as have offended you: 'tis the most exquisite revenge, and the only one that is allowable: you gratify your passion, and you intrench upon no virtue. Cæsar has set us an example of it; his lieutenant Labienus deserted from him at a time that he stood in most need of him, and went over to Pompey, leaving great riches in Cæsar's camp. Cæsar sent them after him, with a message to tell him, " that was the manner of Cæsar's re-" venge."

'Tis prudent to make a good use of other people's faults, even when they do us mischief; but very often they only begin the wrongs, and we finish them; they give us indeed a right against themselves, but we make an ill use of it: we are for taking too much advantage of their faults. This is an injustice and a violence that makes the standers-by against us. If we suffered with moderation all the world would be for us, and the faults of those that attack us would be doubled by our patience.

When you know that your friends have not treated you as they ought, take no notice of it; as soon as ever you shew that you perceive it, their malignity increases, and you give a loose to their hatred: whereas by dissembling it, you flatter their self-love; they enjoy the pleasure of imposing on you; they fancy themselves your superiors, as long as they are not discovered; they triumph in your mistake, and feel another pleasure in not ruining you quite. By not letting them see that you know them, you give them time to repent and come to themselves; and there needs nothing but a seasonable piece of service, and a different manner of taking things, to make them more attached to you than ever.

Be inviolable in your word; but to gain it an entire confidence, remember that you must be extremely scrupulous in keeping it. Shew your regard to truth even in things indifferent; and consider that there is

nothing so despicable as to deviate from it. 'Tis a common saying, that lying shews that people despise God, and stand in fear of man; and that the man who speaks truth and does good resembles the Deity. We should likewise avoid swearing; the bare word of an honest person should have all the credit and authority of an oath.

Politeness is a desire of pleasing: nature gives it, education and the world improve it. Politeness is a supplement to Virtue. They say it came into the world when that daughter of Heaven abandoned it. In ruder times, when Virtue bore a greater sway, they knew less of Politeness; it came in with Voluptuousness; it is the daughter of Luxury and Delicacy. It has been disputed, whether it approaches nearest to vice or virtue. Without pretending to decide the question, or define politeness, may I be allowed to speak my sentiments of it? I take it to be one of the greatest bonds of society, as it contributes most to the peace of it; 'tis a preparation to charity, and an imitation too of humility. True politeness is modest; and as it aims to please, it knows that the way to carry its point, is to shew that we do not prefer ourselves to others, but give them the first rank in our esteem.

Pride keeps us off from society: our self-love gives us a peculiar rank, which is always disposed with us. Such a high esteem of ourselves as makes others feel it, is almost always punished with an universal con-

tempt. Politeneſs is the art of reconciling agreeably what we owe to others, and what one owes to one's ſelf; for theſe duties have their bounds, which when they exceed, 'tis flattery with regard to others, and pride with regard to yourſelf; 'tis the moſt ſeducing quality in nature.

The moſt polite perſons have generally a good deal of ſweetneſs in their converſation, and engaging qualities: 'tis the girdle of Venus; it ſets off, and gives graces and charms to all that wear it; and with it you cannot fail to pleaſe.

There are ſeveral degrees of politeneſs. You carry it to a higher point in proportion to the delicacy of your way of thinking: it diſtinguiſhes itſelf in all your behaviour, in your converſation, and even in your ſilence.

Perfect politeneſs forbids us to diſplay our parts and talents with aſſurance; it even borders upon cruelty, to ſhew one's ſelf happy when we have certain misfortunes before our eyes. Converſation in the world is enough to poliſh our outward behaviour; but there muſt be a good deal of delicacy to form a politeneſs of mind. A nice politeneſs formed with art and taſte, will make the world excuſe you a great many failings, and improve your good qualities. Such as are defective in point of behaviour have the greater need of ſolid qualities, and make

flow advances in gaining a reputation. In a word, politeness cofts but little, and is of vaft advantage.

Silence always becomes a young perfon; there is a modefty and dignity in keeping it; you fit in judgment upon others, and run no hazard yourfelf: but guard yourfelf againft a proud and infulting filence; it fhould be the refult of your prudence, and not the confequence of your pride. But as there is no holding our peace always, it is fit for us to know that the principal rule for fpeaking well is to think well.

When your notions are clear and diftinct, your difcourfe will be fo too; let a proper decorum and modefty run through them. In all your difcourfes pay a regard to received cuftoms and prejudices; expreffions declare the fentiments of the heart, and the fentiments form the behaviour.

Be particularly careful not to fet up for a joker; 'tis an ill part to act, and by making others laugh, we feldom make ourfelves efteemed. Pay a great deal more attention to others than to yourfelf, and think how to fet them out rather than to fhine yourfelf: we fhould learn how to liften to other people's difcourfe, and not betray an abfence of mind either by our eyes or our manner. Never dwell upon ftories: if you chance to tell any, do it in a genteel and clofe manner; let what you fay be new, or at leaft give a new turn. The world is full of people,

TO HER DAUGHTER.

that are dinning things into your ears, without saying any thing to entertain the mind. Whenever we speak, we should take care either to please or instruct; when you call for the attention of the company, you should make them amends by the agreeableness of what you say: an indifferent discourse cannot be too short.

You may approve what you hear, but should very seldom admire it: admiration is proper to blockheads. Never let your discourse have an air of art and cunning; the greatest prudence lies in speaking little, and shewing more diffidence of one's self than of other people. An upright conduct, and a reputation for probity, gains more confidence and esteem, and at the long-run more advantages too in point of fortune, than any by-ways. Nothing makes you so worthy of the greatest matters, and raises you so much above others, as an exact probity.

Use yourself to treat your servants with kindness and humanity. 'Tis a saying of one of the Antients, " that we ought to consider them as unhappy friends." Remember that the vast difference between you and them is owing merely to chance ; never make them uneasy in their state of life, or add weight to the trouble of it. There is nothing so poor and mean as to be haughty to any body that is in your service.

Never use any harsh language ; it should never come out of the mouth of a delicate and polite person.

Servitude being settled in opposition to the natural equality of mankind, it behoves us to soften it. What right have we to expect our servants should be without faults, when we are giving them instances every day of our own? Let us rather bear with them. When you shew yourself in all your humours and fits of passion, (for we often lay ourselves open before our servants) how do you expose yourself to them? Can you have any right afterwards to reprimand them? A mean familiarity with them is indeed ever to be avoided; but you owe them assistance, advice, and bounties suitable to their condition and wants.

One should keep up authority in one's family, but it should be a mild authority. We should not indeed always threaten without punishing, for fear of bringing our threats into contempt; but we should not call in authority till persuasion has failed. Remember that humanity and christianity put all the world on the same foot. The impatience and heat of youth, joined to the false notion they give you of yourself, make you look upon your servants as creatures of a different species; but how contrary are such sentiments to the modesty that you owe to yourself, and the humanity you owe to others.

Never relish or encourage the flattery of servants; and to prevent the impression which their fawning speeches frequently repeated may make upon you, con-

sider that they are hirelings paid to serve your weaknesses and pride.

If by misfortune, Daughter, you should not think fit to follow my Advice and Precepts, though they be lost upon you, they will still be useful to myself, as laying me under new obligations. These reflections are fresh engagements to me to exert myself in the way of virtue. I fortify my reason even against myself; for I am now under a necessity of following it, or else I expose myself to the shame of having known it, and yet been false to it.

There is nothing, my Daughter, more mortifying than to write upon subjects that put me in mind of all my faults: by laying them open to you, I give up my right to reprimand you; I furnish you with arms against myself. And I allow you freely to use them, if you see any vices in me inconsistent with the virtues that I recommend to you; for all Advice and Precepts want authority, when they are not supported by example.

FABLES

FOR THE

FEMALE SEX.

FABLES

FOR THE

FEMALE SEX.

BY EDWARD MOORE.

TENTH EDITION.

" Truth under fiction I impart,
" To weed out folly from the heart,
" And shew the paths, that lead astray
" The wand'ring nymph from wisdom's way."

DUBLIN;

PRINTED BY GRAISBERRY AND CAMPBELL,
FOR JOHN ARCHER, NO. 80, DAME-STREET.

1790.

TABLE

OF

CONTENTS.

FABLE I.
THE EAGLE, AND THE ASSEMBLY OF BIRDS. 188

FABLE II.
THE PANTHER, THE HORSE, AND OTHER BEASTS. 192

FABLE III.
THE NIGHTINGALE AND GLOW-WORM. 198

FABLE IV.
HYMEN AND DEATH. 200

TABLE OF CONTENTS.

FABLE V.
THE POET AND HIS PATRON. 203

FABLE VI.
THE WOLF, THE SHEEP, AND THE LAMB. 208

FABLE VII.
THE GOOSE, AND THE SWANS, 215

FABLE VIII.
THE LAWYER, AND JUSTICE. 219

FABLE IX.
THE FARMER, THE SPANIEL AND THE CAT. 225

FABLE X.
THE SPIDER, AND THE BEE. 230

FABLE XI.
THE YOUNG LION, AND THE APE. 234

FABLE XII.
THE COLT, AND THE FARMER. 239

TABLE OF CONTENTS.

FABLE XIII.
THE OWL, AND THE NIGHTINGALE. 244

FABLE XIV.
THE SPARROW, AND THE DOVE. 249

FABLE XV.
THE FEMALE SEDUCERS. 286

FABLE XVI.
LOVE AND VANITY. 293

TABLE OF CONTENTS.

FABLE XIII.
THE OWL AND THE NIGHTINGALE

FABLE XIV.
THE SPARROW AND THE DOVE

FABLE XV.
THE FEMALE SEDUCERS

FABLE XVI.
PITY AND VANITY

FABLE I.

THE EAGLE, AND THE ASSEMBLY OF BIRDS.

TO HER

ROYAL HIGHNESS

THE

PRINCESS OF WALES.

THE moral lay, to beauty due,
I write, *fair Excellence*, to you;
Well pleas'd to hope my vacant hours
Have been employ'd to sweeten yours.
Truth under fiction I impart,
To weed out folly from the heart,
And shew the paths, that lead astray
The wandring nymph from wisdom's way.

I flatter none. The great and good
Are by their actions underſtood;
Your monument if actions raiſe,
Shall I deface by idle praiſe?
I echo not the voice of fame,
That dwells delighted on your name;
Her friendly tale, however true,
Were flatt'ry, if I told it you.

The proud, the envious, and the vain,
The jilt, the prude, demand my ſtrain;
To theſe, deteſting praiſe, I write,
And vent, in charity, my ſpite,
With friendly hand I hold the glaſs
To all, promiſcuous as they paſs;
Should folly there her likeneſs view,
I fret not that the mirror's true;
If the fantaſtic form offend,
I made it not, but would amend.

Virtue, in every clime and age,
Spurns at the folly-ſoothing page,
While ſatire, that offends the ear
Of vice and paſſion, pleaſes her.

Premising this, your anger spare,
And claim the fable, you, who dare.

The birds in place, by factions press'd,
To Jupiter their pray'rs address'd;
By specious lies the state was vex'd,
Their counsels libellers perplexed;
They begg'd (to stop seditious tongues)
A gracious hearing of their wrongs.
Jove grants their suit. The Eagle sate,
Decider of the grand debate.

The Pye, to trust and pow'r preferr'd,
Demands permission to be heard.
Says he, prolixity of phrase
You know I hate. This libel says,
" Some birds there are, who prone to noise,
" Are hir'd to silence wisdom's voice,
" And skill'd to chatter out the hour,
" Rise by their emptiness to pow'r."
That this is aim'd direct at me,
No doubt, you'll readily agree;
Yet well this sage assembly knows,
By parts to government I rose;

My prudent counsels prop the state;
Magpies were never known to prate.

 The Kite rose up. His honest heart
In virtue's suff'rings bore a part.
That there were birds of prey he knew;
So far the libeller said true.
" Voracious, bold, to rapine prone,
" Who knew no int'rest but their own;
" Who hov'ring o'er the farmer's yard,
" Nor pigeon, chick, nor duckling spar'd."
This might be true, but if apply'd
To him, in troth, the sland'rer ly'd.
Since ign'rance then might be misled,
Such things, he thought, were best unsaid.

 The Crow was vex'd. As yester-morn
He flew across the new sown corn,
A screaming boy was set for pay,
He knew, to drive the crows away:
Scandal had found him out in turn,
And buzz'd abroad, that crows love corn.

 The Owl arose, with solemn face,
And thus harangu'd upon the case.

That Magpies prate, it may be true,
A Kite may be voracious too,
Crows fometimes deal in new fown peafe;
He libels not, who ftrikes at thefe;
The flander's here—" But there are birds,
" Whofe wifdom lies in looks, not words;
" Blund'rers, who level in the dark,
" And always fhoot befide the mark."
He names not me; but, thefe are hints,
Which manifeft at whom he fquints;
I were indeed that blund'ring fowl,
To queftion if he meant an owl.

Ye wretches, hence! the Eagle cries;
'Tis confcience, confcience, that applies;
The virtuous mind takes no alarm,
Secur'd by innocence from harm,
While guilt, and his affociate fear,
Are ftartled at the paffing air.

FABLE II.

THE PANTHER, THE HORSE, AND OTHER BEASTS.

THE man, who seeks to win the fair,
(So custom says) must truth forbear;
Must fawn and flatter, cringe and lie,
And raise the goddess to the sky;
For truth is hateful to her ear,
A rudeness which she cannot bear——
A rudeness?—Yes,—I speak my thoughts;
For truth upbraids her with her faults.

How wretched, Cloe, then am I
Who love you, and yet cannot lie,
And still to make you less my friend,
I strive your errors to amend?
But shall the senseless fop impart
The softest passion to your heart,
While he, who tells you honest truth,
And points to happiness your youth,

Determines, by his care, his lot,
And lives neglected, and forgot?

 Trust me, my dear, with greater ease,
Your taste for flatt'ry I could please.
And similies in each dull line,
Like glow-worms in the dark, should shine.
What if I say your lips disclose
The freshness of the op'ning rose?
Or that your cheeks are beds of flow'rs,
Enripen'd by refreshing show'rs?
Yet certain as these flow'rs shall fade,
Time ev'ry beauty will invade.
The butterfly of various hue,
More than the flow'r resembles you;
Fair, flutt'ring, fickle, busy thing,
To pleasure ever on the wing,
Gayly coquetting for an hour,
To die, and ne'er be thought of more.
Would you the bloom of youth should last?
'Tis virtue that must bind it fast,
An easy carriage, wholly free
From four reserve, or levity;

Good-natur'd mirth, an open heart,
And looks unskill'd in any art;
Humility, enough to own
The frailties, which a friend makes known,
And decent pride, enough to know
The worth that virtue can bestow.

 These are the charms which ne'er decay,
Tho' youth, and beauty fade away,
And time, which all things else removes,
Still heightens virtue, and improves.

 You'll frown, and ask to what intent,
This blunt address to you is sent?
I'll spare the question, and confess
I'd praise you, if I lov'd you less;
But rail, be angry, or complain,
I will be rude, while you are vain.

 Beneath a Lion's peaceful reign,
When beasts met friendly on the plain,
A Panther, of majestic port,
(The vainest female of the court)
With spotted skin, and eyes of fire,
Fill'd ev'ry bosom with desire;

Where'er she mov'd, a servile croud
Of fawning creatures cring'd and bow'd;
Assemblies ev'ry week she held,
(Like modern belles) with coxcombs fill'd,
Where noise, and nonsense, and grimace,
And lies and scandal, fill'd the place.

Behold the gay, fantastic thing,
Encircled by the spacious ring;
Low-bowing, with important look,
As first in rank, the monkey spoke.
" Gad take me, madam, but I swear,
" No angel ever look'd so fair——
" Forgive my rudeness, but I vow,
" You were not quite divine till now,
" Those limbs! that shape! and then those eyes
" O close them, or the gazer dies!"

Nay, gentle Pug, for goodness hush,
I vow, and swear, you make me blush;
I shall be angry at this rate——
'Tis so like flatt'ry which I hate.

The Fox, in deeper cunning vers'd,
The beauties of her mind rehears'd,

And talk'd of knowledge, taſte, and ſenſe,
To which the fair have moſt pretence;
Yet well he knew them always vain
Of what they ſtrive not to attain,
And play'd ſo cunningly his part,
That Pug was rivall'd in his art.

The Goat avow'd his am'rous flame,
And burnt—for what he durſt not name;
Yet hop'd a meeting in the wood
Might make his meaning underſtood.
Half angry at the bold addreſs,
She frown'd; but yet ſhe muſt confeſs,
Such beauties might inflame his blood,
But ſtill his phraſe was ſomewhat rude.
The Hog her neatneſs much admir'd;
The formal Aſs her ſwiftneſs fir'd;
While all to feed her folly ſtrove,
And by their praiſes ſhar'd her love.

The Horſe, whoſe gen'rous heart diſdain'd
Applauſe, by ſervile flatt'ry gain'd,
With graceful courage, ſilence broke,
And thus with indignation ſpoke.

When flatt'ring monkeys fawn and prate,
They juftly raife contempt, or hate;
For merit's turn'd to ridicule,
Applauded by the grinning fool.
The artful fox your wit commends,
To lure you to his felfifh ends;
From the vile flatt'rer turn away,
For knaves make friendfhips to betray.
Difmifs the train of fops, and fools,
And learn to live by wifdom's rules.
Such beauties might the lion warm,
Did not your folly break the charm;
For who would court that lovely fhape,
To be the rival of an ape?

He faid; and fnorting in difdain,
Spurn'd at the croud, and fought the plain.

FABLE III.

THE NIGHTINGALE, AND GLOW-WORM.

THE prudent nymph, whofe cheeks difclofe
The lilly, and the blufhing rofe,
From public view her charms will fkreen,
And rarely in the croud be feen;
This fimple truth fhall keep her wife,
" The faireft fruits attract the flies."

One night, a Glow-worm, proud and vain,
Contemplating her glitt'ring train,
Cry'd, fure there never was in nature
So elegant, fo fine a creature,
All other infects that I fee,
The frugal ant, induftrious bee,
Or filk-worm, with contempt I view;
With all that low, mechanic crew,

Who fervilely their lives employ
In bufinefs, enemy to joy.
Mean, vulgar herd! ye are my fcorn,
For grandeur only I was born,
Or fure am fprung from race divine,
And plac'd on earth to live, and fhine.
Thofe lights, that fparkle fo on high,
Are but the glow-worms of the fky,
And kings on earth their gems admire,
Becaufe they imitate my fire.

She fpoke. Attentive on a fpray,
A nightingale forbore his lay;
He faw the fhining morfel near
And flew, directed by the glare;
A while he gaz'd with fober look,
And thus the trembling pray befpoke.

Deluded fool, with pride elate,
Know, 'tis thy beauty brings thy fate;
Lefs dazling, long thou might'ft have lain
Unheeded on the velvet plain;
Pride, foon or late, degraded mourns,
And beauty wrecks, whom fhe adorns.

FABLE IV.

HYMEN AND DEATH.

SIXTEEN, d'ye ſay? Nay, then 'tis time
Another year deſtroys your prime.
But ſtay—The ſettlement! " That's made."
Why then's my ſimple girl afraid?
Yet hold a moment, if you can,
And heedfully the fable ſcan.

The ſhades were fled, the morning bluſh'd,
The winds were in their caverns huſh'd,
When Hymen, penſive and ſedate,
Held o'er the fields his muſing gait.
Behind him, through the green-wood ſhade,
Death's meagre form the God ſurvey'd,
Who quickly with gigantic ſtride,
Out-went his pace, and join'd his ſide.
The chat on various ſubjects ran,
Till angry Hymen thus began.

Relentless Death, whose iron sway,
Mortals reluctant must obey,
Still of thy pow'r shall I complain,
And thy too partial hand arraign?
When Cupid brings a pair of hearts,
All over stuck with equal darts,
Thy cruel shafts my hopes deride,
And cut the knot, that Hymen ty'd.

Shall not the bloody, and the bold,
The miser, hoarding up his gold,
The harlot, reeking from the stew,
Alone thy fell revenge pursue?
But must the gentle, and the kind
Thy fury, undistinguish'd, find?

The monarch calmly thus reply'd;
Weigh well the cause, and then decide.
That friend of yours, you lately nam'd,
Cupid, alone is to be blam'd;
Then let the charge be justly laid;
That idle boy neglects his trade,
And hardly once in twenty years,
A couple to your temple bears.

The wretches, whom your office blends,
Silenus now, or Plutus fends;
Hence care, and bitterness, and strife
Are common to the nuptial life.

Believe me; more than all mankind,
Your vot'ries my compassion find;
Yet cruel am I call'd, and base,
Who seek the wretched to release,
The captive from his bonds to free,
Indissoluble, but for me.

'Tis I entice him to the yoke;
By me, your crouded altars smoke;
For mortals boldly dare the noose,
Secure that Death will set them loose.

FABLE V.

THE POET, AND HIS PATRON.

WHY, Celia, is your spreading waist
So loose, so negligently lac'd?
Why must the wrapping bed-gown hide
Your snowy bosom's swelling pride?
How ill that dress adorns your head,
Distain'd, and rumpled from the bed!
Those clouds, that shade your blooming face,
A little water might displace.
As nature ev'ry morn bestows
The crystal dew to cleanse the rose.
Those tresses, as the raven black,
That wav'd in ringlets down your back,
Uncomb'd, and injur'd by neglect,
Destroy the face, which once they deck'd.

Whence this forgetfulness of dress?
Pray, madam, are you marry'd? Yes.

Nay, then indeed the wonder ceaſes,
No matter now how looſe your dreſs is;
The end is won, your fortune's made,
Your ſiſter now may take the trade.

 Alas! what pity 'tis to find
This fault in half the female kind!
From hence proceed averſion, ſtrife,
And all that ſours the wedded life.
Beauty can only point the dart,
'Tis neatneſs guides it to the heart;
Let neatneſs then, and beauty ſtrive
To keep a wav'ring flame alive.

 'Tis harder far (you'll find it true)
To keep the conqueſt, than ſubdue;
Admit us once behind the ſcreen,
What is there farther to be ſeen?
A newer face may raiſe the flame,
But ev'ry woman is the ſame.

 Then ſtudy chiefly to improve
The charm, that fix'd your huſband's love;
Weigh well his humour. Was it dreſs,
That gave your beauty pow'r to bleſs?

Pursue it still; be neater seen,
'Tis always frugal to be clean;
So shall you keep alive desire,
And time's swift wing shall fan the fire.

 In garret high (as stories say)
A Poet sung his tuneful lay;
So soft, so smooth his verse, you'd swear,
Appollo, and the Muses there;
Thro' all the town his praises rung,
His sonnets at the play-house sung;
High waveing o'er his lab'ring head,
The goddess Want her pinions spread,
And with poetic fury fir'd,
What Phœbus faintly had inspir'd.

 A noble youth, of taste and wit,
Approv'd the sprightly things he writ,
And sought him in his cobweb dome,
Discharg'd his rent, and brought him home.

 Behold him at the stately board,
Who, but the Poet, and my Lord!

Each day, deliciously he dines,
And greedy quaffs the gen'rous wines;
His sides were plump, his skin was sleek,
And plenty wanton'd on his cheek;
Astonish'd at the change so new,
Away th' inspiring goddess flew.

Now, dropt for politics, and news,
Neglected lay the drooping muse,
Unmindful whence his fortune came,
He stifled the poetic flame;
Nor tale, nor sonnet, for my lady,
Lampoon, nor epigram was ready.

With just contempt his patron saw,
(Resolv'd his bounty to withdraw)
And thus, with anger in his look,
The late-repenting fool bespoke.

Blind to the good that courts thee grown,
Whence has the sun of favour shone?
Delighted with thy tuneful art,
Esteem was growing in my heart,

But idly thou reject'ſt the charm,
That gave it birth, and kept it warm.

 Unthinking fools alone deſpiſe
The arts, that taught them firſt to riſe.

FABLE VI.

THE WOLF, THE SHEEP, AND THE LAMB.

DUTY demands, the parent's voice
Should sanctify the daughter's choice;
In that is due obedience shewn;
To choose belongs to her alone.

May horror seize his midnight hour,
Who builds upon a parent's pow'r,
And claims by purchase vile and base,
The loathing maid for his embrace;
Hence virtue sickens; and the breast,
Where peace had built her downy nest,
Becomes the troubled seat of care,
And pines with anguish and despair.

FABLES.

A Wolf, rapacious, rough, and bold,
Whose nightly plunders thin'd the fold,
Contemplating his ill-spent life,
And cloy'd with thefts, would take a wife.
His purpose known, the savage race,
In num'rous crowds, attend the place;
For why, a mighty Wolf he was,
And held dominion in his jaws.
Her fav'rite whelp each mother brought,
And humbly his alliance sought;
But cold by age, or else too nice,
None found acceptance in his eyes.

It happen'd, as at early dawn,
He solitary cross'd the lawn,
Stray'd from the fold, a sportive Lamb
Skip'd wanton by her fleecy Dam;
When Cupid, foe to man and beast,
Discharg'd an arrow at his breast.
The tim'rous breed the robber knew,
And trembling o'er the meadow flew;
Their nimblest speed the Wolf o'ertook,
And courteous, thus the Dam bespoke.

Stay, fairest, and suspend your fear,
Trust me, no enemy is near;
These jaws, in slaughter oft imbru'd,
At length have known enough of blood,
And kinder business brings me now,
Vanquish'd at beauty's feet to bow.
You have a daughter———Sweet forgive
A Wolf's address———In her I live;
Love from her eye like lightning came,
And set my marrow all on flame;
Let your consent confirm my choice,
And ratify our nuptial joys.
Me ample wealth, and pow'r attend,
Wide o'er the plains my realms extend;
What midnight robber dare invade
The fold, if I the guard am made?
At home the shepherd's cur may sleep,
While I secure his master's sheep.
Discourse like this, attention claim'd;
Grandeur the mother's breast inflam'd;
Now fearless by his side she walk'd
Of settlements, and jointures talk'd,

Propos'd, and doubled her demands
Of flow'ry fields, and turnip-lands.
The Wolf agrees. Her bosom swells;
To miss her happy fate she tells.
And of the grand alliance vain,
Contemns her kindred of the plain.

The loathing Lamb with horror hears,
And wearies out her Dam with pray'rs;
But all in vain; mamma best knew
What unexperienc'd girls should do;
So, to the neighb'ring meadow carry'd,
A formal ass the couple marry'd,

Torn from the tyrant-mother's side,
The trembler goes, a victim-bride,
Reluctant meets the rude embrace,
And bleats among the howling race.
With horror oft her eyes behold
Her murder'd kindred of the fold;
Each day a sister-lamb is serv'd,
And at the glutton's table carv'd;
The crashing bones he grinds for food,
And slakes his thirst with streaming blood.

Love, who the cruel mind detests,
And lodges but in gentle breasts,
Was now no more. Enjoyment past,
The savage hunger'd for the feast;
But (as we find in human race,
A mask conceals the villain's face)
Justice must authorize the treat;
Till then he long'd, but durst not eat.

As forth he walk'd, in quest of prey,
The hunters met him on the way;
Fear wings his flight; the marsh he sought,
The snuffing dogs are set at fault.
His stomach baulk'd, now hunger gnaws,
Howling he grinds his empty jaws;
Food must be had——and lamb is nigh;
His maw invokes the fraudful lye.
Is this (dissembling rage, he cry'd)
The gentle virtue of a bride?
That, league'd with man's destroying race,
She sets her husband for the chace?
By treach'ry prompts the noisy hound
To scent his footsteps on the ground?

Thou trait'refs vile ! for this thy blood
Shall glut my rage, and dye the wood !

So faying, on the lamb he flies,
Beneath his jaws the victim dies.

FABLE VII.

THE GOOSE, AND THE SWANS.

I HATE the face, however fair,
That carries an affected air;
The lisping tone, the shape constrain'd,
The study'd look, the passion feign'd,
Are fopperies, which only tend
To injure what they strive to mend.
With what superior grace enchants
The face which nature's pencil paints!
Where eyes, unexercis'd in art,
Glow with the meaning of the heart!
Where freedom, and good-humour sit,
And easy gaiety, and wit!
Tho' perfect beauty be not there,
The master lines, the finish'd air,
We catch from ev'ry look delight,
And grow enamour'd at the sight;

For beauty, tho' we all approve,
Excites our wonder, more than love,
While the agreeable strikes sure,
And gives the wounds, we cannot cure.

 Why then, my Amoret, this care,
That forms you, in effect, less fair?
If nature on your cheek bestows
A bloom, that emulates the rose,
Or from some heav'nly image drew
A form, Appelles never knew,
Your ill-judg'd aid will you impart,
And spoil by meretricious art?
Or had you, nature's error, come
Abortive from the mother's womb,
Your forming care she still rejects,
Which only heightens her defects.
When such of glitt'ring jewels proud,
Still press the foremost in the croud,
At ev'ry public shew are seen,
With look awry, and aukward mien,
The gaudy dress attracts the eye,
And magnifies deformity.

Nature may under-do her part,
But seldom wants the help of art ;
Trust her, she is your surest friend,
Nor made your form for you to mend.

A Goose, affected, empty, vain,
The shrillest of the cackling train.
With proud, and elevated crest,
Precedence claim'd above the rest.

Says she, I laugh at human race,
Who say, geese hobble in their pace ;
Look here !——the sland'rous lie detect ;
Not haughty man is so erect.
That peacock yonder ! lord how vain
The creature's of his gaudy train !
If both were stript, I'd pawn my word,
A goose would be the finer bird.
Nature, to hide her own defects,
Her bungled work with fin'ry decks ;
Were geese set off with half that show,
Would men admire the peacock ? no.

Thus vaunting, crofs the mead fhe ftalks,
The cackling breed attend her walks,
The fun fhot down his noon-tide beams,
The Swans were fporting in the ftreams;
Their fnowy plumes, and ftately pride
Provok'd her fpleen. Why there fhe cry'd
Again, what arrogance we fee!—
Thofe creatures! how they mimic me!
Shall ev'ry fowl the waters fkim,
Becaufe we geefe are known to fwim?
Humility, they foon fhall learn,
And their own emptinefs difcern.

So faying, with extended wings,
Lightly upon the waves fhe fprings,
Her bofom fwells, fhe fpreads her plumes,
And the fwan's ftately creft affumes.
Contempt and mockery enfu'd,
And burfts of laughter fhook the flood.

A fwan, fuperior to the reft,
Sprung forth, and thus the fool addrefs'd.
Conceited thing! elate with pride,
Thy affectation all deride;

These airs thy aukwardness impart,
And shew thee plainly as thou art.
Among thy equals of the flock,
Thou had'st escap'd the public mock,
And as thy parts to good conduce
Been deem'd an honest hobbling goose.

Learn hence, to study wisdom's rules;
Know, foppery's the pride of fools,
And striving nature to conceal,
You only her defects reveal.

FABLE VIII.

THE LAWYER, AND JUSTICE.

LOVE! thou divineſt good below,
Thy pure delights few mortals know.
Our rebel hearts thy ſway diſown,
While tyrant luſt uſurps thy throne!
The bounteous god of nature made,
The ſexes for each other's aid,
Their mutual talents to employ,
To leſſen ills, and heighten joy.
To weaker woman he aſſign'd
That ſoft'ning gentleneſs of mind,
That can with ſympathy impart
Its likeneſs, to the rougheſt heart.
Her eyes with magic pow'r endu'd
To fire the dull, and awe the rude.
His roſy fingers on her face
She'd laviſh ev'ry blooming grace.

And stamp'd (perfection to display)
His mildest image on her clay.

 Man, active, resolute, and bold,
He fashion'd in a diff'rent mould.
With useful arts his mind inform'd,
His breast with nobler passions warm'd;
He gave him knowledge, taste, and sense,
And courage for the fair's defence.
Her frame, resistless to each wrong,
Demands pretection from the strong;
To man she flies when fear alarms,
And claims the temple of his arms.
By nature's author thus declar'd
The woman's sov'reign and her guard,
Shall man, by treach'rous wile invade
The weakness, he was meant to aid?
While beauty, given to inspire
Protecting love, and soft desire,
Lights up a wild-fire in the heart,
And to its own breast points the dart,
Becomes the spoiler's base pretence
To triumph over innocence?

The wolf, that tears the tim'rous sheep,
Was never set the fold to keep;
Nor was the tyger, or the pard
Meant the benighted trav'lers guard;
But man, the wildest beast of prey,
Wears friendships semblance to betray;
His strength against the weak employs,
And where he should protect, destroys.

Past twelve o'clock, the watchman cry'd,
His brief the studious Lawyer ply'd;
The all-prevailing fee lay nigh,
The earnest of to-morrow's lie;
Sudden the furious winds arise,
The jarring casement shatter'd flies,
The doors admit a hollow sound,
And rattling from their hinges bound;
When Justice in a blaze of light
Reveal'd her radiant form to sight.

The wretch with thrilling horror shook,
Loose ev'ry joint, and pale his look,
Not having seen her in the courts,
Or found her mentioned in reports,

He afk'd, with fault'ring tongue, her name,
Her errand there, and whence fhe came?

 Sternly the white-rob'd fhade reply'd,
(A crimfon glow her vifage dy'd)
Can'ft thou be doubtful who I am?
Is Juftice grown fo ftrange a name?
Were not your courts for Juftice rais'd
'Twas there of old my altars blaz'd.
My guardian thee did I elect,
My facred temple to protect,
That thou and all thy venal tribe
Should fpurn the goddefs for a bribe?
Aloud the ruin'd client cries,
Juftice has neither ears, nor eyes!
In foul alliance with the bar,
'Gainft me the judge denounces war,
And rarely iffues his decree,
But with intent to baffle me.

 She paus'd. Her breaft with fury burn'd,
The trembling Lawyer thus return'd.
I own the charge is juftly laid,
And weak th' excufe that can be made;

FABLES.

Yet search the spacious globe, and see
If all mankind are not like me.
The gown-man skill'd in Romish lies,
By faith's false glass deludes our eyes,
O'er conscience rides without controul,
And robs the man, to save his soul.

 The doctor, with important face,
By sly design, mistakes the case,
Prescribes, and spins out the disease,
To trick the patient of his fees.
The soldier, rough with many a scar
And red with slaughter, leads the war;
If he a nation's trust betray,
The foe has offer'd double pay.

 When vice o'er all mankind prevails,
And weighty int'rest turns the scales.
Must I be better than the rest,
And harbour Justice in my breast?
On one side only take the fee,
Content with poverty and thee?

 Thou blind to sense, and vile of mind,
Th' exasperated shade rejoin'd,

If virtue from the world is flown,
Will others' faults excufe thy own?
For fickly fouls the prieft was made,
Phyficians, for the body's aid,
The foldier guarded liberty,
Man woman, and the lawyer me,
If all are faithlefs to their truft,
They leave not thee the lefs unjuft.
Henceforth your pleadings I difclaim,
And bar the fanction of my name;
Within your courts it fhall be read,
That Juftice from the law is fled.

She fpoke; and hid in fhades her face,
'Till HARDWICK footh'd her into grace.

FABLE IX.

THE FARMER, THE SPANIEL, AND THE CAT.

WHY knits my dear her angry brow?
What rude offence alarms you now?
I said, that Delia's fair, 'tis true,
But did I say, she equall'd you?
Can't I another's face commend,
Or to her virtues be a friend,
But instantly your forehead lours,
As if her merit lessen'd yours?
From female envy never free,
All must be blind, because you see.
Survey the gardens, fields, and bow'rs,
The buds, the blossoms, and the flow'rs,
Then tell me where the wood-bine grows,
That vies in sweetness with the rose?

Or where the lilly's snowy white,
That throws such beauties on the sight?
Yet folly is it to declare,
That these are neither sweet, nor fair.
The chrystal shines with fainter rays,
Before the di'amond's brighter blaze;
And fops will say the di'mond dies
Before the lustre of your eyes;
But I, who deal in truth, deny
That neither shine when you are by.

When zephirs o'er the blossoms stray,
And sweets along the air convey,
Shan't I the fragrant breeze inhale,
Because you breathe a sweeter gale?

Sweet are the flow'rs that deck the field,
Sweet is the smell the blossoms yield,
Sweet is the summer gale that blows,
And sweet, tho' sweeter you, the rose.

Shall envy then torment your breast,
If you are lovelier than the rest?
For while I give to each her due,
By praising them, I flatter you,

And praising moſt, I ſtill declare
You faireſt, where the reſt are fair.

As at his board a Farmer ſate,
Repleniſh'd by his homely treat,
His fav'rite Spaniel near him ſtood,
And with his maſter ſhar'd the food;
The crackling bones his jaws devour'd,
His lapping tongue the trenchers ſcour'd;
Till ſated now, ſupine he lay,
And ſnor'd the riſing fumes away.

The hungry Cat, in turn, drew near,
And humbly crav'd a ſervant's ſhare;
Her modeſt worth the maſter knew,
And ſtrait the fat'ning morſel threw;
Enrag'd, the ſnarling cur awoke,
And thus, with ſpiteful envy, ſpoke.

They only claim a right to eat,
Who earn by ſervices their meat;
Me, zeal and induſtry inflame
To ſcour the fields and ſpring the game,

Or, plunged in the wintry wave,
For man the wounded bird to save,
With watchful diligence I keep,
From prowling wolves, his fleecy sheep;
At home, his midnight hours secure,
And drive the robber from the door.
For this, his breast with kindness glows;
For this, his hand the food bestows;
And shall, thy Indolence impart,
A warmer friendship to his heart,
That thus he robs me of my due,
To pamper such vile things as you?
I own (with meekness puss reply'd)
Superior merit on your side;
Nor does my breast with envy swell,
To find it recompenc'd so well;
Yet I, in what my nature can,
Contribute to the good of man.
Whose claws destroy the pilf'ring mouse?
Who drives the vermin from the house?
Or, watchful for the lab'ring swain,
From lurking rats secure the grain?

From hence if he rewards beſtow,
Why ſhould your heart with gall o'erflow?
Why pine my happineſs to ſee,
Since there's enough for you and me?

Thy words are juſt, the Farmer cry'd,
And ſpurn'd the ſnarler from his ſide.

FABLE X.

THE SPIDER, AND THE BEE.

THE nymph, who walks the public ſtreets,
And ſets her cap at all ſhe meets,
May catch the fool, who turns to ſtare
But men of ſenſe avoid the ſnare.

As on the margin of the flood,
With ſilken line, my Lydia ſtood,
I ſmil'd to ſee the pains you took,
To cover o'er the fraudful hook.
Along the foreſt as we ſtray'd,
You ſaw the boy his lime-twigs ſpread;
Gueſs'd you the reaſon of his fear,
Left, heedleſs, we approach'd too near?
For as behind the buſh we lay,
The linnet flutter'd on the ſpray.

Needs there such caution to delude
The scaly fry, and feather'd brood?
And think you, with inferior art,
To captivate the human heart?
The maid, who modestly conceals
Her beauties, while she hides, reveals,
Give but a glimpse, and fancy draws,
Whate'er the Grecian Venus was.
From Eve's first fig-leaf to brocade,
All dress was meant for fancy's aid,
Which evermore delighted dwells
On what the bashful nymph conceals.

When Celia struts in man's attire,
She shews too much to raise desire,
But from the hoop's bewitching round
Her very shoe has power to wound.
The roving eye, the bosom bare,
The forward laugh, the wanton air
May catch the fop; for gudgeons strike
At the bare hook, and bait, alike,
While salmon play regardless by,
'Till art, like nature, forms the fly.

Beneath a peasant's homely thatch,
A Spider long had held her watch;
From morn to night with restless care,
She spun her web, and wove her snare.
Within the limits of her reign,
Lay many a heedless captive slain,
Or flutt'ring struggled in the toils,
To burst the chains, and shun her wiles.
A straying Bee, that perch'd hard by,
Beheld her with disdainful eye.
And thus began. Mean thing give o'er,
And lay thy slender threads no more;
A thoughtless fly, or two at most,
Is all the conquest thou can'st boast,
For bees of sense, thy arts evade,
We see so plain the nets are laid.

The gaudy tulip, that displays
Her spreading foliage to the gaze,
That points her charms at all she sees,
And yields to ev'ry wanton breeze,
Attracts not me. Where blushing grows,
Guarded with thorns, the modest rose,

Enamour'd, round and round I fly,
Or on her fragrant bosom lie;
Reluctant, she my ardor meets,
And bashful renders up her sweets.

To wiser heads attention lend,
And learn this lesson from a friend.
She, who with modesty retires,
Adds fewel to her lover's fires,
While such incautious jilts as you,
By folly your own schemes undo.

FABLE XI.

THE YOUNG LION, AND THE APE.

'TIS true, I blame your lover's choice,
Tho' flatter'd by the public voice,
And peevish grow, and sick to hear
His exclamations, O how fair!
I listen not to wild delights,
And transports of expected nights;
What is to me your hoard of charms,
The whiteness of your neck and arms?
Needs there no acquisition more,
To keep contention from the door?
Yes; pass a fortnight, and you'll find,
All beauty cloys, but of the mind.

Sense, and good-humour ever prove
The surest cords to fasten love.

Yet, Phillis (simplest of your sex)
You never think, but to perplex.
Coquetting it with ev'ry ape,
That struts abroad in human shape;
Not that the coxcomb is your taste,
But that it stings your lover's breast;
To-morrow you resign the sway,
Prepar'd to honour, and obey,
The tyrant-mistress change for life,
To the submission of a wife.
Your follies, if you can, suspend,
And learn instruction from a friend.
Reluctant hear the first address,
Think often, 'ere you answer, yes;
But once resolv'd, throw off disguise,
And wear your wishes in your eyes.
With caution ev'ry look forbear,
That might create one jealous fear.
A lover's rip'ning hopes confound,
Or give the gen'rous breast a wound.
Contemn the girlish arts to teaze,
Nor use your pow'r, unless to please;

For fools alone with rigour sway,
When, soon or late, they must obey,

The king of brutes, in life's decline,
Resolv'd dominion to resign;
The beasts were summon'd to appear,
And bend before the royal heir.
They came; a day was fix'd; the croud
Before their future monarch bow'd.

A dapper Monkey, proud and vain,
Step'd forth, and thus address'd the train.

Why cringe my friends with slavish awe,
Before this pageant king of straw?
Shall we anticipate the hour,
And 'ere we feel it, own his pow'r?
The counsels of experience prize,
I know the maxims of the wise;
Subjection let us cast away,
And live the monarchs of to-day;
'Tis ours the vacant hand to spurn,
And play the tyrant each in turn,

So shall he right from wrong discern,
And mercy, from oppression learn,
At others woes be taught to melt,
And loath the ills himself has felt.

He spoke; his bosom swell'd with pride,
The youthful Lion thus reply'd.

What madness prompts thee to provoke
My wrath, and dare th' impending stroke?
Thou wretched fool! can wrongs impart
Compassion to the feeling heart?
Or teach the grateful breast to glow,
The hand to give, or eye to flow?
Learn'd in the practice of their schools,
From women thou hast drawn thy rules;
To them return, in such a cause,
From only such expect applause;
The partial sex I don't condemn,
For liking those, who copy them.

Would'st thou the gen'rous lion bind,
By kindness bribe him to be kind;
Good offices their likeness get,
And payment lessens not the debt;

With multiplying hand he gives
The good from others he receives;
Or for the bad makes fair return,
And pays with int'reſt, ſcorn for ſcorn.

FABLE XII.

THE COLT, AND THE FARMER.

TELL me, Corinna, if you can,
Why so averse, so coy to man?
Did nature, lavish of her care,
From her best pattern form you fair,
That you ungrateful to her cause,
Should mock her gifts and spurn her laws?
And miser-like, with-hold that store,
Which, by imparting, blesses more?
Beauty's a gift, by heaven assign'd,
The portion of the female kind;
For this the yielding maid demands
Protection at her lover's hands;
And tho' by wasting years it fade,
Remembrance tells him, once 'twas paid.

And will you then this wealth conceal,
For age to ruſt, or time to ſteal?
The ſummer of your youth to rove,
A ſtranger to the joys of love?
Then, when life's winter haſtens on,
And youth's fair heritage is gone,
Dow'rleſs to court ſome peaſant's arms,
To guard your wither'd age from harms?
No gratitude to warm his breaſt,
For blooming beauty, once poſſeſs'd;
How will you curſe that ſtubborn pride,
Which drove your bark acroſs the tide,
And ſailing before folly's wind,
Left ſenſe and happineſs behind?

Corinna, leſt theſe whims prevail,
To ſuch as you, I write my tale.

A Colt, for blood and mettled ſpeed,
The choiceſt of the running breed,
Of youthful ſtrength, and beauty vain,
Refus'd ſubjection to the rein;
In vain the groom's officious ſkill
Oppos'd his pride, and check'd his will;

FABLES.

In vain the master's forming care
Restrain'd with threats, or sooth'd with pray'r;
Of freedom proud, and scorning man,
Wild o'er the spacious plains he ran.
Where e'er luxuriant nature spread
Her flow'ry carpet o'er the mead,
Or bubbling streams, soft-gliding pass,
To cool and freshen up the grass,
Disdaining bounds, he crop'd the blade,
And wanton'd in the spoil he made.

In plenty thus the summer pass'd,
Revolving winter came at last;
The trees no more a shelter yield,
The verdure withers from the field,
Perpetual snows invest the ground,
In icy chains the streams are bound,
Cold, nipping winds, and rattling hail
His lank, unshelter'd sides assail.

As round he cast his rueful eyes,
He saw the thatch-roof'd cottage rise;
The prospect touch'd his heart with cheer,
And promis'd kind deliv'rance near.

A ſtable, erſt his ſcorn, and hate,
Was now become his wiſh'd retreat;
His paſſion cool, his pride forgot,
A Farmer's welcome yard he ſought.

 The maſter ſaw his woeful plight,
His limbs, that totter'd with his weight,
And friendly to the ſtable led.
And ſaw him litter'd, dreſs'd, and fed.
In ſlothful eaſe, all night he lay;
The ſervants roſe at break of day;
The market calls. Along the road
His back muſt bear the pond'rous load;
In vain he ſtruggles, or complains,
Inceſſant blows reward his pains.
To-morrow varies but his toil;
Chain'd to the plough, he breaks the ſoil;
While ſcanty meals at night repay
The painful labours of the day.

 Subdu'd by toil, with anguiſh rent,
His ſelf-upbraidings found a vent.
Wretch that I am! he ſighing ſaid
By arrogance, and folly led;

Had but my restive youth been brought
To learn the lesson nature taught,
Then had I, like my sires of yore,
The prize from ev'ry courser bore;
While man, bestow'd rewards, and praise,
And females crown'd my latter days.
Now lasting servitude's my lot,
My birth contemn'd, my speed forgot,
Doom'd am I, for my pride to bear
A living death, from year to year.

FABLE XIII.

THE OWL, AND THE NIGHTINGALE.

TO know the miſtreſs' humour right,
See if her maids are clean and tight,
If Betty waits without her ſtays,
She copies but her ladies ways.
When miſs comes in with boiſt'rous ſhout,
And drops no court'ſey, going out,
Depend upon't, mamma is one,
Who reads, or drinks too much alone.

If bottled beer her thirſt aſſwage,
She feels enthuſiaſtic rage,
And burns with ardor to inherit
The gifts and workings of the ſpirit.
If learning crack her giddy brains,
No remedy, but death remains.

Sum up the various ills of life,
And all are sweet to such a wife.
At home, superior wit she vaunts,
And twits her husband with his wants;
Her ragged offspring all around,
Like pigs, are wallowing on the ground.
Impatient ever of controul,
And knows no order but of soul;
With books her litter'd floor is spread
Of nameless authors, never read;
Foul linen, petticoats, and lace
Fill up the intermediate space.
Abroad, at visitings, her tongue
Is never still, and always wrong,
All meanings she defines away,
And stands, with truth and sense, at bay.

If e'er she meets a gentle heart,
Skill'd in the housewife's useful art,
Who makes her family her care,
And builds contentment's temple there,
She starts at such mistakes in nature,
And cries, lord help us!—what a creature!

Meliſſa, if the moral ſtrike,
You'll find the fable not unlike.

 An Owl, puff'd up with ſelf-conceit,
Lov'd learning better than his meat;
Old manuſcripts he treaſur'd up,
And rummag'd ev'ry grocer's ſhop;
At paſtry-cooks was known to ply,
And ſtrip, for ſcience, every pye.
For modern poetry and wit,
He had read all that Blackmore writ.
So intimate with Curl was grown,
His learned treaſures were his own,
To all his authors had acceſs,
And ſometimes would correct the preſs.
In logic he acquir'd ſuch knowledge,
You'd ſwear him fellow of a college.
Alike to ev'ry art and ſcience,
His daring genius bid defiance.
And ſwallow'd wiſdom, with that haſte,
That cits do cuſtard at a feaſt.

 Within the ſhelter of a wood,
One ev'ning, as he muſing ſtood,

Hard by, upon a leafy spray,
A Nightingale began his lay.
Sudden he starts, with anger stung,
And screeching interrupts the song.

Pert, busy thing, thy airs give o'er,
And let my contemplations soar.
What is the music of thy voice,
But jarring dissonance and noise?
Be wise. True harmony thou'lt find,
Not in the throat, but in the mind;
By empty chirping not attain'd,
But by laborious study gain'd.
Go read the authors, Pope explodes,
Fathom the depth of Cibber's odes.
With modern plays improve thy wit,
Read all the learning, Henley writ,
And if thou needs must sing, sing then,
And emulate the ways of men:
So shalt thou grow, like me, refin'd,
And bring improvement to thy kind.

Thou wretch, the little warbler cry'd,
Made up of ignorance and pride,

Aſk all the birds, and they'll declare,
A greater blockhead wings not air.
Read o'er thyſelf, thy talents ſcan,
Science was only meant for man.
No ſenſeleſs authors me moleſt,
I mind the duties of my neſt,
With careful wing protect my young,
And chear their ev'nings with a ſong.
Make ſhort the weary trav'ler's way,
And warble in the poet's lay.

Thus, following nature, and her laws,
From men and birds I claim applauſe,
While nurs'd in pedantry and ſloth,
An Owl is ſcorn'd alike by both.

FABLE XIV.

THE SPARROW, AND THE DOVE.

IT was, as learn'd traditions say,
Upon an April's blithsome day,
When pleasure, ever on the wing,
Return'd, companion of the spring,
And chear'd the birds with am'rous heat,
Instructing little hearts to beat;
A sparrow, frolick, gay, and young,
Of bold address, and flippant tongue,
Just left his lady of a night,
Like him, to follow new delight.

The youth, of many a conquest vain,
Flew off to seek the chirping train;
The chirping train he quickly found,
And with a saucy ease, bow'd round.

For every she his bosom burns,
And this, and that he woes by turns;
And here a sigh, and there a bill,
And here——those eyes! so form'd to kill!
And now with ready tongue, he strings
Unmeaning, soft, resistless things;
With vows, and dem——me's skill'd to woo,
As other pretty fellows do.
Not that he thought this short essay
A prologue needful to his play;
No, trust me, says our learned letter,
He knew the virtuous sex much better;
But these he held as specious arts,
To shew his own superior parts,
The form of decency to shield,
And give a just pretence to yield.

Thus finishing his courtly play,
He mark'd the fav'rite of a day;
With careless impudence drew near,
And whisper'd Hebrew in her ear;
A hint, which like the mason's sign,
The conscious can alone divine.

FABLES.

The fluttering nymph, expert at feigning,
Cry'd, Sir!——pray Sir, explain your meaning——
Go prate to thofe that may endure ye——
To me this rudenefs!——I'll affure ye!——
Then off fhe glided, like a fwallow,
As faying——you guefs where to follow.

To fuch as know the party fet,
'Tis needlefs to declare they met;
The parfon's barn, as authors mention,
Confefs'd the fair had apprehenfion.
Her honour there fecure from ftain,
She held all farther trifling vain,
No more affected to be coy,
But rufh'd, licentious, on the joy.

Hift, love! the male companion cry'd,
Retire a while, I fear we're fpy'd;
Nor was the caution vain; he faw
A Turtle, ruftling in the ftraw,
While o'er her callow brood fhe hung,
And fondly thus addrefs'd her young.

Ye tender objects of my care!
Peace, peace, ye little helplefs pair;

Anon he comes, your gentle sire,
And brings you all your hearts require.
For us, his infants and his bride,
For us, with only love to guide,
Our lord assumes an eagle's speed,
And like a lion, dares to bleed.
Nor yet by wint'ry skies confin'd,
He mounts upon the rudest wind,
From danger tears the vital spoil,
And with affection sweetens toil.
Ah cease, too vent'rous! cease to dare,
In thine, our dearer safety spare,
From him, ye cruel falcons stray,
And turn, ye fowlers, far away!

Should I survive to see the day,
That tears me from myself away,
That cancels all that heav'n could give,
The life, by which alone, I live,
Alas, how more than lost were I,
Who, in the thought, already die!

Ye pow'rs, whom men and birds obey,
Great rulers of your creatures, say,

FABLES.

Why mourning comes, by blifs convey'd,
And ev'n the fweets of love allay'd?
Where grows enjoyment, tall, and fair,
Around it twines entangling care;
While fear, for what our fouls poffefs,
Enervates ev'ry pow'r to blefs;
Yet friendfhip forms the blifs above,
And, life! what art thou, without love?
Our hero, who had heard apart,
Felt fomething moving in his heart,
But quickly, with difdain, fupprefs'd
The virtue, rifing in his breaft;
And firft he feign'd to laugh aloud,
And next, approaching, fmil'd and bow'd.

Madam, you muft not think me rude;
Good manners never can intrude;
I vow I came thro' pure good nature!
(Upon my foul a charming creature)
Are thefe the comforts of a wife?
This careful, cloifter'd, moaping life?
No doubt, that odious thing, call'd duty
Is a fweet province for a beauty.

Thou pretty ignorance! thy will
Is meafur'd to thy want of fkill;
That good old-fafhion'd dame, thy mother,
Has taught thy infant years no other—
The greateft ill in the creation
Is fure the want of education.

But think ye?—tell me without feigning,
Have all thefe charms no farther meaning?
Dame nature, if you don't forget her,
Might teach your ladyfhip much better.
For fhame, reject this mean employment,
Enter the world, and tafte enjoyment;
Where time, by circling blifs, we meafure;
Beauty was form'd alone for pleafure;
Come, prove the bleffing, follow me,
Be wife, be happy, and be free.

Kind Sir, reply'd our matron chafte,
Your zeal feems pretty much in hafte;
I own, the fondnefs to be blefs'd,
Is a deep thirft in ev'ry breaft;
Of bleffings too I have my ftore,
Yet quarrel not, fhould heav'n give more;

Then prove the change to be expedient,
And think me, Sir, your moſt obedient.
Here turning, as to one inferior,
Our gallant ſpoke, and ſmil'd ſuperior.
Methinks, to quit your boaſted ſtation
Requires a world of heſitation,
Where brats, and bonds are held a bleſſing,
The caſe, I doubt, is paſt redreſſing,
Why, child, ſuppoſe the joys I mention,
Were the mere fruits of my invention,
You've cauſe ſufficient for your carriage,
In flying from the curſe of marriage;
That ſly decoy, with vary'd ſnares.
That takes your widgeons in by pairs;
Alike to huſband, and to wife,
The cure of love, and bane of life;
The only method of forecaſting,
To make misfortune firm, and laſting;
The ſin, by heav'n's peculiar ſentence,
Unpardon'd, thro' a life's repentance.
It is the double ſnake, that weds
A common tail to diff'rent heads,

P

That leads the carcafs ftill aftray,
By dragging each a diff'rent way.
Of all the ills, that may attend me,
From marriage, mighty gods, defend me!

Give me frank nature's wild demefne,
And boundlefs tract of air ferene,
Where fancy, ever wing'd for change,
Delights to fport, delights to range;
There, Liberty! to thee is owing
Whate'er of blifs is worth beftowing,
Delights, ftill vary'd, and divine,
Sweet goddefs of the hills are thine.

What fay you now, you pretty pink you?
Have I, for once, fpoke reafon, think you?
You take me now for no romancer——
Come, never ftudy for an anfwer;
Away, caft ev'ry care behind ye,
And fly where joy alone fhall find you.

Soft yet, return'd our female fencer,
A queftion more, or fo——and then *Sir*.

You've rally'd me with sense exceeding,
With much fine wit, and better breeding;
But pray Sir, how do you contrive it?
Do those of your world never wive it?
" No, no,"—How then?—" Why dare I tell
" What does the business full as well."
Do you ne'er love?—" An hour at leisure."
Have you no friendships?——" Yes, for pleasure."
No care for little ones?—" We get 'em,
" The rest the mothers mind—and let 'em."

 Thou wretch, rejoin'd the kindling dove,
Quite lost to life, as lost to love!
Whene'er misfortune comes, how just!
And come misfortune surely must;
In the dread season of dismay,
In that your hour of trial, say,
Who then shall prop your sinking heart,
Who bear affliction's weightier part.

 Say, when the black-brow'd welkin bends,
And winter's gloomy form impends,
To mourning turns all transient cheer,
And blasts the melancholy year;

For times at no perfuafion, ftay,
Nor vice can find perpetual May;
Then where's that tongue, by folly led,
That foul of pertnefs, whither fled?
All fhrunk within thy lonely neft,
Forlorn, abandon'd, and unblefs'd;
No friends, by cordial bonds ally'd,
Shall feek thy cold, unfocial fide,
No chirping pratlers to delight,
Shall turn the long-enduring night,
No bride her words of balm impart,
And warm thee at her conftant heart.

Freedom, reftrain'd by reafon's force,
Is as the fun' unvarying courfe,
Benignly active, fweetly bright,
Affording warmth, affording light;
But torn from virtue's facred rules,
Becomes a comet, gaz'd by fools.
Foreboding cares, and ftorms, and ftrife,
And fraught with all the plagues of life.

Thou fool! by union ev'ry creature
Subfifts, thro' univerfal nature;

And this, to beings void of mind,
Is wedlock, of a meaner kind.

While womb'd in space, primæval clay
A yet unfashion'd embryo lay,
The source of endless good above
Shot down his spark of kindling love;
'Touch'd by the all-enliv'ning flame,
Then motion first exulting came,
Each atom sought its sep'rate class,
Thro' many a fair enamour'd mass,
Love cast the central charm around,
And with eternal nuptials bound.
Then form, and order o'er the sky,
First train'd their bridal pomp on high,
The sun display'd his orb to fight,
And burn'd with hymeneal light.

Hence nature's virgin womb conceiv'd,
And with the genial burthen heav'd;
Forth came the oak, her first-born heir,
And scal'd the breathing steep of air;
Then infant stems, of various use,
Imbib'd her soft, maternal juice,

The flow'rs, in early bloom difclos'd,
Upon her fragrant breaft repos'd;
Within her warm embraces grew
A race of endlefs form, and hue;
Then pour'd her leffer offspring round,
And fondly cloth'd their parent ground.

Nor here alone the virtue reign'd,
By matter's cumb'ring form detain'd,
But thence, fubliming, and refin'd,
Afpir'd, and reach'd its kindred mind.
Caught in the fond celeftial fire,
The mind perceiv'd unknown defire,
And now with kind effufion flow'd,
And now with cordial ardours glow'd,
Beheld the fympathetic fair,
And lov'd its own refemblance there;
On all with circling radiance fhone,
But cent'ring, fix'd on one alone;
There clafp'd the heav'n appointed wife,
And doubled every joy of life.

Here ever bleffing, ever blefs'd,
Refides this beauty of the breaft.

As from his palace, here the god
Still beams effulgent blifs abroad,
Here gems his own eternal round,
The ring, by which the world is bound,
Here bids his feat of empire grow,
And builds his little heav'n below.

 The bridal partners thus ally'd,
And thus in fweet accordance ty'd,
One body, heart and fpirit live,
Enrich'd by ev'ry joy they give;
Like echo, from her vocal hold,
Return'd in mufic twenty fold.
Their union firm, and undecay'd,
Nor time can fhake, nor pow'r invade,
But as the ftem, and fcion ftand,
Ingrafted by a fkilful hand,
They check the tempeft's wint'ry rage,
And bloom and ftrengthen into age.
A thoufand amities unknown,
And pow'rs, perceiv'd by love alone,
Endearing looks, and chafte defire,
Fan and fupport the mutual fire,

Whose flame, perpetual, as refin'd,
Is fed by an immortal mind.

Nor yet the nuptial sanction ends,
Like Nile it opens and descends,
Which, by apparent windings led,
We trace to its celestial head.
The fire, first springing from above,
Becomes the source of life and love,
And gives his filial heir to flow,
In fondness down on sons below;
Thus roll'd in one continu'd tide,
To time's extremest verge they glide,
While kindred streams, on either hand,
Branch forth in blessings o'er the land.

Thee, wretch! no lisping babe shall name,
No late-returning brother claim,
No kinsman on thy road rejoice,
No sister greet thy ent'ring voice,
With partial eyes no parents see,
And bless their years, restor'd in thee.

In age rejected, or declin'd,
An alien, even among thy kind,

The partner of thy scorn'd embrace,
Shall play the wanton in thy face,
Each spark unplume thy little pride,
All friendship fly thy faithless side,
Thy name shall like thy carcass rot,
In sickness spurn'd, in death forgot.

All giving pow'r! great source of life!
O hear the parent! hear the wife!
That life, thou lendest from above,
Tho' little, makes it large in love;
O bid my feeling heart expand
To ev'ry claim, on ev'ry hand,
To those, from whom my days I drew,
To these, in whom those days renew,
To all my kin, however wide,
In cordial warmth, as blood ally'd,
To friends with steely fetters twin'd,
And to the cruel, not unkind.
But chief, the lord of my desire,
My life, my self, my soul, my fire,
Friends, children, all that wish can claim,
Chaste passion clasp, and rapture name;

O spare him, spare him, gracious pow'r!
O give him to my latest hour!
Let me my length of life employ,
To give my sole enjoyment joy,
His love, let mutual love excite,
Turn all my cares to his delight,
And ev'ry needless blessing spare,
Wherein my darling wants a share.

When he with graceful action wooes,
And sweetly bills, and fondly cooes,
Ah! deck me to his eyes alone,
With charms attractive as his own.
And in my circling wings caress'd,
Give all the lover to my breast.
Then in our chaste, connubial bed,
My bosom pillow'd for his head,
His eyes, with blissful slumbers close,
And watch, with me, my lord's repose,
Your peace around his temples twine,
And love him with a love like mine.

And, for I know his gen'rous flame,
Beyond whate'er my sex can claim,

Me too to your protection take,
And spare me for my husband's sake;
Let one unruffled calm delight
The loving, and belov'd unite,
One pure desire our bosoms warm,
One will direct, one wish inform;
Thro' life, one mutual aid sustain,
In death, one peaceful grave contain.

While, swelling with the darling theme,
Her accents pour'd an endless stream,
The well-known wings a sound impart,
That reach'd her ear, and touch'd her heart:
Quick dropp'd the music of her tongue,
And forth with eager joy she sprung.
As swift her ent'ring consort flew,
And plum'd and kindled at the view;

Their wings, their souls embracing meet,
Their hearts with answ'ring measure beat;
Half lost in sacred sweets, and bless'd
With raptures felt, but ne'er express'd.

Strait to her humble roof she led
The partner of her spotless bed;

Her young, a flutt'ring pair, arife,
Their welcome fparkling in their eyes,
Tranfported, to their fire they bound,
And hang with fpeechlefs action round.
In pleafure wrapt, the parents ftand,
And fee their little wings expand;
The fire, his life fuftaining prize
To each expecting bill applies,
There fondly pours the wheaten fpoil,
With tranfport giv'n, tho' won with toil;
While all collected at the fight
And filent thro' fupreme delight,
The fair high heav'n of blifs beguiles,
And on her lord, and infants fmiles.

The Sparrow, whofe attention hung
Upon the Dov's enchanting tongue,
Of all his little flights difarm'd,
And from himfelf, by virtue, charm'd,
When now he faw, what only feem'd,
A fact, fo late a fable deem'd,
His foul to envy he refign'd,
His hours of folly to the wind,

In secret wish'd a turtle too,
And sighing to himself, withdrew.

FABLE XV.

THE FEMADE SEDUCERS.

'TIS faid of widow, maid, and wife,
That honour is a woman's life;
Unhappy fex! who only claim
A being in the breath of fame,
Which tainted, not the quick'ning gales,
That fweep Sabæa's fpicy vales,
Nor all the healing fweets reftore,
That breathe along Arabia's fhore.

The trav'ler, if he chance to ftray,
May turn uncenfur'd to his way;
Polluted ftreams again are pure,
And deepeft wounds admit a cure;
But woman! no redemption knows,
The wounds of honour never clofe.

Tho' diftant ev'ry hand to guide,
Nor fkill'd on life's tempeftuous tide,
If once her feeble bark recede,
Or deviate from the courfe decreed,
In vain fhe feeks the friendly fhore,
Her fwifter folly flies before;
The circling ports againft her clófe,
And fhut the wand'rer from repofe,
'Till by conflicting waves oppreft,
Her found'ring pinnace finks to reft.

Are there no off'rings to atone
For but a fingle error?———None.
Tho' woman is avow'd of old,
No daughter of celeftial mould,
Her temp'ring not without allay,
And form'd but of the finer clay,
We challenge from the mortal dame,
The ftrength angelic natures claim;
Nay more; for facred ftories tell,
That ev'n immortal angels fell.

Whatever fills the teeming fphere
Of humid earth, and ambient air,

With varying elements endu'd,
Was form'd to fall. aad rife renew'd.

The ſtars no fix'd duration know,
Wide oceans ebb, again to flow,
The moon repletes her waining face,
All-beauteous, from her late difgrace,
And funs, that mourn approaching night,
Refulgent rife, with new-born light.

In vain may death, and time fubdue,
While nature mints her race anew,
And holds fome vital fpark apart,
Like virtue, hid in ev'ry heart;
'Tis hence, reviving warmth is feen,
To cloath a naked world in green.
No longer barr'd by winter's cold,
Again the gates of life unfold:
Again each infect tries his wing,
And lifts frefh pinions on the fpring;
Again from ev'ry latent root
The bladed ftem, and tendril fhoot,
Exhaling incenfe to the fkies,
Again to perifh, and to rife.

And muſt weak woman then diſown
The change to which a world is prone?
In one meridian brightneſs ſhine
And ne'er like ev'ning ſuns decline?
Reſolv'd and firm alone?————Is this
What we demand of woman!—Yes.

But ſhould the ſpark of veſtal fire,
In ſome unguarded hour expire,
Or ſhould the nightly thief invade
Heſperia's chaſte, and ſacred ſhade,
Of all the blooming ſpoils poſſeſs'd,
The dragon honour charm'd to reſt,
Shall virtue's flame no more return?
No more with virgin ſplendor burn?
No more the ravag'd garden blow
With ſpring's ſucceeding bloſſom?—No.
Pity may mourn, but not reſtore,
And woman falls————to riſe no more.

Within this ſublunary ſphere,
A country lies————no matter where;

The clime may readily be found,
By all, who tread poetic ground.
A ſtream, call'd life, acroſs it glides,
And equally the land divides;
And here, of vice the province lies,
And there, the hills of virtue riſe.

Upon a mountain's airy ſtand,
Whoſe ſummit look'd to either land,
An antient pair their dwelling choſe,
As well for proſpect, as repoſe;
For mutual faith they long were fam'd,
And Temp'rance, and Religion, nam'd.

A num'rous progeny divine,
Confeſs'd the honours of their line;
But in a little daughter fair,
Was center'd more than half their care;
For heav'n to gratulate her birth,
Gave ſigns of future joy to earth;
White was the robe this infant wore,
And chaſtity the name ſhe bore.

As now the maid in ſtature grew,
(A flow'r juſt op'ning to the view)

Oft' thro' her native lawns she stray'd,
And wrestling with the lambkins play'd,
Her looks diffusive sweets bequeath'd,
The breeze grew purer as she breath'd,
The morn her radiant blush assum'd,
The spring with earlier fragrance bloom'd,
And nature, yearly, took delight,
Like her, to dress the world in white.

But when her rising form was seen,
To reach the crisis of fifteen,
Her parents up the mountain's head,
With anxious step their darling led;
By turns they snatch'd her to their breast,
And thus the fears of age express'd.

O joyful cause of many a care!
O daughter, too divinely fair!
Yon world, on this important day,
Demands thee to a dang'rous way;
A painful journey, all must go,
Whose doubted period none can know,
Whose due direction who can find,
Where reason's mute, and sense is blind?

Ah, what unequal leaders thefe,
Thro' fuch a wide, perplexing maze!
Then mark the warnings of the wife,
And learn, what love and years advife.

Far to the right thy profpect bend,
Where yonder tow'ring hills afcend;
Lo, there the arduous path's in view,
Which virtue and her fons purfue;
With toil o'er lefs'ning earth they rife,
And gain, and gain upon the fkies.
Narrow's the way her children tread,
No walk for pleafure fmoothly fpread,
But rough, and difficult, and fteep,
Painful to climb, and hard to keep.

Fruits immature thofe lands difpenfe,
A food indelicate to fenfe,
Of tafte unpleafant, yet from thofe
Pure health, with chearful vigour flows,
And ftrength, unfeeling of decay,
Throughout the long, laborious way.

Hence, as they fcale that heav'nly road,
Each limb is lighten'd of its load;

FABLES.

From earth refining still they go
And leave the mortal weight below·
Then spreads the strait, the doubtful clears,
And smooth the rugged path appears,
For custom turns fatigue to ease,
And, taught by virtue, pain can please.

At length, the toilsome journey o'er,
And near the bright, celestial shore,
A gulph, black, fearful, and profound,
Appears, of either world the bound.
Thro' darkness, leading up to light,
Sense backward shrinks, and shuns the fight,
For there the transitory train,
Of time, and form, and care, and pain,
And matter's gross, incumb'ring mass,
Man's late associates, cannot pass,
But sinking, quit the immortal charge,
And leave the wond'ring soul at large;
Lightly she wings her obvious way,
And mingles with eternal day.

Thither, O thither wing thy speed,
Tho' pleasure charm, or pain impede;

To such th' all-bounteous pow'r has giv'n,
For present earth, a future heav'n;
For trivial loss, unmeasur'd gain,
And endless bliss, for transient pain.
Then fear, ah! fear to turn thy sight,
Where yonder flow'ry fields invite;
Wide on the left the path-way bends,
And with pernicious ease descends;
There sweet to sense, and fair to show,
New-planted Edens seem to blow,
Trees, that delicious poison bear,
For death is vegetable there.

Hence is the frame of health unbrac'd,
Each sinew slack'ning at the taste,
The soul to passion yields her throne,
And sees with organs not her own;
While, like the slumb'rer in the night,
Pleas'd with the shadowy dream of light,
Before her alienated eyes,
The scenes of fairy-land arise;
The puppet-world's amusing show,
Dipt in the gayly-colour'd bow,

Scepters, and wreaths, and glitt'ring things,
The toys of infants, and of kings,
That tempt along the baneful plain,
The idly wife, and lightly vain,
'Till verging on the gulphy shore,
Sudden they sink, and rise no more.

But lift to what thy fates declare,
Tho' thou art woman, frail as fair,
If once thy sliding foot should stray,
Once quit yon heav'n appointed way,
For thee, lost maid, for thee alone,
Nor pray'rs shall plead, nor tears attone;
Reproach, scorn, infamy, and hate,
On thy returning steps shall wait.
Thy form be loath'd by ev'ry eye,
And ev'ry foot thy presence fly.

Thus arm'd with words of potent sound,
Like guardian-angels plac'd around,
A charm, by truth divinely cast,
Forward our young advent'rer pass'd.
Forth from her sacred Eye-lids sent,
Like morn, fore-running radiance went,

While honour, hand-maid late aſſign'd,
Upheld her lucid train behind.

 Awe-ſtruck the much admiring croud
Before the virgin viſion bow'd,
Gaz'd with an ever new delight,
And caught freſh virtue at the ſight;
For not of earth's unequal frame
They deem'd the heav'n-compounded dame,
If matter, ſure the moſt refin'd,
High-wrought, and temper'd into mind,
Some darling daughter of the day,
And body'd by her native ray.

 Where-e'er ſhe paſſes, thouſands bend,
And thouſands, where ſhe moves, attend,
Her ways obſervant eyes confeſs,
Her ſteps purſuing praiſes bleſs;
While to the elevated maid
Oblations, as to heav'n, are paid.

 'Twas on an ever-blithſome day,
The jovial birth of roſy May,
When genial warmth, no more ſuppreſs'd,
New melts the froſt in ev'ry breaſt,

The cheek with secret flushing dyes,
And looks kind things from chastest eyes;
The sun with healthier visage glows,
Aside his clouded kerchief throws,
And dances up th' etherial plain,
Where late he us'd to climb with pain,
While nature, as from bonds set free,
Springs out, and gives a loose to glee.

And now for momentary rest,
The nymph her travel'd step repress'd,
Just turn'd to view the stage attain'd,
And glory'd in the height she gain'd.

Out-stretch'd before her wide survey,
The realms of sweet perdition lay,
And pity touch'd her soul with woe,
To see a world so lost below;
When strait the breeze began to breathe
Airs, gently wafted from beneath,
That bore commission'd witchcraft thence,
And reach'd her sympathy of sense;
No sounds of discord, that disclose
A people sunk, and lost in woes.

Q

But as of present good possess'd,
The very triumph of the bless'd.
The Maid in wrapt attention hung,
While thus approaching Sirens sung.

Hither, fairest, hither haste,
Brightest beauty, come and taste
What the pow'rs of bliss unfold,
Joys, too mighty to be told;
Taste what extasies they give,
Dying raptures taste, and live.

In thy lap, disdaining measure,
Nature empties all her treasure,
Soft desires, that sweetly languish,
Fierce delights, that rise to anguish;
Fairest, dost thou yet delay?
Brightest beauty come away.

List not, when the froward chide,
Sons of pedantry, and pride,
Snarlers, to whose feeble sense,
April sunshine is offence;
Age and envy will advise
Ev'n against the joys they prize.

Come, in pleafure's balmy bowl,
Slake the thirftings of thy foul,
'Till thy raptur'd pow'rs are fainting
With enjoyment, paft the painting;
Faireft, doft thou yet delay?
Brighteft beauty, come away.

So fung the Sirens, as of yore,
Upon the falfe Aufonian fhore;
And, O! for that preventing chain,
That bound Ulyffes on the main,
That fo our Fair One might withftand
The covert ruin now at hand.

The fong her charm'd attention drew,
When now the tempters ftood in view;
Curiofity with prying eyes,
And hands of bufy, bold emprize;
Like Hermes, feather'd were her feet,
And, like fore-running fancy fleet,
By fearch untaught, by toil untir'd,
To novelty fhe ftill afpir'd,
Taftelefs of ev'ry good poffefs'd,
And but in expectation blefs'd,

With her, affociate, Pleafure came,
Gay Pleafure, frolic-loving dame,
Her mien, all fwimming in delight,
Her beauties, half reveal'd to fight;
Loofe flow'd her garments from the ground,
And caught the kiffing winds around.
As erft Medufa's looks were known
To turn beholders into ftone,
A dire reverfion here they felt,
And in the eye of pleafure melt.
Her glance with fweet perfuafion charm'd,
Unnerv'd the ftrong, the fteel'd difarm'd;
No fafety ev'n the flying find,
Who vent'rous, look but once behind.

Thus was the much admiring Maid,
While diftant, more than half betray'd.
With fmiles, and adulation bland,
They join'd her fide, and feiz'd her hand;
Their touch envenom'd fweets inftill'd,
Her frame with new pulfations thrill'd,
While half confenting, half denying,
Reluctant now, and now complying,

Amidſt a war of hopes, and fears,
Of trembling wiſhes, ſmiling tears,
Still down, and down, the winning Pair
Compell'd the ſtruggling, yielding Fair.

As when ſome ſtately veſſel bound,
To bleſt Arabia's diſtant ground,
Borne from her courſes, haply lights
Where Barca's flow'ry clime invites,
Conceal'd around whoſe treach'rous land,
Lurks the dire rock, and dang'rous ſand;
The pilot warns with ſail and oar,
To ſhun the much ſuſpected ſhore,
In vain; the tide too ſubtly ſtrong,
Still bears the wreſtling bark along,
Till found'ring, ſhe reſigns to fate,
And ſinks, o'erwhelm'd, with all her freight.

So, baffling ev'ry bar to ſin,
And heav'n's own pilot, plac'd within,
Along the devious ſmooth deſcent,
With pow'rs increaſing as they went,
The Dames accuſtom'd to ſubdue,
As with a rapid current drew,

And o'er the fatal bounds convey'd
The loft, the long reluctant Maid.

Here ftop, ye fair ones, and beware,
Nor fend your fond affections there;
Yet, yet your darling, now deplor'd,
May turn, to you, and heav'n, reftor'd;
Till then, with weeping honour wait,
The fervant of her better fate,
With honour, left upon the fhore,
Her friend, and handmaid now no more;
Nor, with the guilty world, upbraid
The fortunes of a wretch, betray'd,
But o'er her failing caft a veil,
Rememb'ring, you yourfelves are frail.
And now from all-enquiring light,
Faft fled the confcious fhades of night,
The Damfel, from a fhort repofe,
Confounded at her plight, arofe.

As when, with flumb'rous weight opprefs'd,
Some wealthy mifer finks to reft,
Where felons eye the glitt'ring prey,
And fteal his hoard of joys away;

He, borne where golden Indus ftreams,
Of pearl, and quarry'd di'mond dreams,
Like Midas, turns the glebe to ore,
And ftands all wrapt amidft his ftore,
But wakens, naked, and defpoil'd
Of that, for which his years had toil'd.

So far'd the Nymph, her treafure flown,
And turn'd, like Niobe, to ftone,
Within, without, obfcure, and void,
She felt all ravag'd, all deftroy'd.
And, O thou curs'd, infidious coaft!
Are thefe the bleffings thou canft boaft?
Thefe, virtue! thefe the joys they find,
Who leave thy heav'n-topt hills behind?
Shade me ye pines, ye caverns hide,
Ye mountains cover me, fhe cry'd!

Her trumpet Slander rais'd on high,
And told the tidings to the fky;
Contempt, difcharg'd a living dart,
A fide-long viper to her heart;
Reproach breath'd poifons o'er her face,
And foil'd, and blafted ev'ry grace;

Officious Shame, her handmaid new,
Still turn'd the mirror to her view,
While those in crimes the deepest dy'd,
Approach'd to whiten at her side,
And ev'ry lewd, insulting dame
Upon her folly rose to fame.

What should she do? Attempt once more
To gain the late-deserted shore?
So trusting, back the Mourner flew,
As fast the train of fiends pursue.

Again, the farther shore's attain'd,
Again the land of virtue gain'd;
But echo, gathers in the wind;
And shows her instant foes behind.
Amaz'd, with headlong speed she tends,
Where late she left an host of friends;
Alas! those shrinking friends decline,
Nor longer own that form divine,
With fear they mark the following cry,
And from the lonely Trembler fly,
Or backward drive her on the coast,
Where peace was wreck'd and honour lost.

From earth, thus hoping aid in vain.
To heav'n, not daring to complain,
No truce, by hostile clamour giv'n,
And from the face of friendship driv'n,
The Nymph sunk prostrate on the ground,
With all her weight of woes around.

Enthron'd within a circling sky,
Upon a mount o'er mountains high,
All radiant sate, as in a shrine,
Virtue, first effluence divine;
Far, far above the scenes of woe,
That shut this cloud-rapt world below;
Superior goddess, essence bright,
Beauty of uncreated light,
Whom should mortality survey,
As doom'd upon a certain day,
The breath of frailty must expire,
The world dissolve in living fire,
The gems of heav'n, and solar flame
Be quench'd by her eternal beam,
And nature, quick'ning in her eye,
To rise a new-born phœnix, die.

Hence, unreveal'd to mortal view,
A veil around her form she threw,
Which three sad sisters of the shade,
Pain, care, and melancholy made.

Thro' this her all-enquring eye,
Attentive stom her station high,
Beheld, abandon'd to despair,
The ruins of her fav'rite Fair;
And with a voice, whose awful sound,
Appall'd the guilty world around,
Bid the tumultuous winds be still,
To numbers bow'd each list'ning hill,
Uncurl'd the surging of the main,
And smooth'd the thorny bed of pain,
The golden harp of heav'n she strung,
And thus the tuneful goddess sung.

Lovely Penitent, arise,
Come and claim thy kindred skies,
Come, thy sister angels say,
Thou hast wept thy stains away.

Let experience now decide,
'Twixt the good, and evil try'd,

FABLES.

In the smooth, enchanted ground,
Say, unfold the treasures found.

Structures, rais'd by morning dreams,
Sands, that trip the flitting streams,
Down, that anchors on the air,
Clouds, that paint their changes there.

Seas, that smoothly dimpling lie,
While the storm impends on high,
Showing, in an obvious glass,
Joys, that in possession pass.

Transient, fickle, light, and gay,
Flatt'ring, only to betray·
What, alas, can life contain!
Life! like all its circles——vain.

Will the stork, intending rest,
On the billow build her nest?
Will the bee demand his store
From the bleak and bladeless shore?

Man alone, intent to stray,
Ever turns from wisdom's way,

Lays up wealth in foreign land,
Sows the sea, and plows the sand.

Soon this elemental mass,
Soon th' encumbring world shall pass,
Form be wrapt in wasting fire,
Time be spent, and life expire.

Then, ye boasted works of men,
Where is your asylum then?
Sons of pleasure, sons of care,
Tell me, mortals, tell me where?

Gone, like traces on the deep,
Like a scepter, grasp'd in sleep,
Dews, exhal'd from morning glades,
Melting snows, and gliding shades.

Pass the world, and what's behind?
Virtue's gold, by fire refin'd;
From an universe deprav'd,
From the wreck of nature sav'd.

Like the life-supporting grain
Fruit of patience, and of pain,

On the swain's autumnal day,
Winnow'd from the chaff away.

Little trembler, fear no more,
Thou hast plenteous crops in store,
Seed, by genial sorrows sown,
More than all thy scorners own.

What tho' hostile earth despise,
Heav'n beholds with gentler eyes;
Heav'n thy friendless steps shall guide,
Chear thy hours, and guard thy side.

When the fatal trump shall sound,
When th' immortals pour around.
Heav'n shall thy return attest,
Hail'd by myriads of the bless'd.

Little native of the skies,
Lovely penitent, arise,
Calm thy bosom, clear thy brow,
Virtue is thy sister now.

More delightful are my woes,
'Than the rapture, pleasure knows,

Richer far the weeds I bring,
Than the robes, that grace a king.

On my wars of shortest date,
Crowns of endless triumph wait,
On my cares a period bless'd,
On my toils, eternal rest.

Come, with virtue at thy side,
Come, be ev'ry bar defy'd,
Till we gain our native shore,
Sister, come, and turn no more.

FABLE XVI.

LOVE AND VANITY.

THE breezy morning breath'd perfume,
The wak'ning flow'rs unveil'd their bloom,
Up with the sun, from short repose,
Gay health, and lusty labour rose,
The milkmaid carol'd at her pail,
And shepherds whistled o'er the dale;
When love, who led a rural life,
Remote from bustle, state, and strife,
Forth from his thatch-roof'd cottage stray'd,
And strol'd along the dewy glade.

A Nymph, who lightly tripp'd it by,
To quick attention turn'd his eye,
He mark'd the gesture of the Fair,
Her self-sufficient grace and air,

Her steps, that mincing, meant to please,
Her study'd negligence and ease;
And curious to enquire what meant
This thing of prettiness, and paint,
Approaching spoke, and bow'd observant,
The Lady, slightly,——Sir, your servant,

 Such beauty in so rude a place!
Fair one, you do the country grace;
At court, no doubt, the public care,
But Love has small acquaintance there.

 Yes, Sir, reply'd the flutt'ring dame,
This form confesses whence it came;
But dear variety, you know,
Can make us pride, and pomp forego.
My name is Vanity. I sway
The utmost islands of the sea;
Within my court all honour centers
I raise the meanest soul that enters,
Endow with latent gifts and graces,
And model fools for posts and places.

 As Vanity appoints at pleasure,
The world receives its weight, and measure:

Hence all the grand concerns of life,
Joys, cares, plagues, passions, peace and strife.

Reflect how far my pow'r prevails,
When I step in, where nature fails,
And ev'ry breach of sense repairing,
Am bounteous still, where heav'n is sparing.

But chief in all their arts, and airs,
Their playing, painting, pouts, and pray'rs,
Their various habits, and complexions,
Fits, frolicks, foibles, and perfections,
Their robing, curling, and adorning,
From noon to night, from night to morning,
From six to sixty, sick or sound,
I rule the female world around,
Hold there a moment, Cupid cry'd,
Nor boast dominion quite so wide,
Was there no province to invade,
But that by love and meekness sway'd?
All other empire I resign,
But be the sphere of beauty mine.

For in the downy lawn of rest,
That opens on a woman's breast,

Attended by my peaceful train,
I chufe to live, and chufe to reign.

 Far-fighted faith 1 bring along,
And truth, above an army ftrong,
And chaftity, of icy mold,
Within the burning tropics cold,
And lowlinefs, to whofe mild brow,
The pow'r and pride of nations bow,
And modefty, with down caft eye,
That lends the morn her virgin dye,
And innocence, array'd in light,
And honour, as a tow'r upright;
With fweetly winning graces, more
Than poets ever dreamt of yore,
In unaffected conduct free,
All fmiling fifters, three times three,
And rofy peace the cherub blefs'd,
That nightly fings us all to reft.

 Hence, from the bud of nature's prime,
From the firft ftep of infant time,
Woman, the world's appointed light,
Has fkirted ev'ry fhade with white;

Has stood for imitation high,
To ev'ry heart and ev'ry eye;
From antient deeds of fair renown,
Has brought her bright memorials down,
To time affix'd perpetual youth,
And form'd each tale of love and truth.

Upon a new Promethean plan,
She molds the essence of a man,
Tempers his mass, his genius fires,
And as a better soul inspires.

The rude she softens, warms the cold,
Exalts the meek, and checks the bold,
Calls sloth from his supine repose,
Within the coward's bosom glows,
Of pride unplumes the lofty crest,
Bids bashful merit stand confess'd,
And like coarse metal from the mines,
Collects, irradiates, and refines.
The gentle science, she imparts,
All manners smooths informs all hearts;
From her sweet influence are felt,
Passions that please, and thoughts that melt;

To ſtormy rage ſhe bids controul,
And ſinks ſerenely on the ſoul,
Softens Ducalion's flinty race,
And tunes the warring world to peace.

Thus arm'd to all that's light and vain,
And freed from thy fantaſtick chain,
She fills the ſphere, by heav'n aſſign'd,
And rul'd by me, o'er-rules mankind.

He ſpoke. The Nymph impatient ſtood,
And laughing, thus her ſpeech renew'd.

And pray, Sir, may I be ſo bold,
To hope your pretty tale is told,
And next demand without a cavil,
What new Utopia do you travel?——
Upon my word theſe high-flown fancies
Shew depth of learning—in romances.
Why, what unfaſhion'd ſtuff you tell us,
Of buckram dames, and tiptoe fellows!
Go, child! and when you're grown maturer,
You'll ſhoot your next opinion ſurer.

O such a pretty knack at painting!
And all for soft'ning, and for fainting!
Guess now, who can, a single feature,
Thro' the whole piece of female nature!
Then mark! my looser hand may fit
The lines too coarse for love to hit.

'Tis said, that woman prone to changing,
Thro' all the rounds of folly ranging,
On life's uncertain ocean riding,
No reason? rule, nor rudder guiding,
Is like the comet's wandring light,
Eccentric, ominous, and bright.
Tractless, and shifting as the wind,
A sea, whose fathom none can find,
A moon, still changing, and revolving,
A riddle, past all human solving,
A bliss, a plague, a heav'n, a hell,
A——something, that no man can tell.

Now learn a secret from a friend,
But keep your council, and attend.

Tho' in their tempers thought so distant,
Nor with their sex, nor selves consistent,

'Tis but the diff'rence of a name,
And ev'ry woman is the fame.
For as the world, however vary'd,
And thro' unnumber'd changes carry'd,
Of elemental modes and forms,
Clouds, meteors, colours, calms, and ftorms,
Tho' in a thoufand fuits array'd,
Is of one fubject matter made;
So, Sir, a woman's conftitution,
The world's enigma, finds folution.
And let her form be what you will
I am the fubject effence ftill.

With the firft fpark of female fenfe,
The fpeck of being, I commence,
Within the womb make frefh advances,
And dictate future qualms and fancies;
Thence in the growing form expand,
With childhood travel hand in hand,
And give a tafte of all their joys,
In gewgaws, rattles, pomp, and noife.

And now, familiar, and unaw'd,
I fend the flutt'ring foul abroad;

Prais'd for her shape, her air, her mien,
The little goddess, and the queen,
Takes at her infant shrine oblation,
And drinks sweet draughts of adulation.

Now blooming, tall, erect, and fair,
To dress, becomes her darling care;
The realms of beauty then I bound,
I swell the hoop's enchanted round,
Shrink in the waist's descending size,
Heav'd in the snowy bosom, rise,
High on the floating lappet sail,
Or curl'd in tresses kiss the gale.
Then to her glass, I lead the fair,
And shew the lovely idol there,
Where, struck as by divine emotion,
She bows with most sincere devotion,
And numb'ring ev'ry beauty o'er,
In secret bids the world adore.

Then all for parking, and parading,
Coquetting, dancing, masquerading;
For balls, plays, courts, and crouds what passion;
And churches, sometimes————if the fashion;

For woman's sense of right and wrong,
Is rul'd by the almighty throng,
Still turns to each meander tame,
And swims the straw of ev'ry stream.
Her soul intrinsic worth rejects,
Accomplish'd only in defects,
Such excellence is her ambition,
Folly, her wisest acquisition,
And ev'n from pity, and disdain,
She'll cull some reason to be vain.

Thus, Sir, from ev'ry form, and feature,
The wealth, and wants of female nature,
And ev'n from vice, which you'd admire,
I gather fewel to my fire,
And on the very base of shame,
Erect my monument of fame.

Let me another truth attempt,
Of which your godship has not dreamt.

Those shining virtues, which you muster,
Whence think you they derive their lustre?
From native honour, and devotion?
O yes, a mighty likely notion!

Trust me, from titled dames to spinners,
'Tis I make saints, whoe'er makes sinners;
'Tis I instruct them to withdraw,
And hold presumptuous man in awe;
For female worth as I inspire,
In just degrees, still mounts the higher,
And virtue, so extremely nice,
Demands long toil, and mighty price,
Like Sampson's pillars, fix'd elate,
I bear the sex's tott'ring state,
Sap these, and in a moment's space,
Down sinks the fabric to its base.

Alike from titles, and from toys,
I spring, the fount of female joys,
In every widow, wife, and miss,
The sole artificer of bliss.
For them each tropic I explore;
I cleave the sand of ev'ry shore;
To them uniting Indias sail,
Sabæa breathes her farthest gale;
For them the bullion I refine,
Dig sense, and virtue from the mine,

And from the bowels of invention,
Spin out the various arts you mention.

Nor bliſs alone my pow'rs beſtow,
They hold the ſov'reign balm of woe;
Beyond the ſtoic's boaſted art,
I ſooth the heavings of the heart;
To pain give ſplendor, and relief,
And gild the pallid face of grief.

Alike the palace, and the plain
Admit the glories of my reign;
Thro' ev'ry age, in ev'ry nation,
Taſte, talents, tempers, ſtate, and ſtation,
Whate'er a woman ſays, I ſay;
Whate'er a womun ſpends, I pay;
Alike I fill, and empty bags,
Flutter, in finery, and rags,
With light coquets thro' folly range,
And with the prude diſdain to change.

And now you'd think, 'twixt you and I,
That things were ripe for a reply——
But ſoft, and while I'm in the mood,
Kindly permit me to conclude,

Their utmoſt mazes to unravel,
And touch the fartheſt ſtep they travel.

When ev'ry pleaſure's run a-ground,
And folly tir'd thro' many a round,
The nymph, conceiving diſcontent hence,
May ripen to an hour's repentance,
And vapours ſhed in pious moiſture,
Diſmiſs her to a church, or cloyſter;
Then on I lead her, with devotion,
Conſpicuous in her dreſs and motion,
Inſpire the heav'nly-breathing air,
Roll up the lucid eye in pray'r,
Soften the voice, and in the face
Look melting harmony and grace.

Thus far extends my friendly pow'r,
Nor quits her in her lateſt hour;
The couch of decent pain I ſpread,
In form recline her languid head,
Her thoughts I methodize in death,
And part not with her parting breath;
Then do I ſet, in order bright,
A length of funeral pomp to ſight,

The glitt'ring tapers, and attire,
The plumes that whiten o'er her bier;
And laſt, preſenting to her eye
Angelic fineries on high,
To ſcenes of painted bliſs I waft her,
And form the heav'n ſhe hopes hereafter.

In truth, rejoin'd love's gentle God,
You've gone a tedious length of road,
And ſtrange, in all the toilſome way,
No houſe of kind refreſhment lay,
No nymph, whoſe virtues might have tempted,
To hold her from her ſex exempted.

For one, we'll never quarrel, man;
Take her, and keep her if you can;
And pleas'd I yield to your petition,
Since every fair, by ſuch permiſſion,
Will hold herſelf the one ſelected,
And ſo my ſyſtem ſtands protected.

O deaf to virtue, deaf to glory,
To truths divinely vouch'd in ſtory!
The Godhead in his zeal return'd,
And kindling at her malice burn'd.

Then sweetly rais'd his voice, and told
Of heav'nly nymphs, rever'd of old;
Hypsipyle, who sav'd her sire;
And Portia's love, approv'd by fire;
Alike Penelope was quoted,
Nor laurel'd Daphne pass'd unnoted,
Nor Laodamia's fatal garter,
Nor fam'd Lucretia, honour's martyr,
Alceste's voluntary steel,
And Catherine, smiling on the wheel.

But who can hope to plant conviction,
Where cavil grows on contradiction?
Some she evades or disavows,
Demurs to all, and none allows;
A kind of antient thing, call'd fables!
And thus the Goddess turn'd the tables.

Now both in argument grew high,
And choler flash'd from either eye;
Nor wonder each refus'd to yield,
The conquest of so fair a field.

When happily arriv'd in view,
A Goddess, whom our grandames knew,

Of aspect grave, and sober gaite,
Majestic, awful, and sedate,
As heav'n's autumnal eve serene,
Where not a cloud o'ercasts the scene;
Once Prudence call'd, a matron fam'd,
And in old Rome, Cornelia nam'd.

Quick at a venture, both agree
To leave their strife to her decree.

And now by each the facts were stated,
In form, and manner as related;
The case was short. They crav'd opinion,
Which held o'er females chief dominion;
When thus the Goddess, answering mild,
First shook her gracious head, and smil'd.

Alas! how willing to comply,
Yet how unfit a judge am I!
In times of golden date, 'tis true,
I shar'd the fickle sex with you,
But from their presence long precluded,
Or held as one whose form intruded,
Full fifty annual suns can tell,
Prudence has bid the sex farewell.

FABLES.

In this dilemma what to do
Or who to think of, neither knew;
For both, still biafs'd in opinion,
And arrogant of fole dominion,
Were forc'd to hold the cafe compounded,
Or leave the quarrel where they found it.

When in the nick, a rural fair,
Of inexperienc'd gait and air,
Who ne'er had crofs'd the neighb'ring lake,
Nor feen the world beyond a wake,
With cambrick coif, and kerchief clean,
Tript lightly by them o'er the green.

Now, now! cry'd love's triumphant Child,
And at approaching conqueft fmil'd,
If Vanity will once be guided,
Our diff'rence foon may be decided;
Behold yon wench, a fit occafion
To try your force of gay perfuafion.
Go you, while I retire aloof,
Go, put thofe boafted pow'rs to proof;
And if your prevalence of art
Tranfcends my yet unerring dart,

I give the fav'rite conteſt o'er,
And ne'er will boaſt my empire more.

At once, ſo ſaid, and ſo conſented;
And well our Goddeſs ſeem'd contented;
Nor pauſing, made a moment's ſtand,
But tript, and took the girl in hand.

Mean while the Godhead, unalarm'd,
As one to each occaſion arm'd,
Forth from his quiver cull'd a dart,
That erſt had wounded many a heart;
Then bending, drew it to the head;
The bowſtring twang'd, the arrow fled,
And, to her ſecret ſoul addreſs'd,
Transfix'd the whiteneſs of her breaſt.

But here the Dame, whoſe guardian care,
Had to a moment watch'd the fair,
At once her pocket mirror drew,
And held the wonder full in view;
As quickly, rang'd in order bright,
A thouſand beauties ruſh to ſight,
A world of charms, till now unknown,
A world, reveal'd to her alone;

Enraptur'd stands the love-sick maid,
Suspended o'er the darling shade,
Here only fixes to admire,
And centers every fond desire.

FINIS.

ALSO AVAILABLE FROM THOEMMES PRESS

For Her Own Good – A Series of Conduct Books

Cœlebs in Search of a Wife
Hannah More
With a new introduction by Mary Waldron
ISBN 1 85506 383 2 : 288pp : 1808–9 edition : £14.75

Female Replies to Swetnam the Woman-Hater
Various
With a new introduction by Charles Butler
ISBN 1 85506 379 4 : 336pp : 1615–20 edition : £15.75

A Complete Collection of Genteel and Ingenious Conversation
Jonathan Swift
With a new introduction by the Rt Hon. Michael Foot
ISBN 1 85506 380 8 : 224pp : 1755 edition : £13.75

Thoughts on the Education of Daughters
Mary Wollstonecraft
With a new introduction by Janet Todd
ISBN 1 85506 381 6 : 192pp : 1787 edition : £13.75

The Young Lady's Pocket Library, or Parental Monitor
Various
With a new introduction by Vivien Jones
ISBN 1 85506 382 4 : 352pp : 1790 edition : £15.75

Also available as a 5 volume set : ISBN 1 85506 378 6
Special Set Price: £65.00

Her Write His Name

Old Kensington *and* The Story of Elizabeth
Anne Isabella Thackeray
With a new introduction by Esther Schwartz-McKinzie
ISBN 1 85506 388 3 : 496pp : 1873 & 1876 editions : £17.75

Shells from the Sands of Time
Rosina Bulwer Lytton
With a new introduction by Marie Mulvey Roberts
ISBN 1 85506 386 7 : 272pp : 1876 edition : £14.75

Platonics
Ethel Arnold
With a new introduction by Phyllis Wachter
ISBN 1 85506 389 1 : 160pp : 1894 edition : £13.75

The Continental Journals 1798-1820
Dorothy Wordsworth
With a new introduction by Helen Boden
ISBN 1 85506 385 9 : 472pp : New edition : £17.75

Her Life in Letters
Alice James
Edited with a new introduction by Linda Anderson
ISBN 1 85506 387 5 : 320pp : New : £15.75

Also available as a 5 volume set : ISBN 1 8556 384 0
Special set price : £70.00

Subversive Women

The Art of Ingeniously Tormenting
Jane Collier
With a new introduction by Judith Hawley
ISBN 1 8556 246 1 : 292pp : 1757 edition : £14.75

Appeal of One Half the Human Race, Women, Against the Pretensions of the Other Half, Men, to Retain them in Political, and thence in Civil and Domestic, Slavery
William Thompson and Anna Wheeler
With a new introduction by the Rt Hon. Michael Foot and Marie Mulvey Roberts
ISBN 1 85506 247 X : 256pp : 1825 edition : £14.75

A Blighted Life: A True Story
Rosina Bulwer Lytton
With a new introduction by Marie Mulvey Roberts
ISBN 1 85506 248 8 : 178pp : 1880 edition : £10.75

The Beth Book
Sarah Grand
With a new introduction by Sally Mitchell
ISBN 1 85506 249 6 : 560pp : 1897 edition : £18.75

The Journal of a Feminist
Elsie Clews Parsons
With a new introduction and notes by Margaret C. Jones
ISBN 1 85506 250 X : 142pp : New edition : £12.75

Also available as a 5 volume set : ISBN 1 85506 261 5
Special set price : £65.00

VIVIEN JONES
is a Senior Lecturer in the School of English at the University of Leeds. She is the editor of *Women in the Eighteenth Century: Constructions of Femininity* (Routledge, 1990), and has published books on Henry James and Jane Austen, and articles on women and writing in the eighteenth century. She is the editor of *Pride and Prejudice* for the new Penguin Classics edition of Austen's works.

Marie Mulvey Roberts is a Senior Lecturer in literary studies at the University of the West of England and is the author of *British Poets and Secret Societies* (1986), and *Gothic Immortals* (1990). From 1994 she has been the co-editor of a Journal: 'Women's Writing; the Elizabethan to the Victorian Period', and the General Editor for three series: *Subversive Women, For Her Own Good,* and *Her Write His Name*. The volumes she has co-edited include: *Sources of British Feminism* (1993), *Perspectives on the History of British Feminism* (1994), *Controversies in the History of British Feminism* (1995) and *Literature and Medicine during the Eighteenth Century* (1993). Among her single edited books are, *Out of the Night: Writings from Death Row* (1994), and editions of Rosina Bulwer Lytton's *A Blighted Life* (1994) and *Shells from the Sands of Time* (1995).

Cover designed by Dan Broughton